DIARY
OF AN
ARCTIC
YEAR

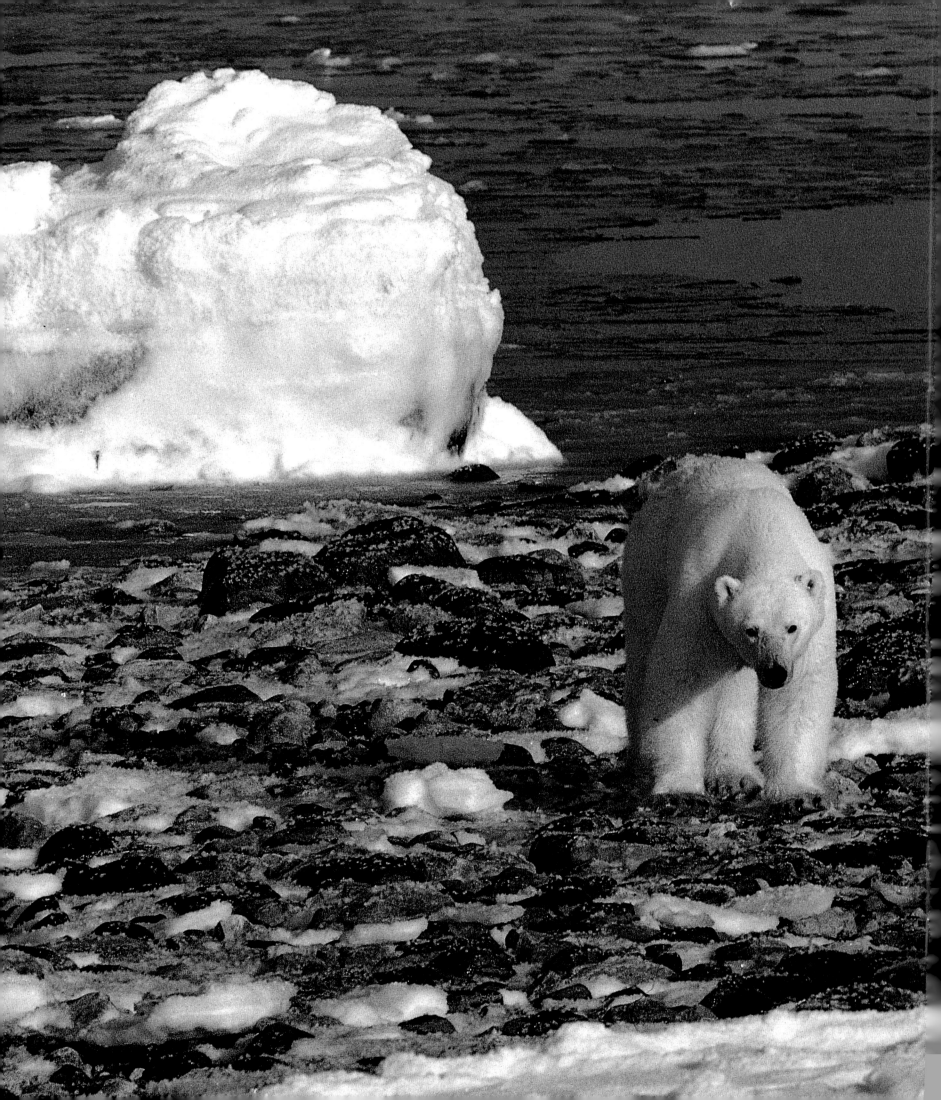

DIARY
OF AN
ARCTIC
YEAR

STEPHEN J.
KRASEMANN

CHRONICLE BOOKS

in association with
Lorraine Greey Publications Limited

Library of Congress Cataloging-in-Publication Data

Krasemann, Stephen J.
 Diary of an Arctic year / Stephen Krasemann.
 p. cm.
 ISBN 0-8118-0027-X

 1. Natural history — Arctic regions. 2. Natural history —
Arctic regions — Pictorial works. 3. Nature photography —
Arctic regions. 4. Krasemann, Stephen J. — Diaries.
I. Title.
QH84.1.K73 1991 91-9358
508.719--dc20 CIP

Produced in association with
Lorraine Greey Publications Limited,
Toronto, Canada.

10 9 8 7 6 5 4 3 2 1

Chronicle Books
275 Fifth Street
San Francisco, California 94103

Map drawn by David Chapman
Designed by Andrew Smith Graphics Inc.

Printed and bound in Singapore by Palace Press

COVER: *Mount McKinley is one of the largest landforms on the face of the earth, occupying 120 square miles.*

INSET: *Young male polar bears are often seen wrestling and playing together, but adult bears are generally solitary hunters, and will not hesitate to attack and eat young, defenseless members of their own species.*

TITLE PAGE: *A polar bear, hungry after a summer of dormancy and fasting, prowls the autumn shore of Hudson Bay.*

INSET: *Superbly adapted to the radical extremes of the northern climate, the arctic fox is entirely comfortable both in the heat of the Arctic summer and in the chill of winter.*

This book is dedicated to all those who encouraged me to persevere as a photographer: my father, Ralph Krasemann, who was always there for me; my late mother, Mary Ellen Krasemann, a provocative painter who taught me to dare to be creative; K.B. Oyer, my grandfather, who versed me in the wilderness; Robert and Barbara Greenler, whose love of wildlife guided and inspired me; Robert Dunne, editor of *Ranger Rick*, whose informative notes meant so much to me. I am also grateful to Karen Altpeter and the late John Strohm, who published my early pictures in *National Wildlife* and *International Wildlife*, and to Robert Gilka, the former director of photography for *National Geographic*. And special thanks to Jon Krakauer for all his help with this book.

CONTENTS

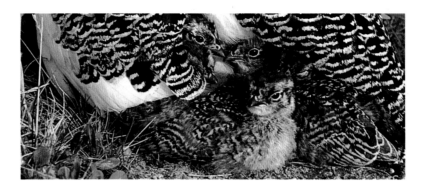

SPRING

SUMMER

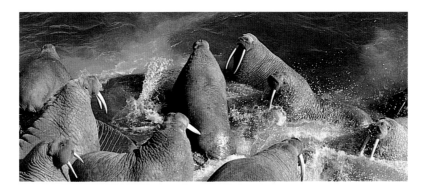

FALL

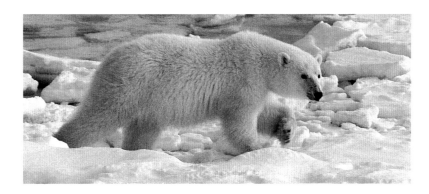

WINTER

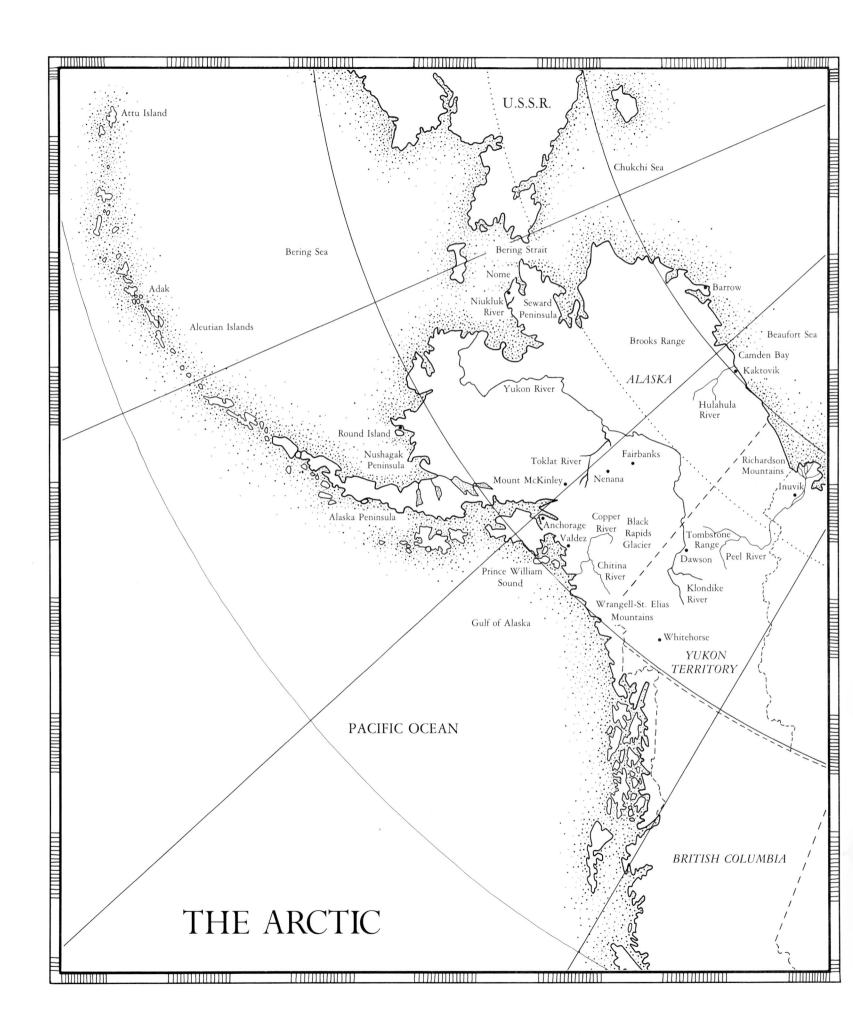

THE ARCTIC

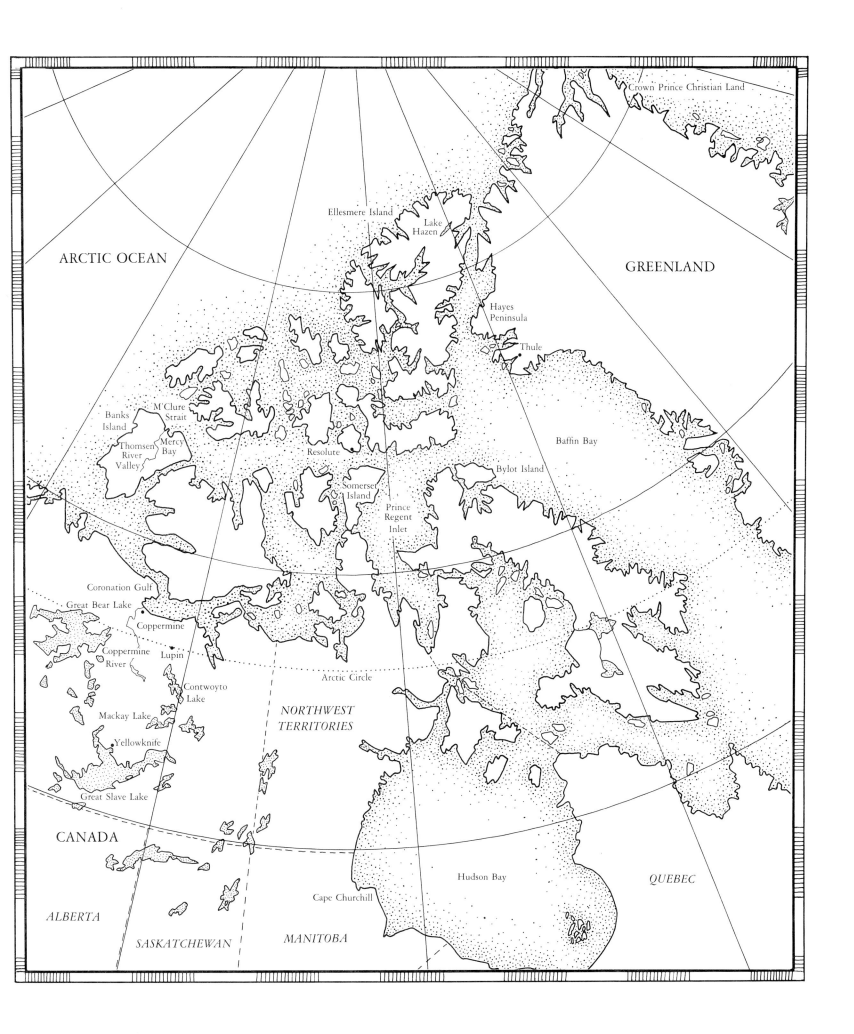

ARCTIC OCEAN

GREENLAND

Crown Prince Christian Land

Ellesmere Island

Lake
Hazen

Hayes
Peninsula

Thule

M'Clure
Strait

Banks
Island

Baffin Bay

Thomsen
River
Valley

Mercy
Bay

Resolute

Bylot Island

Somerset
Island

Prince
Regent
Inlet

Coronation Gulf

Great Bear Lake

Coppermine

Coppermine
River

Lupin

Arctic Circle

Contwoyto
Lake

NORTHWEST
TERRITORIES

Mackay Lake

Yellowknife

Great Slave Lake

CANADA

Hudson Bay

QUEBEC

ALBERTA

Cape Churchill

SASKATCHEWAN

MANITOBA

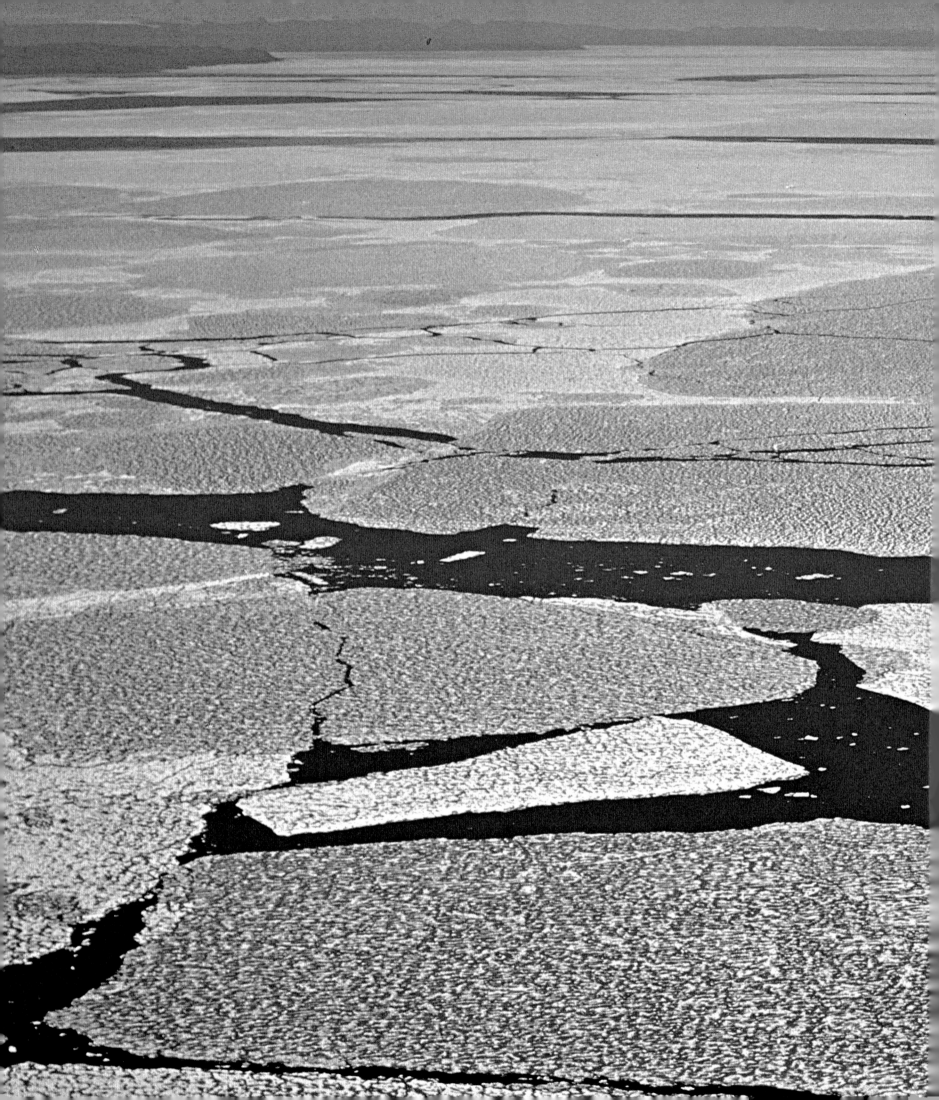

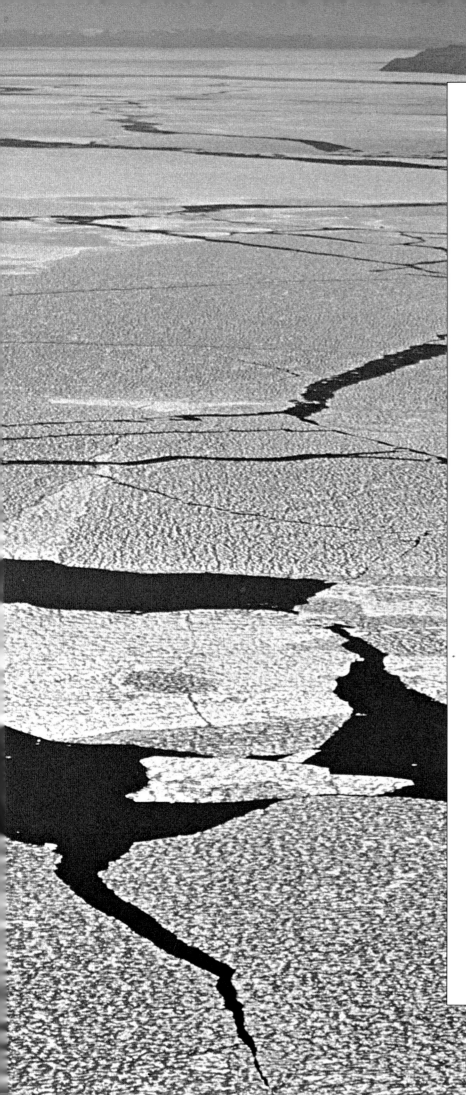

SPRING

FEBRUARY 9

THULE — A winter afternoon on northwestern Greenland's Hayes Peninsula, not far from the village of Thule, a strange, empty land of searing beauty. I have been walking across a hard-frozen hillside — I have no appointments to keep, nor any firm destination — and as the snow squeaks and crunches beneath my heavy boots, I detect something like happiness stirring in my chest. My expansive mood comes in part from the weather — it's clear, dead calm and 4°F below zero which is unusually mild for this time of year up here — but it comes even more from the pale-violet glow at the edge of the southern sky.

This modest band of twilight confirms what the calendar has long been predicting: tomorrow at noon the sun will slide above the horizon, touching the ice with its rays for the first time in ninety-nine days. The sun's appearance will be extremely brief — it will start to set as soon as it rises — but when you haven't seen the light of day in more than three months, even a little sun is cause for celebration. Most of the world considers the vernal equinox, March 21, to mark the first day of spring, the season of promise and rebirth. In the High Arctic we wait not for the equinox but for February 10, the debut of the sun. Never mind that subzero temperatures will be with us until the end of May, or that the sea will still be frozen over come July; the first tiny sliver of daylight spreads hope across the North.

Ice floes, buffeted by winds and tides, break apart to reveal open leads of matte-black water off the coast of Ellesmere Island, not far from the northernmost point of land in North America.

Which is not to imply that the northern winter is without allure. The endless night has a magnificence of its own, a beauty so pure and severe and astonishing that to witness it even once means it is etched into your memory for life. It is not surprising that the polar Inuit who live in and around the village of Thule call the region *Nunassiaq*, the Beautiful Land. And the darkness is by no means absolute. At the moment the moon, which hasn't left the sky for the past five days, is washing the land in a ghostly blue glow. The snow-covered earth reflects enough moonlight for me to pick out the rocky shore of Baffin Bay four or five miles distant. If I look closely, I can even make out my own dim shadow stretching across the ice.

I shift my gaze upward. The midday blackness forms a backdrop for a billion dazzling pricks of light, a phantasmagoric parade of stars, planets and nebulas inching grandly across the sky. If I crane my neck far enough, so that I'm staring almost straight overhead, my gaze falls on the only star up there that never seems to move: alpha *Ursae Minoris*, better known as the North Star. Swinging around it in a tight, lazy circle, like sleepy children around a maypole, are the seven faint stars of the Little Dipper and, a little farther away, the seven brighter ones of the Big Dipper or *Ursae Majoris*, which the ancient Greeks called Artikos, the constellation of the Great Bear.

To the Greeks, of course, Artikos did not appear directly overhead; it was much lower in their sky, directly above the northernmost point on the horizon. They called the distant, mysterious regions that lay beneath these stars Thule, which means the Edge of the Known World, or simply Artikos, the Country of the Great Bear. It was but a short step from Artikos to Arctic, the name we currently use for the topmost reaches of the planet, and where I've lived and roamed and plied my trade as a photographer for most of the past nine years.

For many minutes I stand rapt and motionless in the cold, studying the constellation that lent its name to my adopted home, finding it difficult to believe that in two and a half months those stars will be completely invisible, even at midnight, obscured by a sun that never sets.

FEBRUARY 25

MACKAY LAKE — I'm sitting in the passenger seat of a tractor-trailer rig, a big Kenworth eighteen-wheeler, hauling thirty tons of explosives to the Lupin Mine, a 2,200-foot hole blasted out of the permafrost in the empty center of the Northwest Territories. Lupin, a driller who works there informed me with no small amount of pride, is the northernmost gold mine in the western hemisphere.

The driver of this truck is a skinny young man with jug-handle ears named Roger. It's pleasant enough here inside the heated cab — we're in our shirtsleeves, sipping hot cocoa from a thermos, rolling along to the soothing twang of some country-and-western singer on Roger's tape deck — but just beyond the truck's windows a twenty-knot breeze is kicking up a ground blizzard that makes it all but impossible to see the roadway. The temperature outside is 0°F, or −40°F when you factor in the wind chill. Roger, who has deep, permanent worry lines scribed across his forehead, scowls and mutters, "I wish it wasn't so damn warm out there."

To comprehend how an apparently sane man could think that 0°F is uncomfortably warm, it is necessary to understand that the road over which the truck is moving isn't really a road in any traditional sense of the word: this particular highway is nothing

more than a plowed lane down the middle of a seventy-mile-long frozen lake. The only thing preventing the heavy truck from sinking like a stone into the chilly, 200-foot-deep water directly beneath the rig's wheels is a skin of ice, approximately three feet thick, that has formed across the surface of the lake. Which explains why Roger is fond of cold weather and gets nervous whenever the temperature climbs to a relatively tropical 0°F, which is 27°F above the seasonal mean.

Roger's nervousness is heightened by the fact that it's been this warm for several weeks now. Furthermore, it's not just a single lake that we must cross to reach the mine. All but thirty miles of the 370-mile route to Lupin from Yellowknife — the community of 11,000 that is the Northwest Territories' capital, commercial hub and closest approximation to a city — is over frozen water. Needless to say, Roger doesn't wear a seat belt. Much of the time, in fact, he drives with one hand on the door handle.

Ice highways like this one are laconically called "winter roads" by Roger and the other truckers who drive them. They are common throughout the Arctic; some 1,400 miles of ice roads have been built in the Northwest

Territories alone. They owe their popularity to the fact that conventional land-based roads are prohibitively expensive to build in most of the North. Not only is the countryside exceedingly rugged, but tens of thousands of lakes are scattered across the land as densely as spots on a leopard, necessitating a mind-boggling, bankrupting chain of bridges. Arctic entrepreneurs discovered early, however, that the same profusion of water that precluded overland travel in the summer months could, during the winter's brutal freeze, be used as a natural highway of ice — as long as the temperature stayed low.

From up in the cab of Roger's Kenworth, the snow-covered surface of the lake presents the reassuring illusion of being as solid as concrete, but a walk along the side of the roadway gives a very different impression. At close range, the ice is unexpectedly pretty, polished to a high gloss and tinted from a palette of ethereal, translucent colors that range from pearl to onyx to bright robin's-egg blue. But the ice is also riven with cracks, some several inches wide and running for hundreds of yards. When a truck barrels past, it depresses the ice a few inches, creating waves beneath the frozen lake surface,

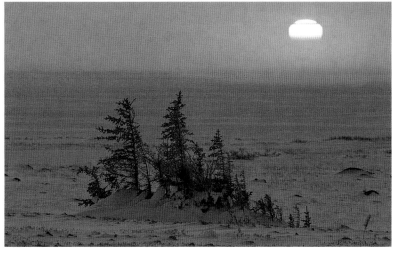

Spruce trees on the taiga

13

which cause the roadway to heave up and down like a huge water bed, accompanied by an alarming chorus of gunshot-like pops and tortured, basso profundo groans. One tends to ask oneself at such moments what in the name of God a forty-ton tractor-trailer rig is doing out in the middle of a major body of water, miles from the nearest shore.

The prospect of riding a truck to a cold, watery grave is the most vivid of the perils confronting those who drive this winter road, but it is by no means the only danger. Severe blizzards can come up without warning, burying the road under four-foot snowdrifts, stranding truckers in the middle of a lake (which is why every driver is required to carry several days' food and water, and enough diesel fuel to keep an engine idling for one week). In addition, a heavy snowfall can weight the frozen lake surface sufficiently to sink the whole thing slightly. Water forced up through fissures in the ice then floods the roadway, causing a truck's drive wheels to spin uselessly.

Even the barren-ground caribou, *Rangifer tarandus groenlandicus*, which number in the thousands along the winter road, create hazards for truckers. The live animals aren't the

problem; it's the ones that have fallen prey to hunters. The ice road to Lupin, which was first opened in 1979, permits any hunter who owns a reliable car to quickly and easily visit vast areas of wilderness that would otherwise be inaccessible without an airplane. When an animal is shot, it is generally hauled to the plowed roadway to be stripped of meat, after which the remains are simply left in the track. Along the southern stretch of the route — where both hunters and caribou are thickest during the winter months — the road is dotted with hundreds of these carcasses. Should a truck inadvertently run over a mound of frozen caribou intestines, the effect is little different from running over a boulder: blown-out tires, broken axles, mangled tie-rods.

As Roger and I continue rolling north through the storm toward Lupin, I have to admit that I'm a little nervous. Naturally, my greatest concern is for my own paltry life, but I also can't help wondering about something else, a larger issue that nobody seems to want to talk about. More than 800 truckloads of freight move over this one winter road alone every winter, including 4.2 million gallons of diesel fuel to power the mine's

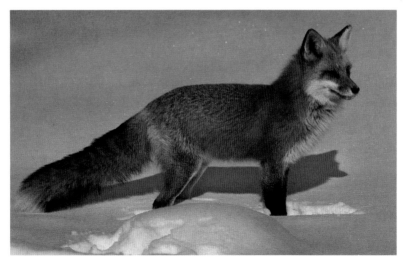

Red fox

generators and heavy machinery, and one-half million pounds of deadly sodium cyanide crystals, which are used to refine raw ore into gold.

What I want to know is what happens if a truck full of diesel oil—or worse, cyanide—goes down in the middle of one of these pristine lakes and breaks apart? These myriad bodies of water are all interconnected and eventually drain into the extremely fragile ecosystems of the Beaufort Sea. Sooner or later a truckload of diesel or cyanide is bound to get spilled and when that sort of accident occurs, the ecological ramifications are not going to be pleasant.

FEBRUARY 26

CONTWOYTO LAKE — Roger and I have been on the winter road for nearly three days now; with any luck—and if the blizzard doesn't cause the track to be covered by drifts—we should reach Lupin tonight. With each mile we travel, the country rising from the lakes becomes more and more forbidding. Yesterday, near the upper end of Mackay Lake, the last of the spruce groves, as tortured and stunted as a bonsai forest, disappeared as we crossed the continent's northern tree line. And there is a corresponding paucity of fauna. Occasionally we'll glimpse an arctic hare or a hardy raven, and this morning during a stop I noticed a small crater in the snow, speckled with a few drops of frozen blood, where an owl had apparently dropped out of the sky to snag a mouse or lemming in its talons. But those have been the only visible signs of life in these parts.

Indeed, beyond the windshield now lies a region of Canada aptly known as the Barrens—a landscape of windblown ice and turtle-back hills so desolate and featureless and unrelentingly white that the appearance of so much as a rock would be a major relief.

Writing about this country in 1890, the explorer Warburton Pike went so far as to call it "the most complete desolation that exists on the face of the earth."

It was John Franklin who first gave the Barrens its name. Franklin, you'll recall, was the Englishman who in an indirect way had more to do with the exploration of the Arctic in the nineteenth century than anyone else. To wit: In 1845 Franklin set sail from England with two ships, the *Erebus* and the *Terror*, determined to pioneer a viable maritime trade route through the arctic latitudes between the Atlantic and Pacific oceans—the infamous Northwest Passage, which at the time existed only in the realm of theory. Franklin and all 128 of his men, however, disappeared without a trace; when they failed to return to England in 1847, a massive search-and-rescue effort was launched. Between 1848 and 1859 more than fifty expeditions were mounted at a cost of untold thousands of pounds, many additional ships and human lives. Along the way, nevertheless, most of the High Arctic was explored and mapped, and the Northwest Passage was eventually—if rather anticlimactically—traversed.

Franklin didn't give the Barrens its name on his ill-starred 1845 expedition, however. He christened the region during an earlier, similarly unlucky expedition between 1819 and 1822 that traveled overland from Hudson Bay to a fur-trading outpost on Great Slave Lake (near the present site of Yellowknife), then north to the mouth of the Coppermine River, east along the shore of Coronation Gulf and finally south across the Barrens back to Great Slave Lake. Franklin managed to get back to England alive on that trip, but just barely: the journey was distinguished by bitter acrimony, inept leadership, starvation, murder and cannibalism.

Eleven of Franklin's men died, and at one point — not far from the shores of Contwoyto Lake, the same godforsaken body of water over which this eighteen-wheeler is currently rolling — Franklin was forced to eat the leather from his own shoes to survive.

The flurry of arctic exploration that occurred in the nineteenth century marked a fundamental shift in the nature of exploration. In previous centuries men had set sail for unknown lands primarily for mercantile, political or religious reasons. Explorers explored, in the immortal words of Spanish conquistador Bernal Diaz del Castillo, "to serve God, and also to get rich."

When Franklin and his countrymen launched expedition after expedition to the Arctic in search of the Northwest Passage, they were fooling themselves if they thought discovering the Passage was likely to benefit society in any great or immediate way. It became obvious early that the Passage was simply too far north, and hence too frequently icebound, to ever succeed as a route for commercial vessels between the oceans. Although few of them would have admitted it, the gentlemanly English naval officers who led most of these northern quests set sail from Britain to answer a contrived, if compelling, challenge that had little utilitarian value. They went for adventure, pure and simple, and to bolster national prestige. The Arctic drew these brave, ill-prepared Englishmen because it was the next obvious challenge, because the rest of the planet had already been explored, because — as George Leigh Mallory would say about Mount Everest a hundred years later — it was there. As the November 1855 edition of *Blackwoods Edinburgh Magazine* put it: "No, there are no more sunny continents — no more islands of the blest hidden under the far horizon, tempting the dreamer over the undiscovered sea; nothing but those weird and tragic shores, those cliffs of everlasting ice and mountains of frozen snow, which have never produced anything to us but a late and sad discovery of the depths of human heroism, patience, and bravery, such as imagination could scarcely dream of."

MARCH 2

LUPIN – The Lupin mine is a complex of orange metal buildings huddled against the elements atop a bare, wind-blasted bluff. In reality it's much more than just a mine. Lupin is a small town, as self-contained as a space station, with eating and sleeping quarters for 150 men and women, a library, racquetball courts, a hockey rink and sauna, a diesel-fired fifteen-megawatt power plant and a cable television network (including one channel that runs X-rated movies twenty-four hours a day). The two- and three-story structures are connected by galvanized steel tunnels, obviating the need for most of the residents ever to venture beyond the mine-complex walls. Indeed, in the offices workers incongruously go about their business in light summer shirts, or skirts and high heels, as if they have no idea that they are in the Arctic — that a blizzard capable of freezing human flesh in a matter of seconds is rattling their windows.

If John Franklin and his nineteenth-century colleagues traveled to these parts largely to find challenge and to further the glory of the British Empire, it is safe to say that most present-day visitors to the Barrens — at least the ones at the Lupin mine — are here strictly for the money. The majority of the Lupin workers are no-nonsense, hard-toiling folk. They put in twelve-hour days, seven days a week, for two weeks straight, then they have two weeks off. The mine owns a Boeing 727 that flies in at the end of every two-week

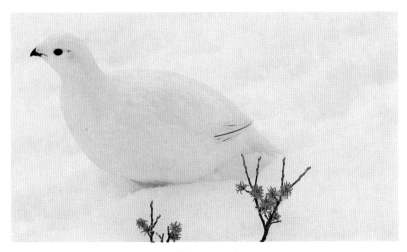

Willow ptarmigan

shift to transport the workers to Edmonton for fourteen days of R and R in the big city, an option virtually everyone exercises. Everybody, that is, but the handful of Inuit on the payroll.

All the Inuit who work at Lupin come from the tiny village of Coppermine, which lies 200 miles to the north on the shore of Coronation Gulf at the mouth of the Coppermine River. The mine flies a Twin Otter airplane to Coppermine at the end of every two-week shift to transport the Inuit back and forth from their homes, but some of the natives prefer to make the trip overland. This morning, for instance, two Inuit men in their late twenties who had just completed a shift at the mine set out on the grueling two-day trip to Coppermine (today, with the wind-chill factor, it is 50°F below zero) on open snowmobiles. They laughed when I expressed my amazement, and told me that being out on the land was a "gift and a great pleasure," not an ordeal. Besides, they said, they wanted to check some trap lines on the way home.

I watched in astonishment as the two men pointed their snow machines to the northwest and roared nonchalantly off toward the horizon. Once they disappeared into that featureless terrain of blowing snow, I wondered how they navigated. How could they possibly know where they were? I posed this question to a white friend of theirs. "I don't have the foggiest idea," he replied, shaking his head, "but I'll tell you this: them two boys know exactly where they are and where they're headed, and they know it every second they're out there. Shoot, for all I know, they navigate by sense of smell."

Outsiders have been mystified by the ways of the arctic aborigines—the Inuit who lived along the coasts and the Athapaskan Indians who inhabited the taiga forests of the interior regions—ever since the first Europeans journeyed to these icebound lands. But if the explorers were perplexed by the workings of the Inuit psyche, they were profoundly impressed by the Inuit's resourcefulness and ingenuity, by their ability to live comfortably in an inhospitable environment with a minimum of resources. Faced with a scarcity of wood and the almost utter absence of metals—materials deemed absolutely essential by most of the world's cultures—these small, smiling people nevertheless seemed to thrive. The white men marveled at the houses made from nothing but blocks of snow and the success with which the Inuit hunted whales,

seals, musk-oxen, birds and even the ferocious polar bear without guns, iron traps or metal-tipped arrows or spears. They were also amazed by the tough, flexible, feather-light sleds constructed from bone, caribou antlers and sealskin thongs, with runners fashioned from fish lapped head-to-tail inside wet, tightly wrapped sealskins arranged into the desired shape and then allowed to freeze solid.

In 1577, commenting on the shortage of wood and metal in the Arctic, a member of Martin Frobisher's historic expedition to Baffin Island noted in his journal that the inventive Inuit compensated by making the most of the native fauna: "Those beastes, flesh, fish and fowles, which they kil, they are meate, drinke, apparell, houses, bedding, hose, shooes, thred, saile for their boates . . . and almost all their riches." To the Europeans, the Inuit's clever use of animal parts, virtually their sole source of raw materials, seemed absolutely limitless.

Winter parkas sewn from caribou hides featured a ruff around the face made from wolverine fur, which — because the wolverine hairs were sharply tapered — kept frost from building up on the ruff when warm, moist breath was exhaled into the frigid air. Trousers were made from polar bear hides, water-proof rain gear from the intestines of seals, insulated boot linings from bird skins turned feather-side in. Fast, graceful kayaks — light enough to be carried easily over ice floes by a solitary man, yet infinitely more seaworthy than any canoe or dinghy, thanks to the unique design of their covered decks and watertight, waist-hugging cockpits — were sewn from walrus skins painstakingly split to half their original thickness. Inuit fashioned ingenious duck snares from springy whalebone and waterproof bags from whole fish skins. Seeming to suffer little from the shortage of metal, they employed bone and walrus ivory to sculpt everything from elaborate buckles to articulated spear points.

The European explorers depended heavily on the native peoples of the North to guide them, to hunt for them and on countless occasions to keep them alive in the cruel arctic environment. Franklin would certainly have died early without assistance from the natives, as would many of those who followed him. Yet the white men, ironically enough, thought the Inuit were backward, hopelessly primitive and intellectually inferior.

The Inuit, for their part, didn't think much of the Kabloonas — their derogatory term for Europeans — either. Inuit humored

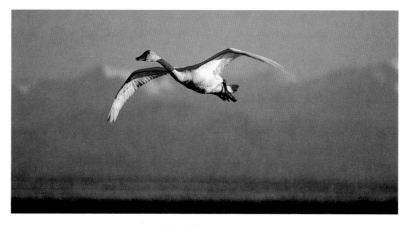

Tundra swan

the explorers and the whalers, but laughed contemptuously among themselves at the Kabloonas' inappropriate clothing and their pathetic inability to feed themselves or even construct adequate shelter. The Inuit also thought it extremely peculiar that the whites traveled for years at a time without the companionship of women.

The Europeans had the last laugh, alas. Within a few decades of their arrival in the Arctic, entire native communities began to succumb to syphilis, diphtheria, smallpox and alcohol. And as the Inuit were assimilated into the European culture, or simply disappeared outright, much of their own remarkable culture vanished along with them, lost forever.

APRIL 12

CHITINA RIVER — Spring, such as it exists at all in the North, is a jumpy, mercurial, extraordinarily slippery season. That holds doubly true here along Alaska's Chitina River, a brawny stream opaque with glacial silt that surges down a wide valley hemmed in by hulking, perennially icebound peaks. The surrounding mountains — the Chugach Range to the south, the Wrangell-St. Elias Mountains to the north and east — reach elevations as great as 19,000 feet above sea level. These massive ranges form a barrier between the wet, relatively temperate maritime climate along the Gulf of Alaska and the harsh continental climate of the Interior. The Chitina Valley, straddling this meteorological fence, flip-flops back and forth between the climes.

Yesterday afternoon, for instance, the sky was a pale, heartless blue, and the plastic thermometer hanging from the zipper-pull on my backpack never climbed above 0°F; right now, less than twenty-four hours later, that same thermometer reads 42°F. An un-

ruly herd of blue-black squall clouds is stampeding up the valley, and my camp is being simultaneously pelted with raindrops and washed with dazzling sunlight.

A short distance away, an unusual double rainbow arcs above the spruce forest, its colors rich and surprisingly brilliant against the leaden sky. In the lower, brighter rainbow a red band runs across the top, melting seamlessly into stripes of orange, yellow, green, blue and, finally, a diaphanous lavender. In the upper rainbow this color scheme is precisely reversed, a dead giveaway that both rainbows are being created within the same raindrops. Between the two rainbows lies a narrow, sullen band of sky that's markedly darker than the patches of atmosphere above or below — a phenomenon physicists have termed Alexander's Dark Band to honor Alexander of Aphrodisias, the minor-league Greek philosopher (and outspoken champion of the then-radical notion of free will) who first observed it.

Rainbows, as we know and Alexander did not, result when a ray of sunlight enters a water droplet, is refracted into its component colors and then bounces off the rear of the droplet toward the person viewing it. The fact that each color in the spectrum of visible light refracts at a slightly different angle explains why we see the colors as discrete bands. Double rainbows like this one occur when the sunlight bounces not once but twice inside the raindrop before exiting; the extra reflection off the spherical inner surface of the droplet — the second bounce — makes the upper rainbow a mirror image of the lower.

As I run all this data through my brain, attempting to marry abstract scientific precepts to the enchanting pastel semicircles adorning the cloudscape up-valley, an overbearing cumulonimbus crowds between me

and the sun at my back, causing the rainbows to vanish suddenly, as if some oaf had tripped over the plug. Thirty seconds later the sky opens, the intermittent shower becomes a deluge, and I decide it's time to retreat inside the dry nylon dome of my tent.

APRIL 14

CHITINA RIVER — The previous days' intimations of spring were predictably short-lived. Last night the sky cleared, the wind began to blow from the north and the temperature dropped back down into single digits. Such wild fluctuations are not unusual at this time of year, but they can create difficulties, nevertheless, for the Dall sheep and other herbivores that live in this valley and the slopes above it.

The problem is the snowpack, which is still substantial here, as it is across most of the North. When the weather stays cold, the snow remains soft and powdery, which permits grazers to paw through it to reach the grasses, sedges and willows that sustain them. When there is a thaw followed by a sharp freeze, however, the snowpack gets wet and then sets like concrete, locking the animals' food beneath an impenetrable, enduring armor of ice. And that can be deadly for the moose, caribou and Dall sheep.

For the past week I've been photographing a small herd of Dall sheep that makes its home on the exposed uplands above the Chitina. Concerned about how these handsome creatures will find food now that the snowpack has frozen as hard as brick, I decided to undertake the 1,500-foot ascent to their lofty haunts one more time, just to see how they are faring.

Leaving camp, I settled into a steady pace, sweating beneath my parka despite the chill in the air. An hour of climbing brought me to the rocky shoulder where I'd encountered the sheep on previous days, but today they were nowhere to be seen. I climbed higher, all the way to the crest of the escarpment, but still no sheep.

Now I sit in the lee of the ridge, nibbling a chocolate bar and taking in the epic sweep of the land. Behind me the distant, dreamy summit of Mount Blackburn floats in the haze; below, tiers of vertical rock broken by stands of forest lead down to the valley, which opens up in the west to join the Copper River gorge. The quiet is monumental, broken only by the low moan of the wind and the occasional clatter of stones down a nearby cliff.

It is a lovely, lonely vista, the kind that encourages melancholy daydreams. My eyelids grow heavy. I feel a nap coming on. As I begin to slip into unconsciousness, however, my eye picks up a blur of motion, a white form moving against the tan rock of the ridge line 150 yards away, and suddenly I see them: six Dall sheep — four youngsters with a pair of full-curl rams. Immediately I realize that my worries about their well-being are unwarranted. The sheep have located bare ground on which to graze by moving to an exposed spot on the windward side of the ridge where the earth has been blown clear of snow.

Upon sighting the animals, I first want to jump to my feet and start stalking them, but as I stand, I think better of it. Dall sheep are skittish creatures, and my approach would likely send them galloping off to higher ground. Over the past week I've taken scores of striking photographs of the animals; perhaps, I decide, it's high time to leave the sheep be. I watch them grazing for a few minutes longer, then turn and head back to camp without even bringing my camera to my eye.

MAY 18

TOKLAT RIVER — The earth still wears a patchwork blanket of snow, but the sun is high and intense, the drifts are disappearing fast and hints of green are appearing here and there across the tundra. I'm sitting on a ridge above Alaska's Toklat River, watching a small drama unfold on a nearby hillside — one of the myriad life-or-death struggles that are the stuff of daily existence in the North.

A barren ground grizzly sow, having just emerged from her winter den, thin and hungry after not eating for months, is hunting a squirrel. An arctic ground squirrel is a tiny creature, seemingly little more than an hors d'oeuvre to a 600-pound bear, but the grizzly is nevertheless pursuing her minuscule prey with all her energy and cunning. Using her massive front paws to fling rooster-tails of dirt high between her rear legs like a dog burying a bone, the bear digs furiously at the entrance to the squirrel's burrow, moving colossal quantities of soil and several boulders two and three feet in diameter.

Every few minutes the sow pauses in her excavation to glance around at the neighboring burrows, just to make sure the squirrel isn't trying to escape out a side door. During one of these pauses, while the bear's attention is directed away from her hole, the squirrel emerges from the burrow at the grizzly's feet and dashes between the bear's legs for freedom. The bear, noticing the squirrel just as it starts its dash, performs an astounding, split-second pirouette, pivoting her considerable bulk around a single front foot, but before she can pounce, the terrified rodent dives down an adjacent burrow.

Immediately the bear begins digging anew, and continues to dig rapidly at this second burrow for forty minutes, excavating much of the hillside — yards and yards of dirt, gravel and boulders — in the process. Finally, when this new pit has all but swallowed her, I see the bear make a little lunge with her snout, like a cat going after a bird. A moment later the grizzly emerges from the immense crater with the tiny squirrel in her jaws. Holding the unlucky rodent on the ground with her paws, she then eats it, biting off one dainty little chunk at a time, seven tiny chunks in all, chewing each one with great deliberation before biting into the next. All things considered, it seems unlikely that this morsel could have provided the grizzly with more calories than she expended trying to catch it, but the bear looks thoroughly pleased with herself.

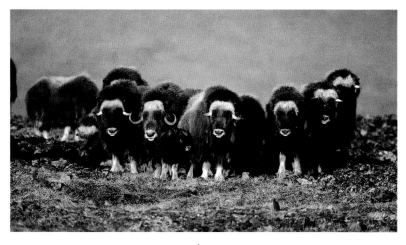

Musk-oxen

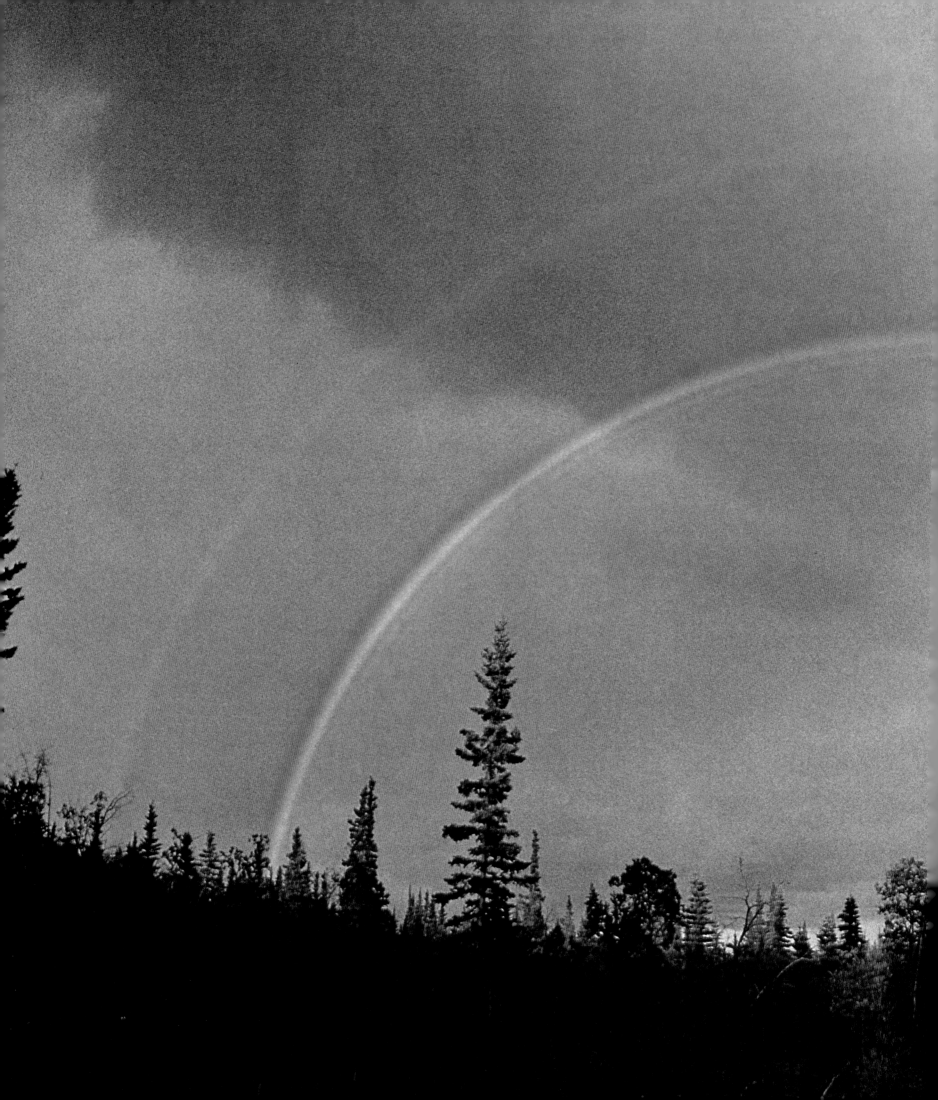

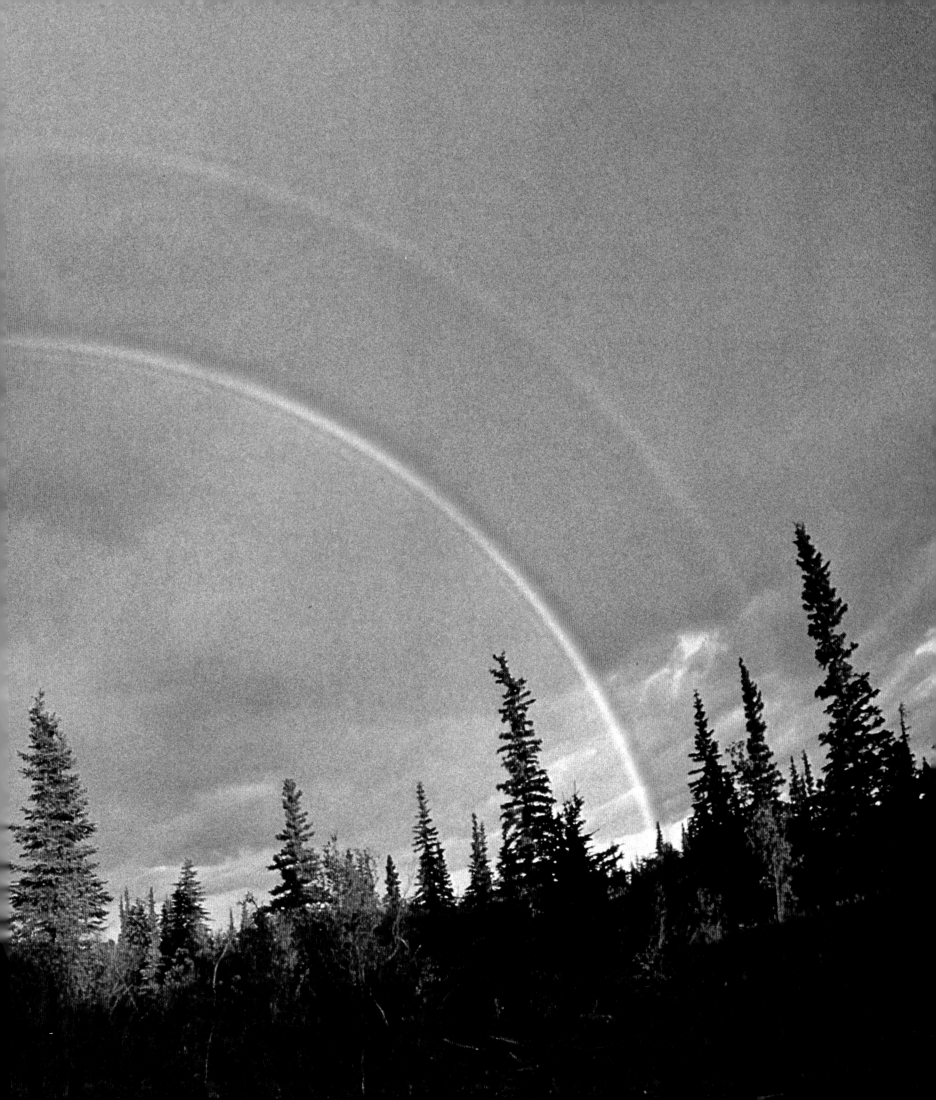

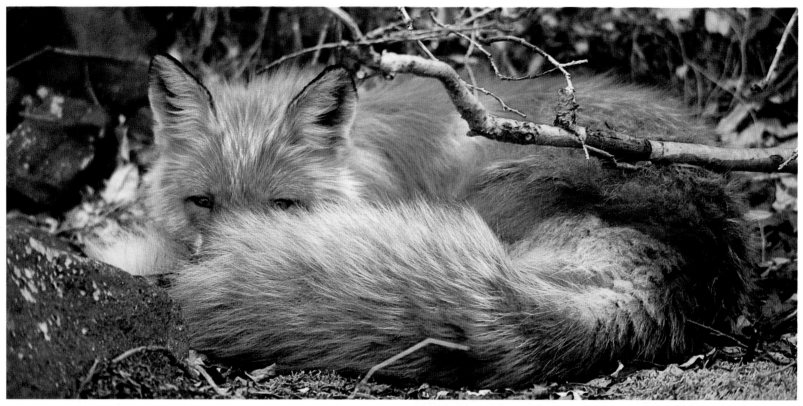

ABOVE: *The pelt of the red fox can range from pale orange to dark gray. Opportunistic feeders, foxes prey largely on microtines such as lemmings and voles, but eagerly eat bird eggs when they are laid on the tundra in late spring.*

RIGHT: *The porcupine is found throughout the Arctic wherever there are trees for it to feed on. It is usually nocturnal but can occasionally be seen by day high on a tree limb, hunched into a ball of quills.*

OPPOSITE: *Sheer granite cliffs pierce the clouds a vertical mile above a frozen valley near Pangnirtung Pass, in Auyuittuq National Park, on Baffin Island's Cumberland Peninsula.*

PREVIOUS PAGES: *A spring rain squall beside the Chitina River creates a striking double rainbow above a thicket of scraggly black spruce.*

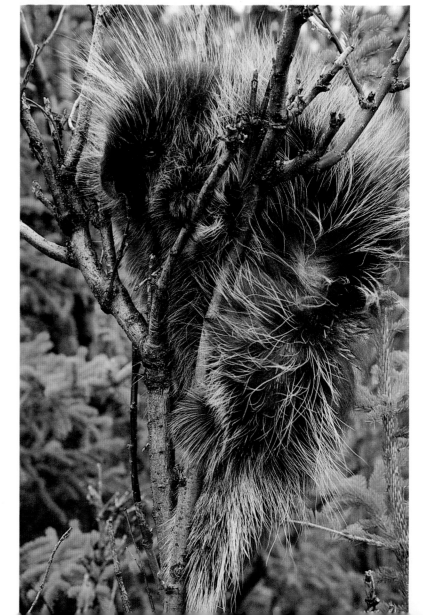

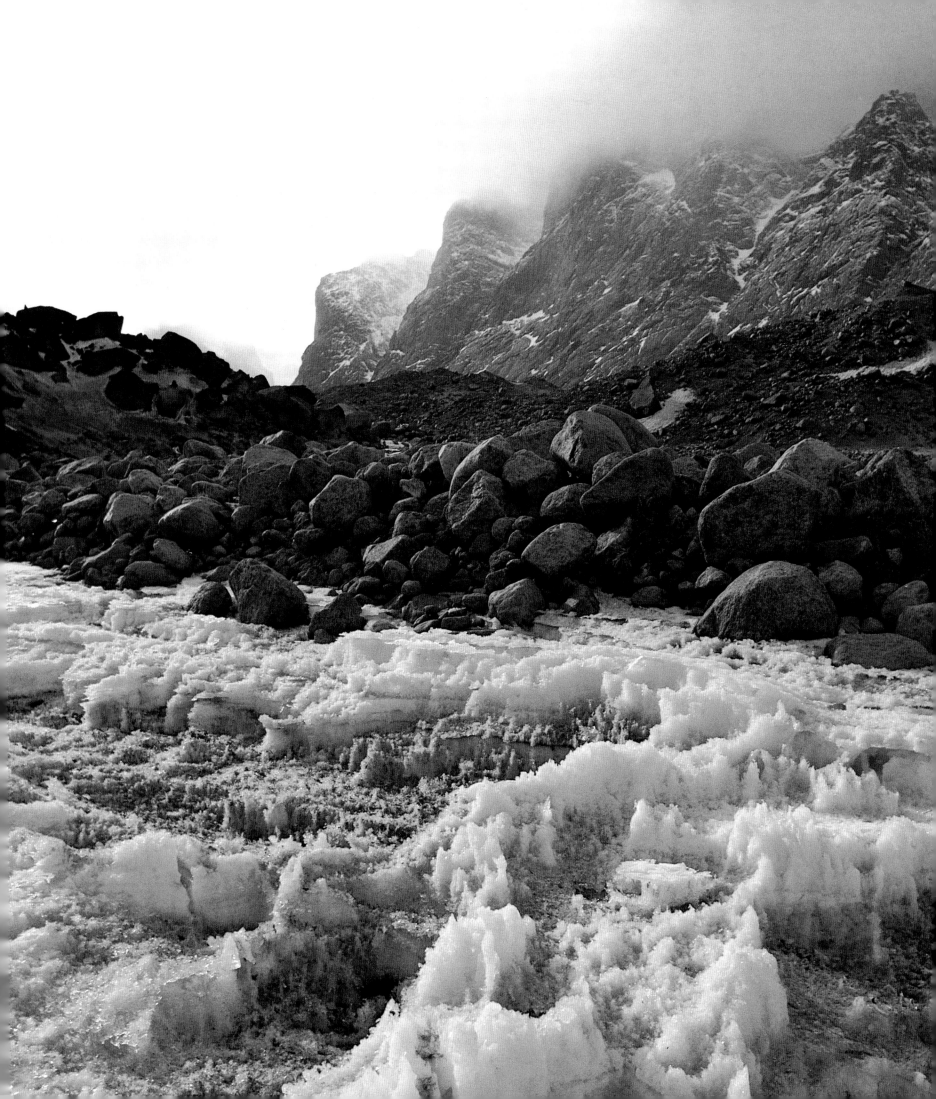

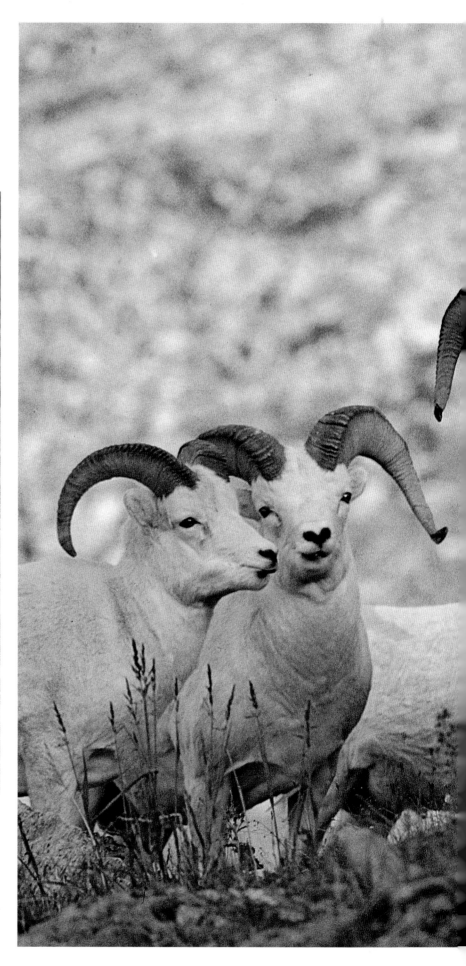

RIGHT: *These Dall sheep are distinguished from the closely related bighorn sheep by their pure white coats and their delicate horns.*

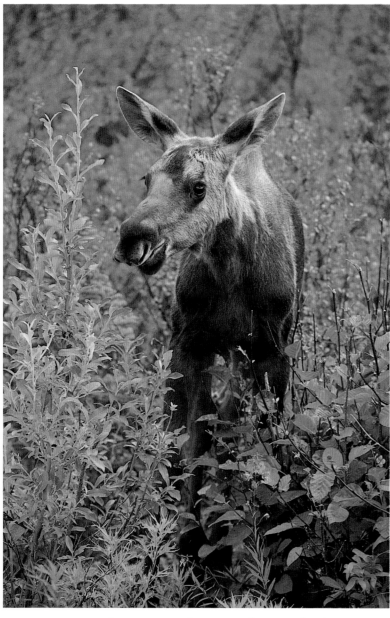

ABOVE: *A young moose browses on leaves and twigs. A circumpolar species that prefers forested areas, moose seldom venture far into open tundra except along valley bottoms where willows are plentiful.*

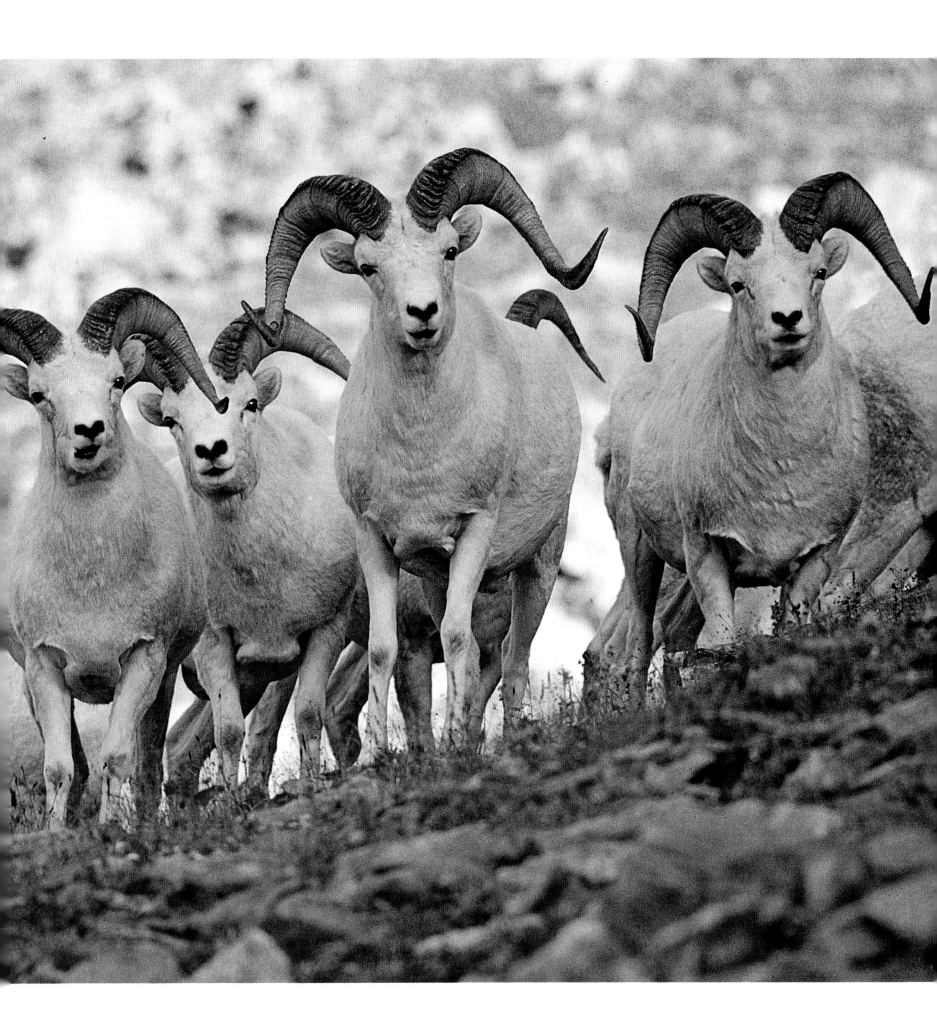

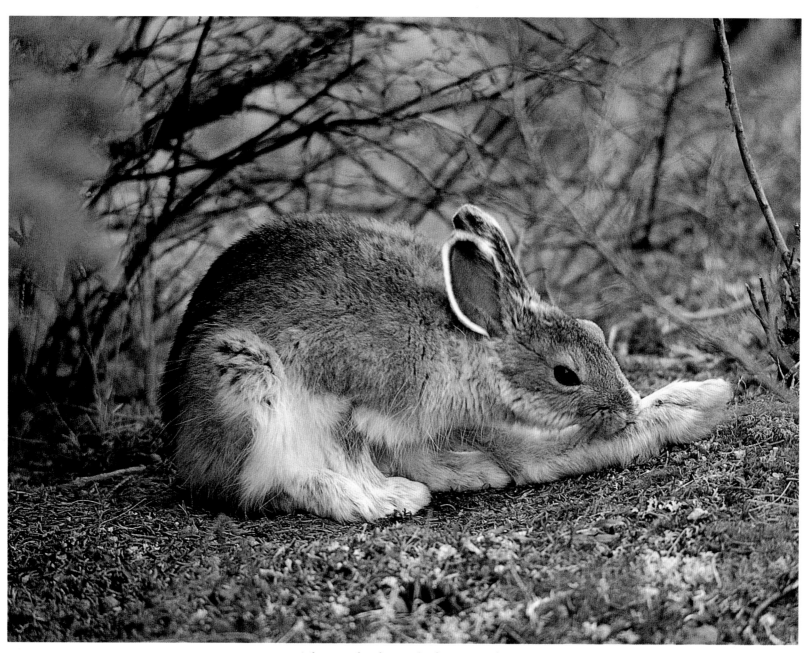

ABOVE: *The snowshoe hare, also known as the varying hare, is much smaller than its relative the arctic hare and prefers forested areas to open tundra. Its large, well-furred feet allow it to travel swiftly over deep snow.*

RIGHT: *The semipalmated sandpiper, like the plover and other sandpipers, typically lays four eggs, which are patterned to be all but invisible on the tundra where the bird nests.*

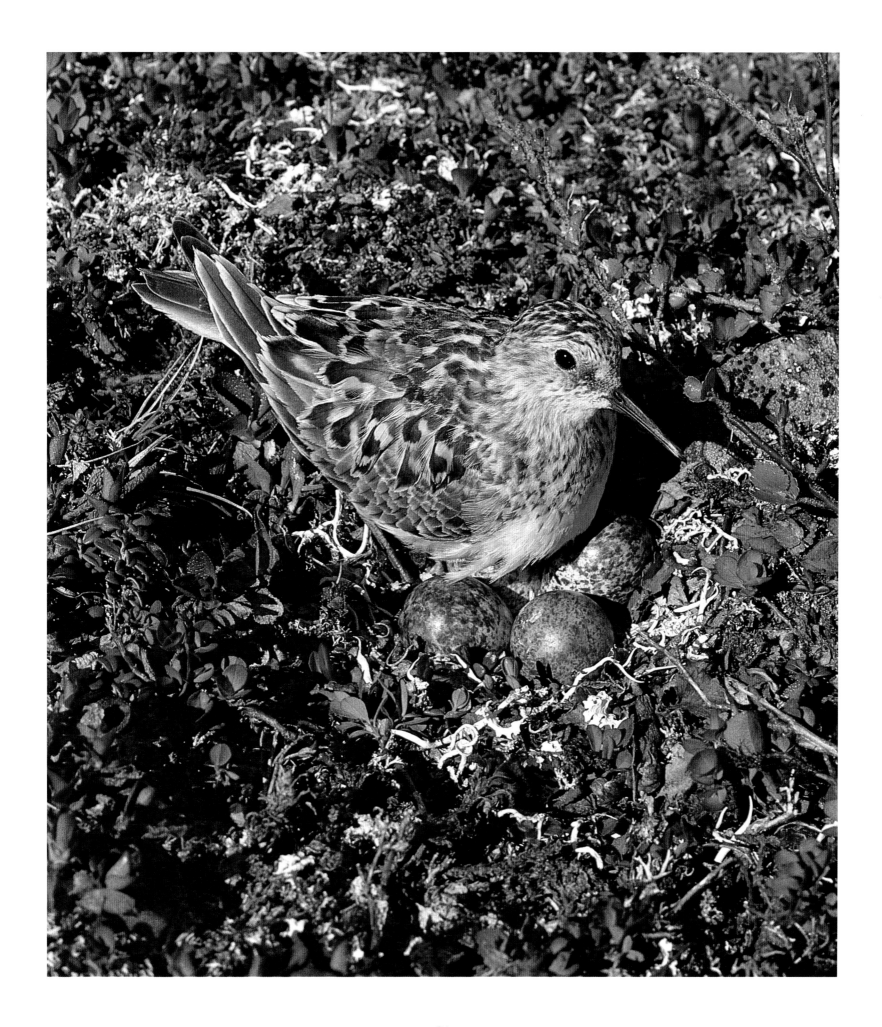

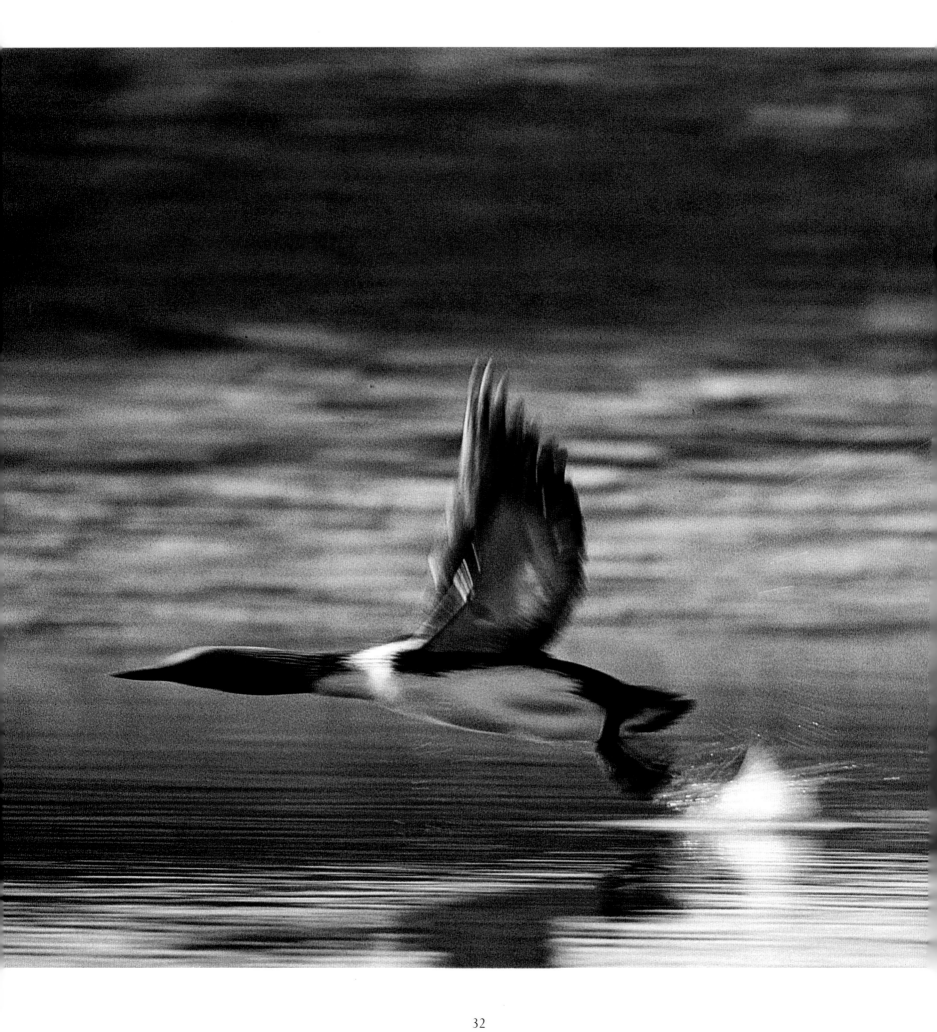

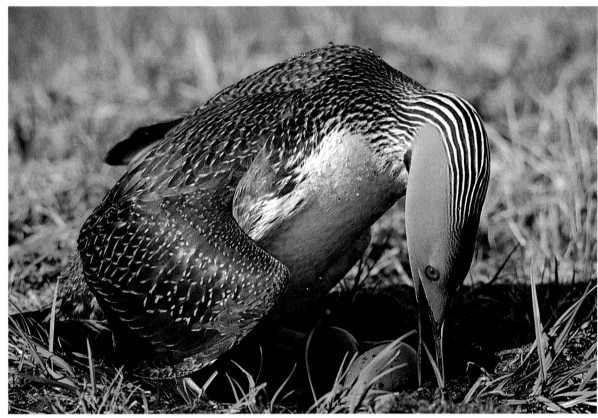

ABOVE: *Loons seldom venture far from water. When nesting on the tundra near bays and lakes, they periodically rotate their eggs with their dagger-like beaks.*

LEFT: *The red-throated loon is a strong swimmer underwater, but its legs are positioned so far back on its ungainly body that on land it can scarcely maneuver at all. Once in the air, the loon is a fast and efficient flyer, but it requires a long stretch of water to become airborne.*

FOLLOWING PAGES: *The barren ground grizzly bear is long-lived but relatively slow to mature, and is not a prodigious breeder. As a consequence the species is easily endangered by habitat destruction and over-hunting, and has disappeared from most of the North American habitat it once roamed.*

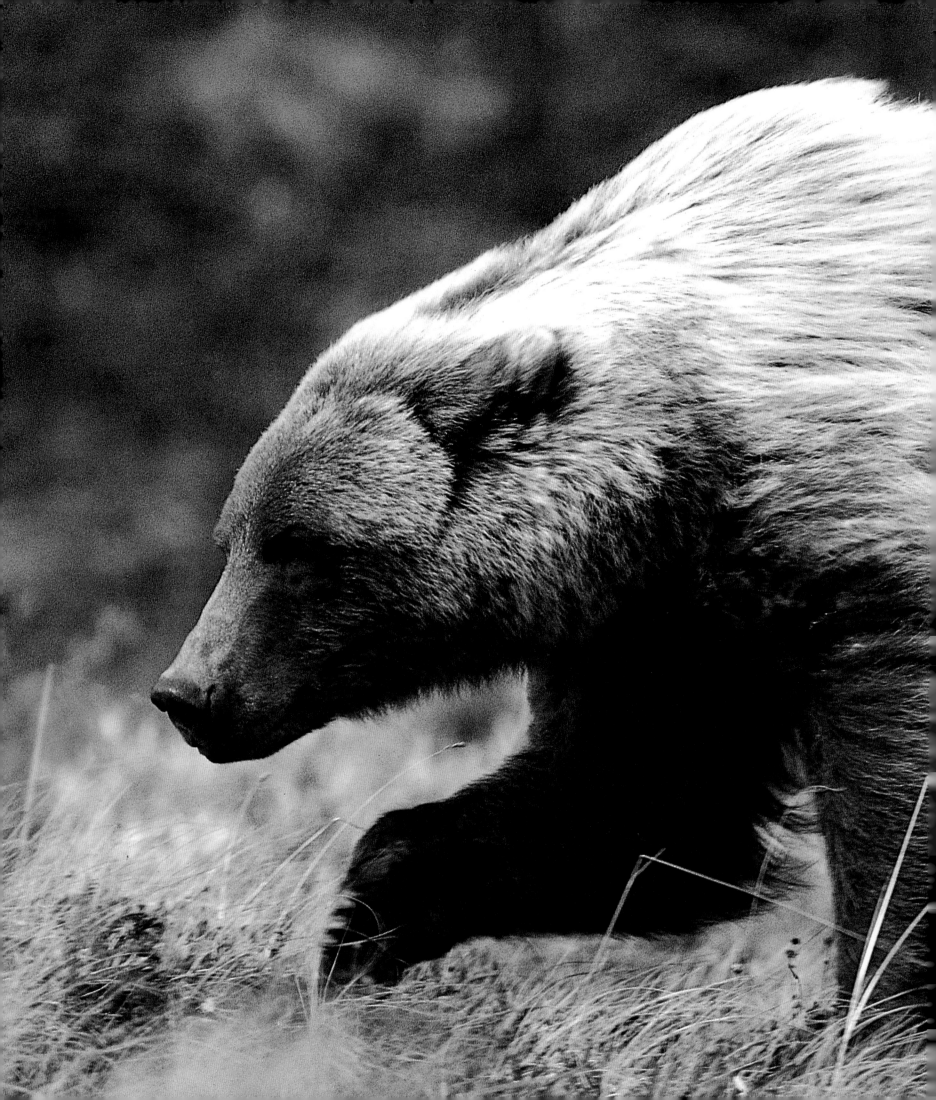

RIGHT: *The mountain goat is distinguished by its white beard, needle-like horns and shoulder hump. It climbs to rock outcrops that would give expert human mountaineers pause.*

OPPOSITE: *When winter finally and reluctantly surrenders its tenacious grip on the Arctic, the tundra erupts into a spectacular riot of wildflowers. At such moments one would never suspect that this landscape wears a mantle of ice and snow for nine months of the year.*

FOLLOWING PAGES: *The St. Elias Mountains, the highest coastal mountain range on earth, were named by the explorer Vitus Bering on July 16, 1741, for the patron saint of the day.*

BELOW: *In winter, ptarmigans gather in small flocks, but as summer approaches, the modest congregations disperse into mating pairs, which go their separate ways to raise their young.*

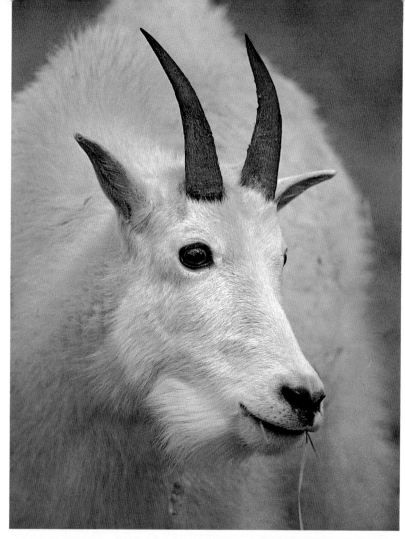

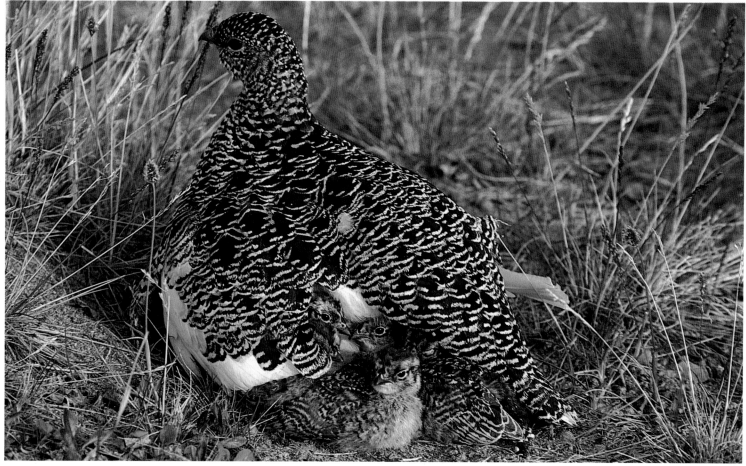

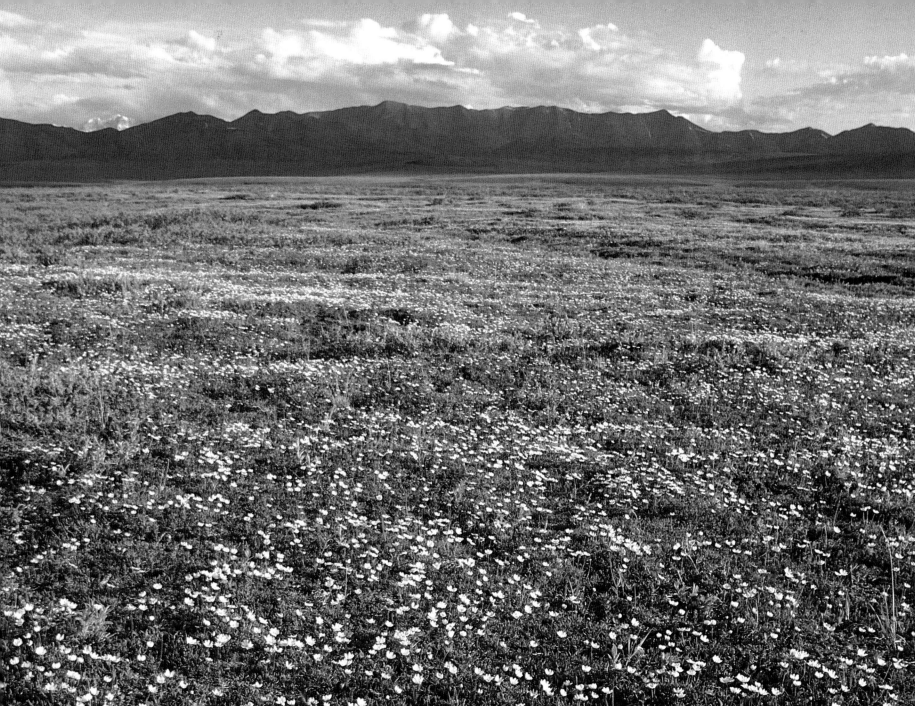

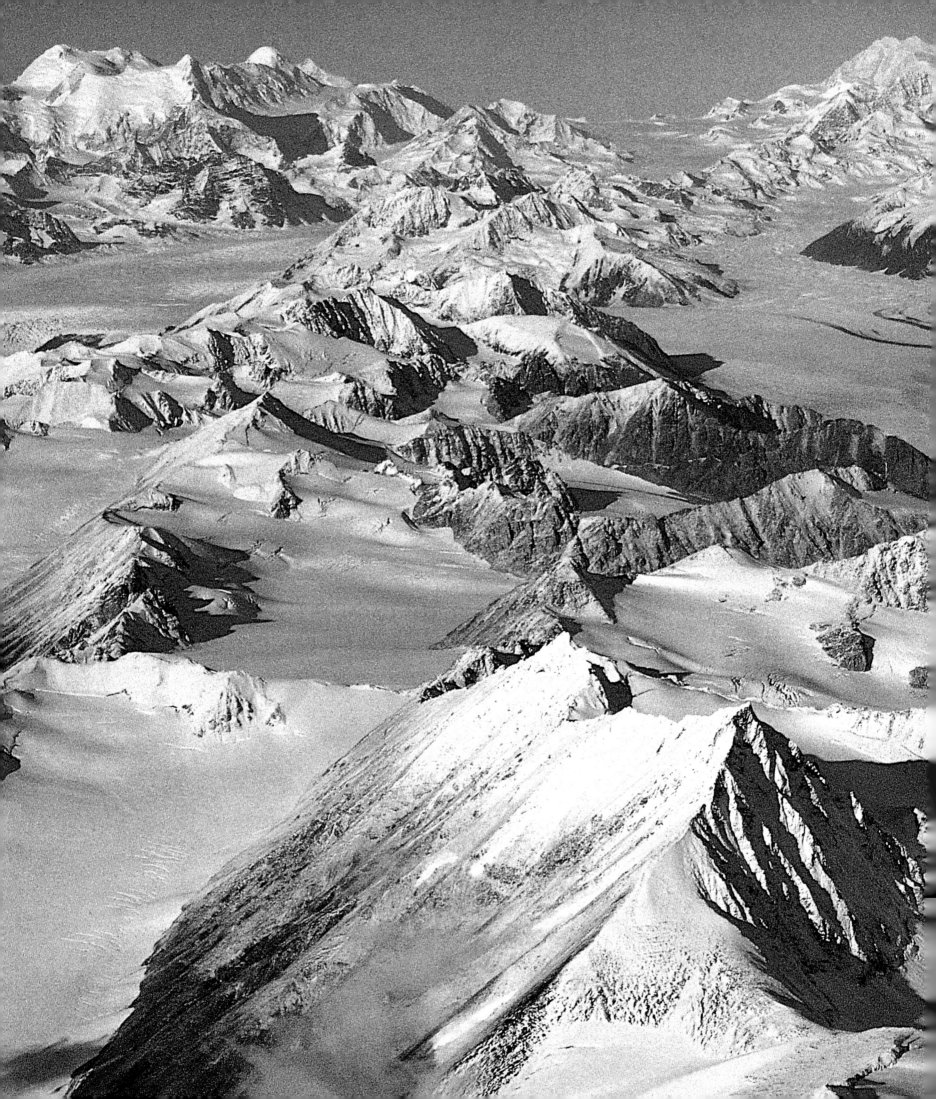

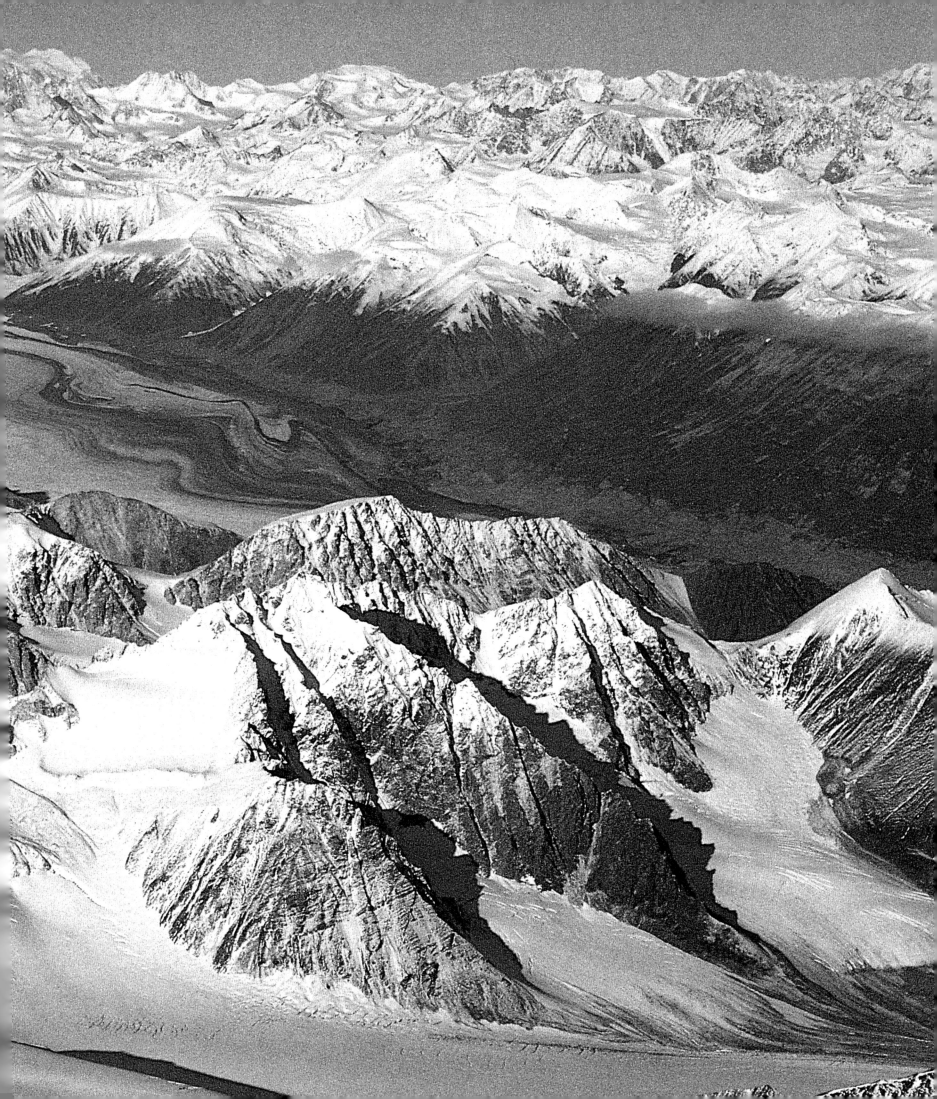

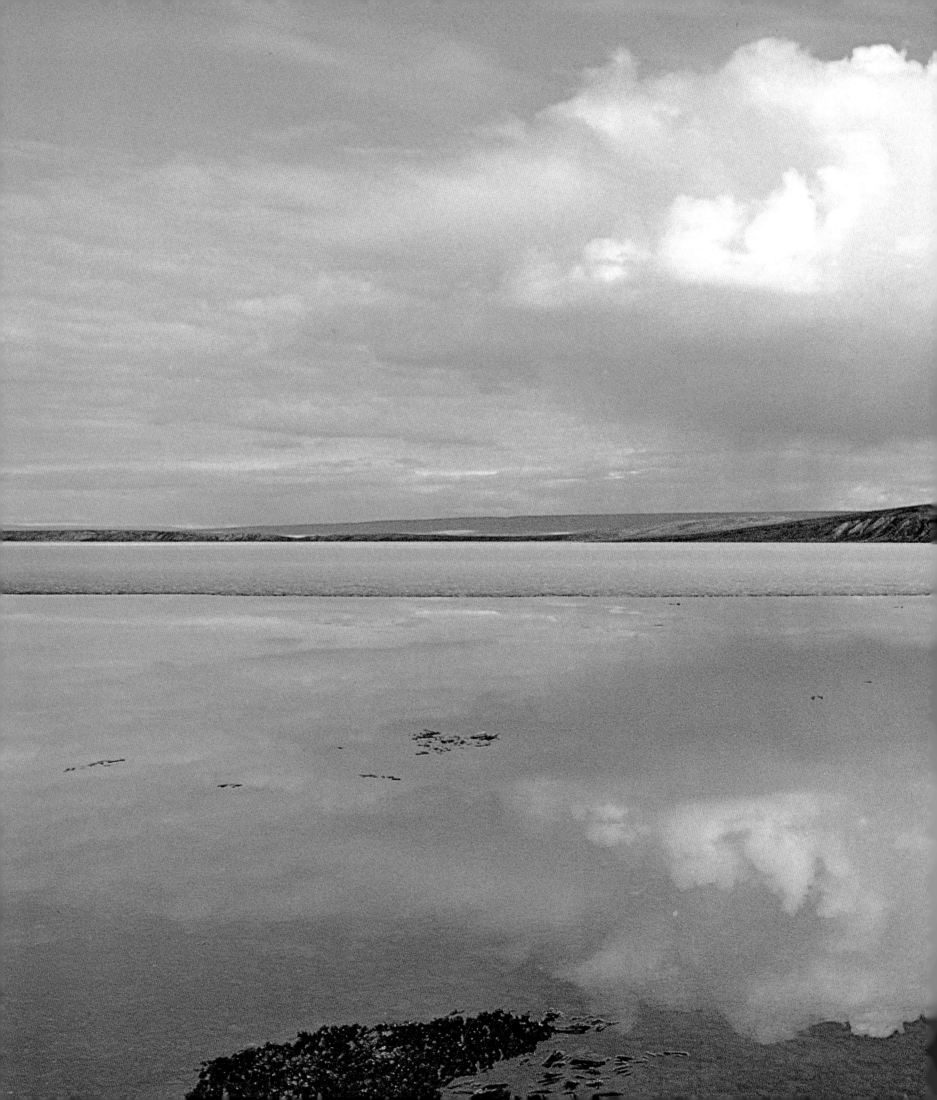

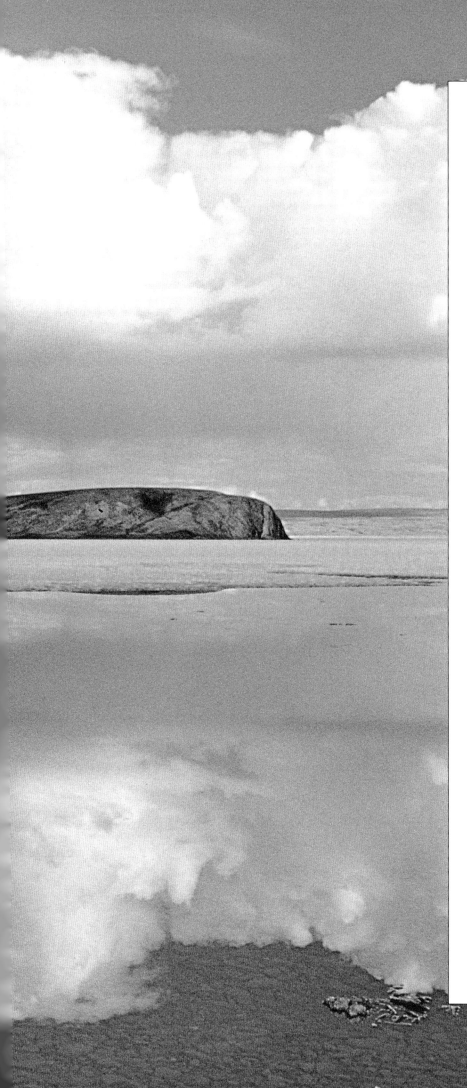

SUMMER

JUNE 26

HULAHULA RIVER — The Brooks Range, the northernmost chain of mountains in the United States, runs in an unbroken arc across the top of Alaska. With the exception of a single pocket of surreal, glacially sculpted granite spires called the Arrigetch Peaks near the center of the chain, the Brooks Range tends to be made up of low, chunky, topographically undistinguished peaks — a hypnotic parade of blocky beige summits that marches for more than 600 miles from the Chukchi Sea to the Canadian border and beyond. The beauty of these mountains is profound, but it is the spare, understated beauty one associates with the deserts of Mexico or the American Southwest; the Brooks Range possesses little of the precipitous, oversized, breathtaking drama of the Alps, the Canadian Rockies or the Alaska Range, and is thus apt to disappoint visitors lacking an appreciation of the subtleties of landscape.

The crest of the Brooks Range coincides with the northern limit of trees in Alaska: fingers of spruce and alder climb the valleys of the chain's southern aspect, but the steeper north-facing slopes tumble bare and rugged to the wide alluvial shelf of the coastal plain. That the plain's huge, boggy expanse of frost polygons and meltwater ponds was once the floor of the Beaufort Sea is apparent from the fossilized coral heads that pepper the riverbeds.

A hundred streams and rivers rush down to the ocean from the north slope of the

As the earth warms under the summer sun, the waters of Lake Hazen melt along the shoreline, but in the middle of the lake they remain frozen year-round.

Brooks Range; I happen, at present, to be camped beside the one known as the Hulahula (the river was named not by the native Indians or Inupiat, but by homesick Hawaiian sailors hunting whales off the nearby shore) at the eastern margin of the coastal plain in the heart of the Arctic National Wildlife Refuge. It's 1:00 A.M. The sun is almost due north and low in the sky, but it's nowhere close to kissing the horizon, let alone fully setting. It will not do that for another forty days or so. I'm awake at this hour not only because the sun is still up, but also because a living tide of caribou is flooding through my camp, and pieces of cartilage in their loosely jointed ankles are making a loud, castanet-like clicking noise that would make it impossible to sleep even if I wanted to.

The first caribou appeared yesterday morning, a few score of them, ambling slowly through my camp in a long, raggedy line. Several hours later the modest trickle had grown into a torrent some hundreds of animals across, then thousands; before long it had turned into the shuffling, wheezing, clicking caribou sea that's now washing south across the coastal plain.

Caribou are ruminants, members of the deer family — the Cervidae. Caribou differ significantly from other deer, however, in that both the male and female of the species are adorned with antlers, and both genders shed their antlers every winter. Until recently taxonomists considered caribou and reindeer — the caribou's Eurasian cousin — discrete species; now both animals are recognized as closely related races of a single species, *Rangifer tarandus*. Some two million of the creatures presently roam the North American Arctic.

The caribou along the Hulahula belong to the Porcupine Herd, which is 180,000 strong. The name comes from a tributary of the Yukon River on the other side of the mountains where the animals spend their winters. The impressive migration begins in late spring, as pregnant cows and young males congregate for the trip north through the snow-choked passes of the Brooks Range, to be followed some weeks later by the mature bulls. It's an arduous journey, during which thousands of animals fall prey to wolves, blizzards, swollen rivers and starvation.

When the first Porcupine caribou arrive on the north slope in early June to calve, the coastal plain is a singularly bleak, unfriendly place. Much of the tundra is still covered with snow; the lakes are frozen; thick banks of fog block the sun; gales roar in unabated

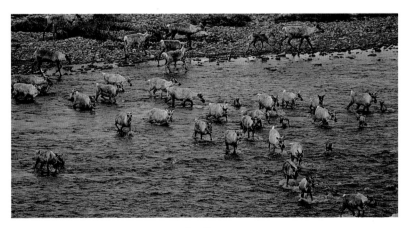

Caribou

from the Beaufort Sea. The caribou nevertheless like this exposed landscape because food becomes plentiful as the snow melts from the tundra, and the predatory packs of wolves that harassed the herd all winter have remained farther south where there are better dens to be had.

Perhaps two weeks ago the pregnant cows in the herd all gave birth within a few days of one another. Now—plagued by the same hellish, recently hatched clouds of blood-sucking mosquitoes that are driving me to the brink of violence—the cows, their newborn offspring and the bulls are all on the move again, heading slowly back toward the high country to the south. Come late August, when the first fall storms dust this campsite with snow, the surrounding plain will be completely empty, and it will be hard to tell that the huge herd was ever here.

JUNE 30

CAMDEN BAY – Yesterday I moved camp down to the coast, a few miles west of the Hulahula's mouth, hoping that a sea breeze would drive the heinous swarms of insects away. If anything, alas, the bugs seem even worse down here.

There are compensations, however. Exotic species of migrating ducks bob in the water just off the beach, and occasionally the faint, misty exhalations of a spouting bowhead whale can be seen in the distance. Arctic foxes come and go. There is always the thrilling, terrifying possibility that a polar bear will wander up the coast, or swim in unnoticed from the pack ice that drifts a few miles offshore. And at the moment, across the ocean to the north, there is a fine view of a comely, jagged wall of mountains jutting above the far horizon.

To the north, of course, there aren't really any mountains—not, at any rate, until

one approaches the Norwegian island of Spitsbergen, which lies 2,000 miles away on the other side of the North Pole. The "peaks" that stand before me, so clearly defined against the sky, are in reality nothing more than the fata morgana, that fabled mirage of the North.

The fata morgana, like other forms of mirage, is created when light waves travel through atmospheric layers that have markedly different temperatures. Each layer of air acts like the lens in a pair of eyeglasses, causing the light rays to bend earthward. The fata morgana occurs only when the layering in the lower atmosphere is just right, and bright sunlight bounces off a distant, highly reflective surface like sea ice. The result is the appearance of a jagged, grayish, slightly fuzzy mountain escarpment (or metropolitan skyline) in the distance, and it can look so convincing that you'd bet any sum of money that it was real.

Indeed, in the nineteenth and early twentieth centuries fata morganas fooled a number of experienced arctic explorers into mapping towering peaks or entire mountainous islands on their charts where there was in reality nothing but flat, empty ocean. Dozens of phantom land masses were inscribed on maps by such experienced explorers as Robert Peary, Charles Francis Hall, John Ross and Vilhjalmur Stefansson. In many cases, when subsequent expeditions were dispatched to verify or deny the existence of these mountain ranges or islands, the second group of explorers saw the same fata morgana the first had, and erroneously confirmed the bogus map work.

JULY 11

BYLOT ISLAND – For most of the year birds are conspicuously absent from the islands of the High Arctic; fewer than a dozen avian

species inhabit the North year-round. Nevertheless, during the few short weeks that make up the arctic summer, the arctic latitudes host a riot of bird life, representing an impressive variety of species. Indeed, other than mosquitoes, birds are the most numerous and visible fauna on the summer tundra.

On this hazy afternoon on Bylot Island I can't walk fifty yards across the tundra without scaring up a jittery plover, a Lapland longspur or a long-tailed jaeger. All these birds nest in the open, close-cropped hill country here, but their nests are surprisingly well camouflaged and difficult to find. I can state this with some authority because two days ago I set out to photograph a clutch of plover eggs, and to do so I first had to locate a nest.

The Lesser golden plover, *Pluvialis dominica*, is a nervous, handsome bird with a rust-colored back, a jet-black face and breast, rakish white side-locks and a whistle that carries across the tundra as a piercing "Oodle-oo! Oodle-oo!" Like killdeer, sandpipers and certain other members of the *Charadriidae* and *Scolopacidae* families, the golden plover has worked up an elaborate, convincing broken-wing act to lead predators away from its nest. Whenever a threatening animal such as a fox or a photographer approaches, a plover will slink twenty-five or thirty feet from its nest before the predator can spot it, then initiate its notorious fake-injury routine: while crying and limping pathetically across the tundra, the bird extends its wings at an awkward angle as though crippled. Maintaining this pose, it then hops in a direction away from its nest, staying just out of the predator's clutches, luring the intruder away with the false promise of an easy meal. As soon as the predator has been duped into following the plover out of the nest's vicinity, the bird experiences a miraculous recovery, takes to the air and loops back to its nest.

Despite much trouble, I eventually managed to locate a plover nest with four small, speckled eggs in it. Even from a few feet away the nest—eggs and all—blended so perfectly into the tundra that it was all but indistinguishable from its surroundings. It had taken me a great deal of watching to find this nest, but the effort was well worth it. A close inspection of the eggs revealed that they were starting to hatch. Excited at this bit of good fortune, I quickly retreated some distance to let the mother plover return, twisted my biggest telephoto lens onto the camera, and settled in to wait for the momentous event.

Three hours after I began my vigil, the first baby plover pecked a hole through the thin shell of calcium that encased it and stumbled into the world with eyes fully open, wearing a soggy coat of down. The moment the baby emerged, the mother flew off with the broken shards of eggshell, one piece at a time, and discarded them far from the nest. In quick succession, the rest of the eggs hatched as well, and within a few hours the hatchlings were venturing out of the nest for brief periods to feed on insects. A day later, incredibly enough, the baby birds had developed sufficiently to fend entirely for themselves, and all four of them disappeared across the tundra. That was yesterday; a few weeks hence, if they have been lucky enough to escape the owls, foxes and falcons lurking hungrily in the environs, the precocious young birds will already be on their way south, bound for some tropical shore thousands of miles distant.

For a golden plover, childhood is a fleeting thing, gone almost before it has had a chance to begin—an evolutionary necessity in a land where summer is fleeting, as well.

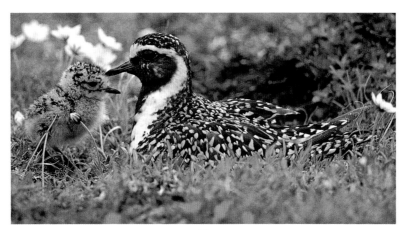

Lesser golden plover

JULY 20

ELLESMERE ISLAND – There's electricity in the air, a kind of magic. It's high summer now, and the tundra is shimmering, vibrant with the hum of life. There isn't a breath of wind. My watch says 2:00 A.M. The postmidnight sun is an eerie, orange orb dangling low in the northern sky. Somewhere just below and to the left of it lies the top of the world — the North Pole itself.

Standing on the shore of Ellesmere Island, up near the 82nd parallel, not far from the northernmost point of land in the western hemisphere, I feel as if I were at the edge of the earth, a sensation that fills me with giddy delight. To the north lies nothing but a vast, drifting jumble of ice floes, the giant white scab of the permanent icecap and then the mythic Pole. It is still hundreds of miles distant, of course, but from this vantage it seems close, just a stroll away, a short walk across the gleaming frozen sea.

Whenever I spend extended periods in the Arctic, I find myself living more and more by sense and intuition, less and less by deductive reasoning and intellect. I feel increasingly like an animal rather than a soft, pink, overly cerebral product of civilization. I begin to feel part of the wilderness, not just a spectator viewing nature from a distance. It is largely a false perception, of course — I will never be other than an ill-adapted intruder in this world — but I take pleasure in the momentary illusion all the same.

As I turn and begin to walk south toward Lake Hazen, red-throated loons scoot back and forth overhead, the staccato *whoosh-whoosh-whoosh* of their wings churning the calm sky as they carry fish from the nearby sea to their progeny. The ghostly form of a snowy owl arcs out of nowhere to snag a lemming. I look around and notice a few of the salt-and-pepper birds perched on hummocks scanning for food with their disquieting orange eyes. Inspecting one of the low hunting perches, after the owl has vacated it, I find the crest of the hummock scattered with snow-colored feathers and a half-dozen "owl balls": regurgitated morsels of bones, skin and tufts of gray fur.

A half-hour later I crest a rise and spook a throng of arctic hares; the startled three-foot-high animals — hundreds of them — bound off en masse through the cotton grass, hopping erect on their rear legs like kangaroos. This peculiar upright posture amazed early explorers to the Arctic; many of them returned to their homelands with tales of "incredible dancing hares."

I never cease to be astounded by the sheer abundance of life in a place so far north, a place that's nearly encircled by permanent ice sheets, and is itself icebound more than nine months out of every year. It's difficult to believe that I'm standing in the midst of a desert as dry as the Mojave or the Sahara. But it is indeed a desert: most of the High Arctic receives fewer than three inches of precipitation a year. The pocket of life in the Lake Hazen basin is simply an oasis in that desert, an arctic Eden that owes its existence to a fortuitous quirk of local topography.

Lake Hazen, a low body of water fifty miles long and seven miles across, is surrounded by a ring of mountains that traps the heat of the summer sun and serves as a barrier to ward off incursions of cold air from outside. In mid-July it is not uncommon for the temperature to get into the sixties or even the low seventies. Additionally, runoff from the glaciers in the surrounding high country permits a rich growth of plant life around the lake.

Herbivores such as lemmings, hares, musk-oxen and caribou come to feed on the sedges and grasses. Owls, foxes, falcons, wolves and other carnivores are in turn attracted by the wealth of prey. As it is in the rest of the Arctic, the variety of species living in the Lake Hazen basin is extremely limited, but those species that are found here exist in mind-boggling numbers.

For hours I walk, losing track of time, mesmerized by the rich red and yellow hues of the lichens on the rocks, the sunlight glinting off the melt pools, the immensity of the perfect sky. A not-unpleasant tiredness inches up the backs of my legs. The low, slurred whistles of phalaropes carry across the tundra.

I'm strolling along, lost in my reveries, when out of the corner of my eye I notice that a large white dog has come up behind me and is trotting at my heels. I glance down at the mutt—it seems a little thin, but wears a docile, friendly expression—and wonder absentmindedly where it could have come from. The animal moves forward and pads along a few feet in front of me with its tongue hanging out, exactly like a well-trained city dog out for a walk with his master. We walk together like this for several seconds, then I suddenly put two and two together and realize that the "dog" is in fact a white wolf.

Wolves are found throughout the Arctic. All belong to the same species, *Canus lupus*, but there are many different subspecies and races, varying greatly in size and color. None is more beautiful or mysterious than the white wolves, which are found only in the Far North. They are gregarious, highly social animals. Indeed, according to Steven Young, the director of the Center for Northern Studies, "Wolves are considered by many to have the most complex social behavior of any nonprimate animal. It has been suggested that until sometime during the last Ice Age wolves and humans were roughly equal in the sophistication of their social system, and that it may have been nip and tuck as to which species would begin to domesticate the other."

Astonished by the white wolf's easygoing behavior, I stop abruptly in my tracks. As I do this, I notice a second wolf coming up the trail, now twenty feet away. It strides nonchalantly past, joins its pal, and they both turn to face me. They hold the pose for a minute or two, gazing at me with quizzical expressions, then turn casually back to the north and trot off.

I stare after the wolves for a long time, long after they have vanished in the distance, marveling at my luck in receiving such a gift.

AUGUST 4

SOMERSET ISLAND – Through the ages people living in temperate lands have concocted wildly divergent portraits of the Arctic. On one hand, the Far North has been viewed as a cruel, frozen wasteland; on the other, a real-life Arcadia—a land of milk and honey, benign and unsullied, where flocks of birds darken the skies, the sea is full of whales and salmon and uncountable numbers of moose, caribou and rodents cover the tundra. In truth the Arctic fits both these images, and neither. In some places it teems with plants and animals; in many others the landscape is as barren as the moon. But even where life exists in abundance, death is never far away.

I am reminded of this fact during a flight from the settlement of Resolute down the east coast of Somerset Island in a small airplane, a vintage de Havilland Twin Otter I've chartered so that I can photograph beluga whales from the air. Out the right-hand window is the rugged shore of Somerset; out the left, ice plates the size of city blocks drift placidly in the matte-black waters of Prince Regent Inlet. The plane banks right over a large bay, and there, silhouetted against the bottom, are more than fifty white whales.

The belugas look like phantoms as they gracefully ply the waters below, bunched loosely around the mouth of a wide, braided stream. I notice three whales far upstream, swimming strongly against the fast, shallow current. It's not uncommon to see belugas swimming in rivers—they like to rub against rocky riverbeds to scrape old skin from their bodies—but I've never seen whales in a stream so shallow: it can't be more than four feet deep, and the belugas' sleek, shiny backs are fully exposed.

Unbeknownst to the whales, a polar bear has also spied their lovely white backs, or perhaps it has scented the robust exhalations that mist every few minutes from the belugas' blowholes. It approaches rapidly across the tundra to stalk the swimmers from the stream bank. The bear waits and waits. Then, when one of the whales unwittingly swims close to the bank, the bear makes its move and leaps on the cetacean's back.

There follows a blur of white bodies accompanied by a tremendous flurry of splashing. A crimson cloud of blood drifts downstream in the current. A minute later the splashing is over. The bear, who weighs perhaps 700 pounds, drags the 2,000-pound beluga up on shore and commences to strip the carcass of blubber while the other two whales swim anxiously back toward the sea.

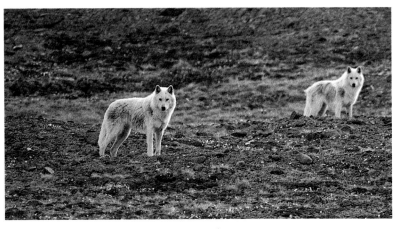

White wolves

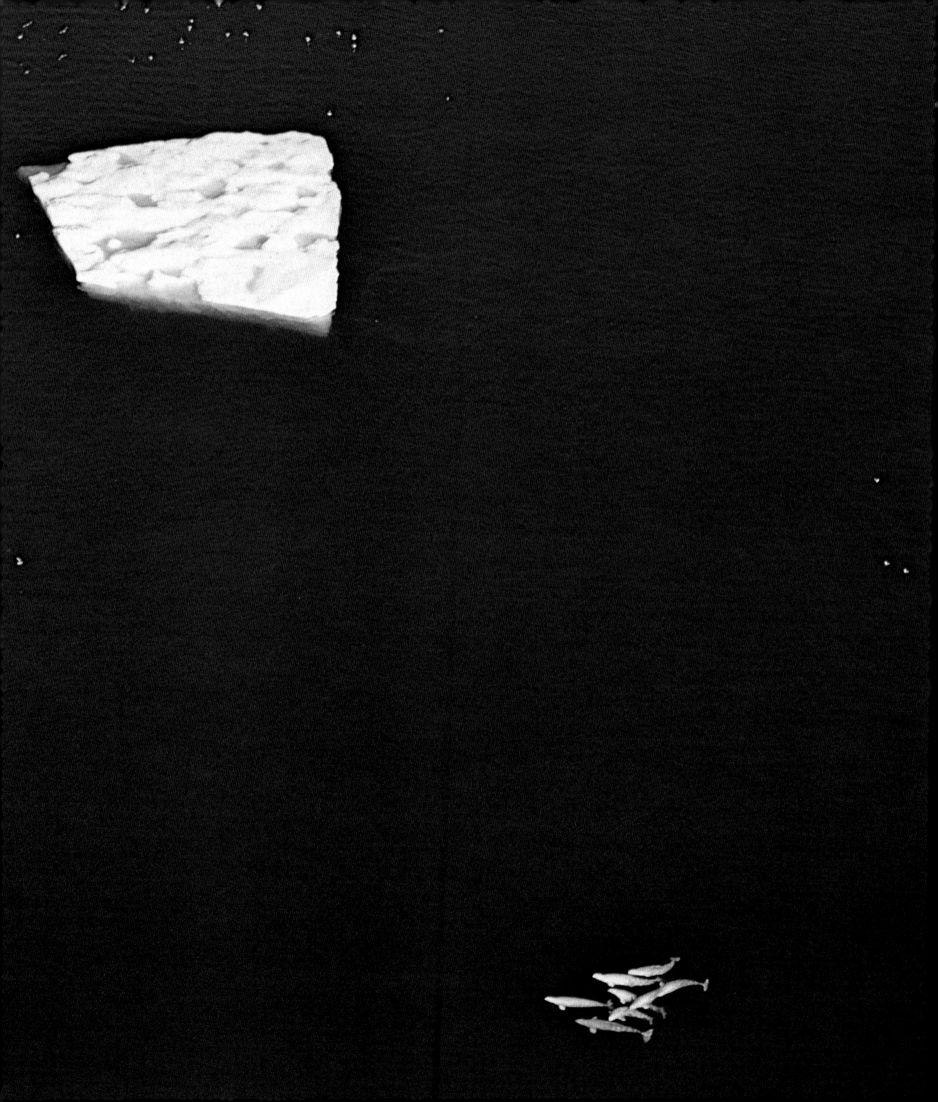

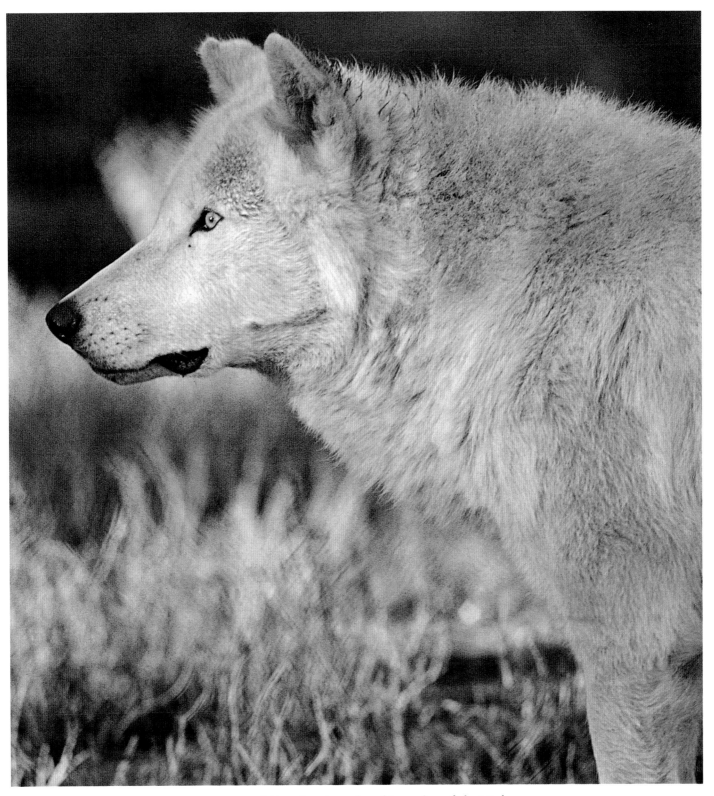

ABOVE: *Like all wolves, the white wolves of the High Arctic have highly expressive faces, which convey their moods and desires to other members of the pack.*

LEFT: *A pod of beluga whales frolics near an ice floe in Prince Regent Inlet. The hides of belugas are pale gray at birth, but turn a lustrous shade of white as the animals mature.*

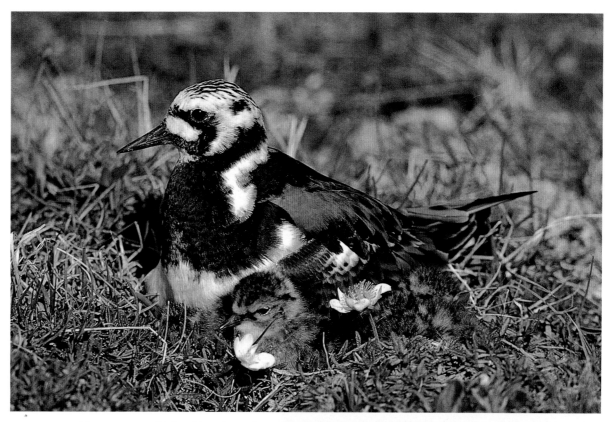

ABOVE: *Ruddy turnstone chicks, like those of most other members of the plover family, can run within minutes of birth, and can fly within a few weeks.*

RIGHT: *A wild rose blooms beside a charred, fallen tree in the boreal forest.*

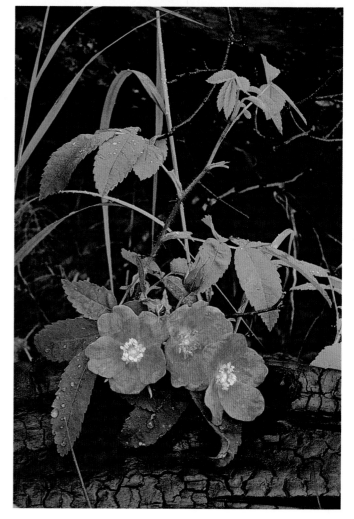

OPPOSITE: *The arctic tern breeds in the High Arctic and winters off the coast of Antarctica, making this the longest migration of any bird on the planet. Fiercely territorial, terns will not hesitate to attack humans who approach too close to their simple, unadorned nests.*

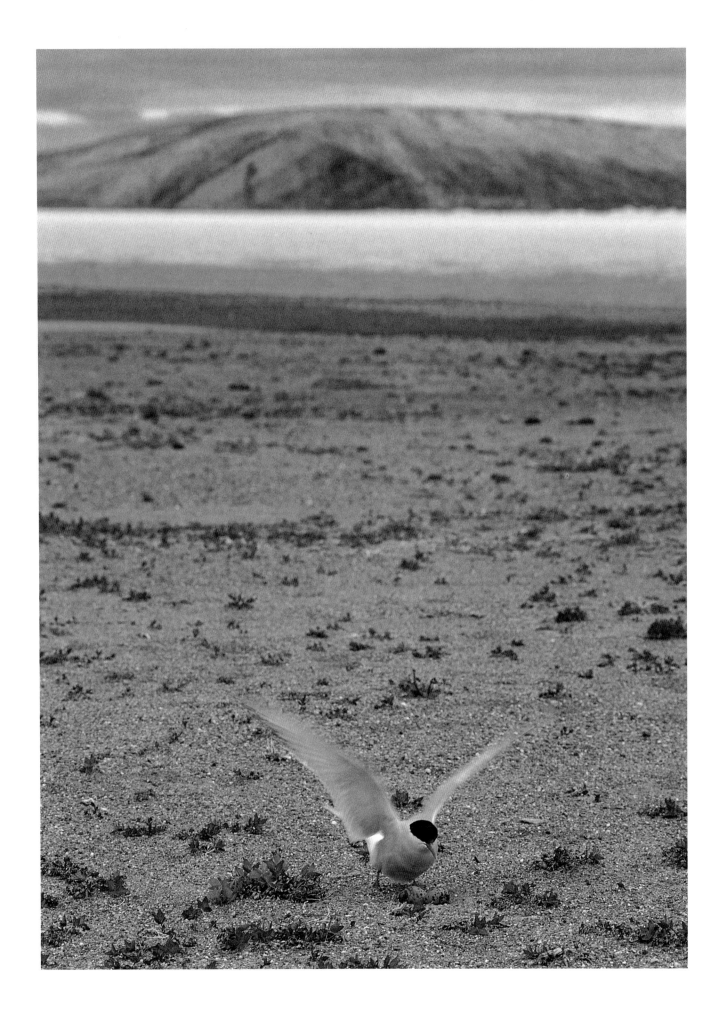

PREVIOUS PAGES: *The cheerful, delicate blue blossoms of mountain forget-me-nots grace the tundra across much of the Arctic. The forget-me-not is the official state flower of Alaska.*

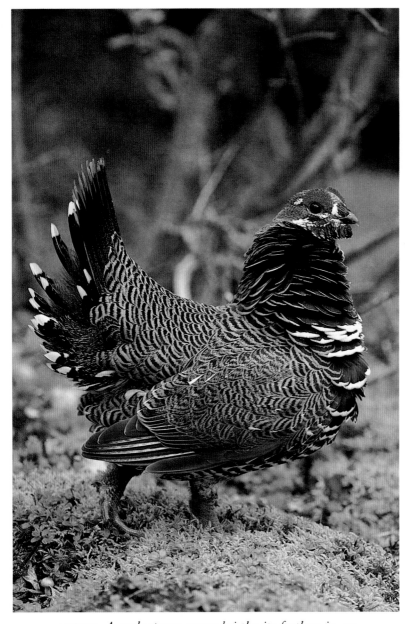

ABOVE: *A male spruce grouse bristles its feathers in an impressive courtship display. Extremely tame, this species is known as the "fool hen" because it can be hunted with nothing more than a rock or a stick.*

RIGHT: *Moose frequently give birth to twins, but approximately one-third of all moose calves are killed by wolves and other predators.*

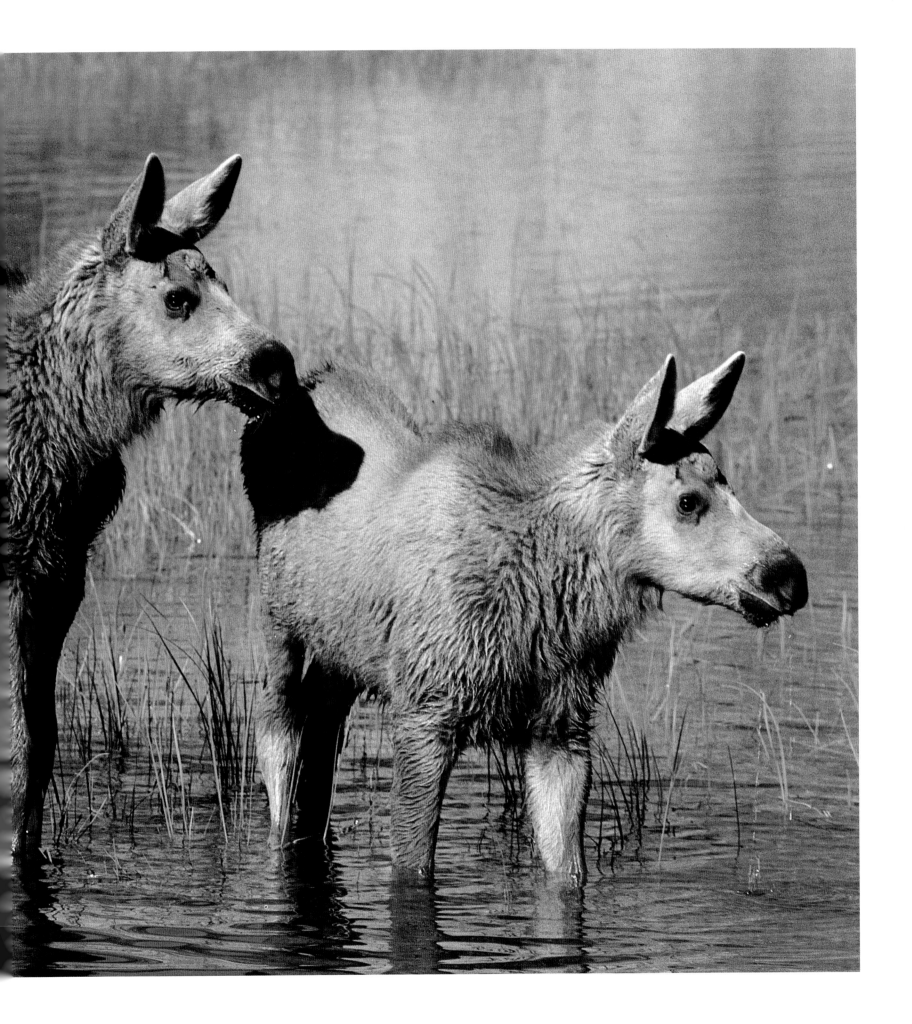

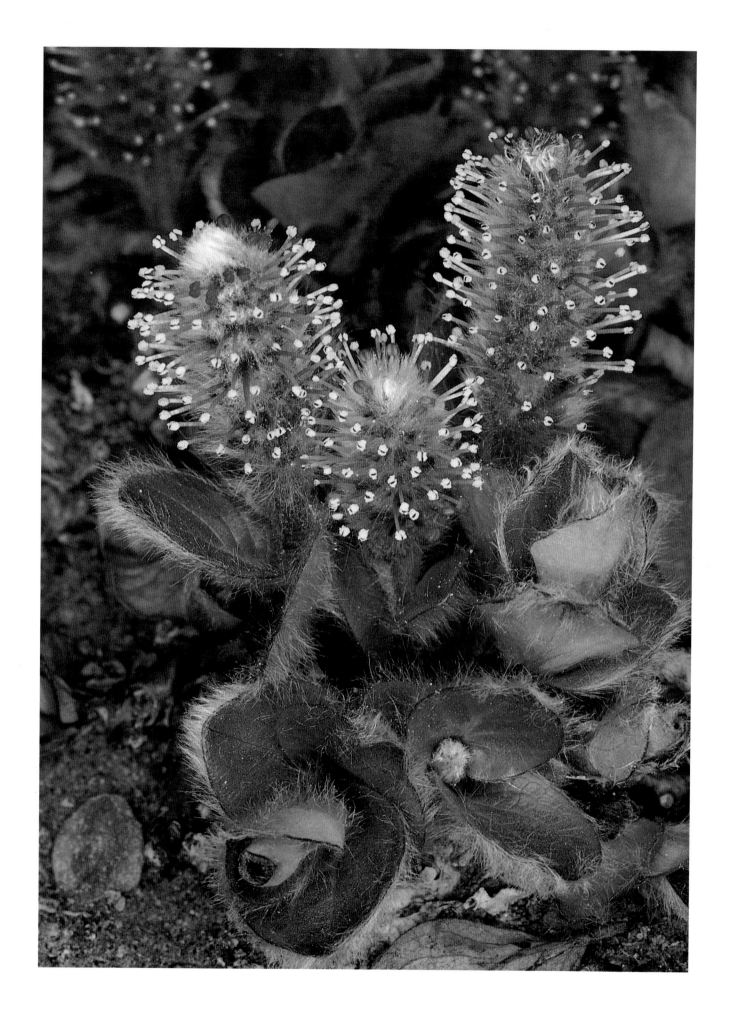

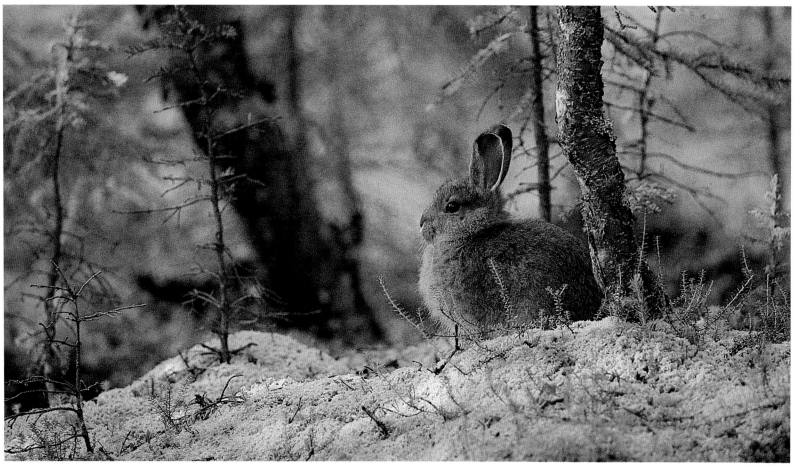

ABOVE: *A snowshoe hare in cautious repose on the forest floor. The climate tends to be more temperate and moisture more abundant in forested regions; hence there is a much greater diversity of species here than in the tundra-covered deserts found further north, in the High Arctic.*

LEFT: *The loud, abrasive chatter of the red squirrel is frequently heard in the boreal forest. After eating, red squirrels leave behind small, distinctive piles of cone cuttings on rocks and logs.*

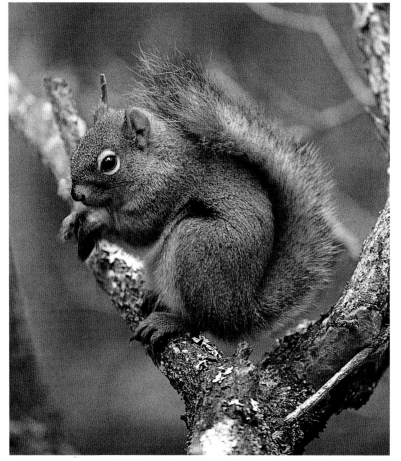

OPPOSITE: *No plant plays a more important role in arctic ecosystems than the willow, a critical food source for moose, hares, ptarmigan and many other species. Here, the catkins of a dwarf willow are bright with yellow pollen.*

PREVIOUS PAGES: *At 20,320 feet above sea level, the summit of Mount McKinley is the highest point on the North American continent. Most Alaskans call the mountain Denali, its original Athabaskan Indian name, meaning "the Great One."*

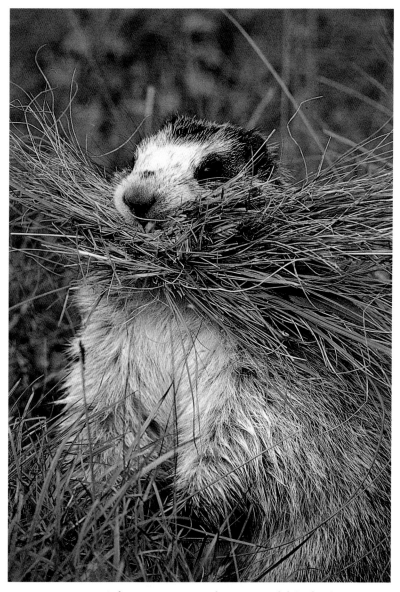

ABOVE: *A hoary marmot gathers a mouthful of sedges for lining for its burrow. At the approach of danger— a bear, a golden eagle, a wolf, a man—the marmot emits a long, piercing whistle that warns both its fellow marmots and other rodents, such as pikas, to scramble for cover.*

RIGHT: *It is theorized that moose forage on submerged aquatic plants in the summer months largely to make up for the lack of sodium in their winter diet of twigs and willow buds.*

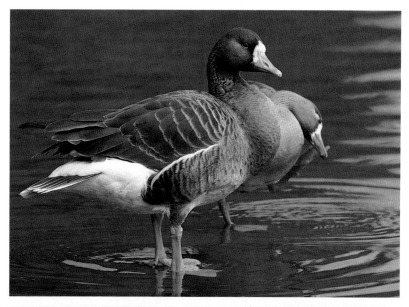

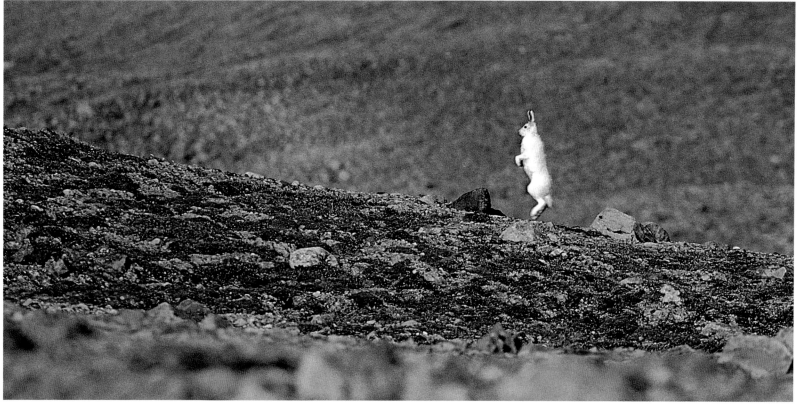

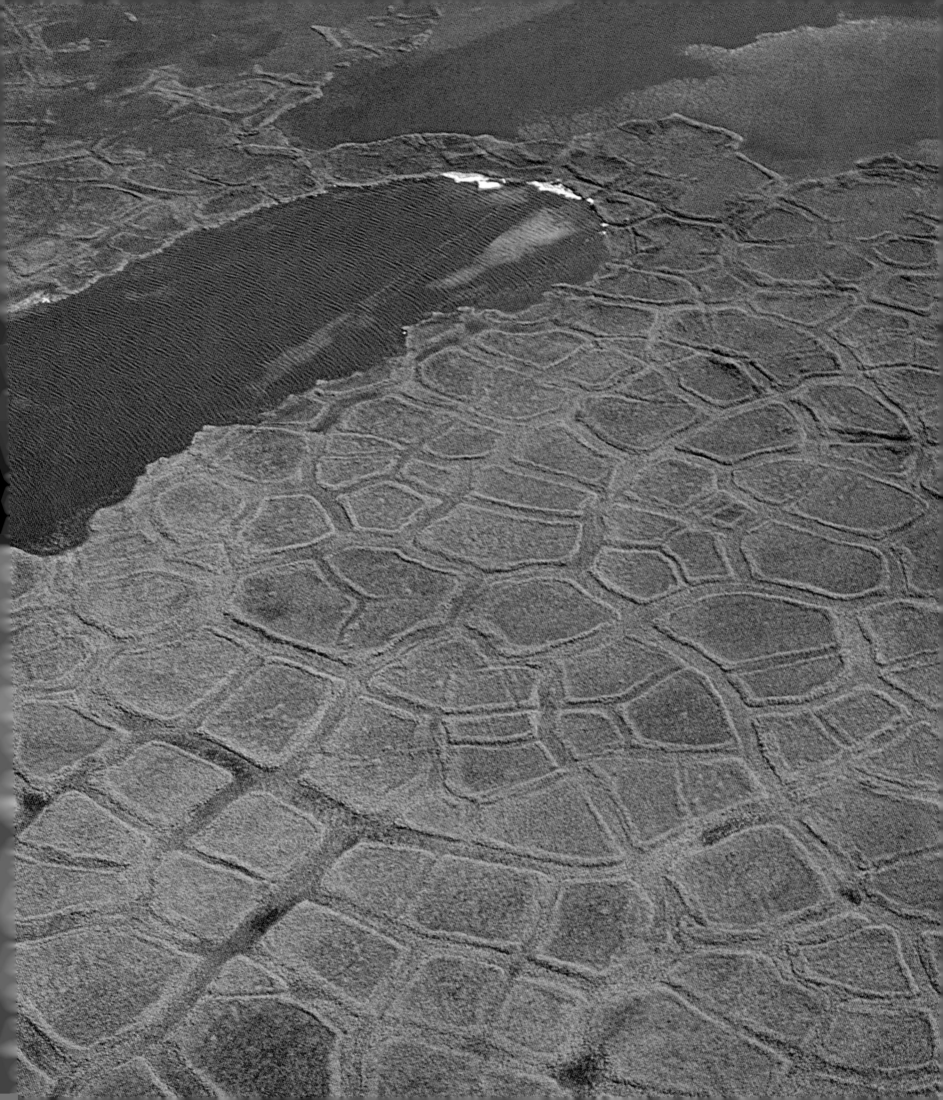

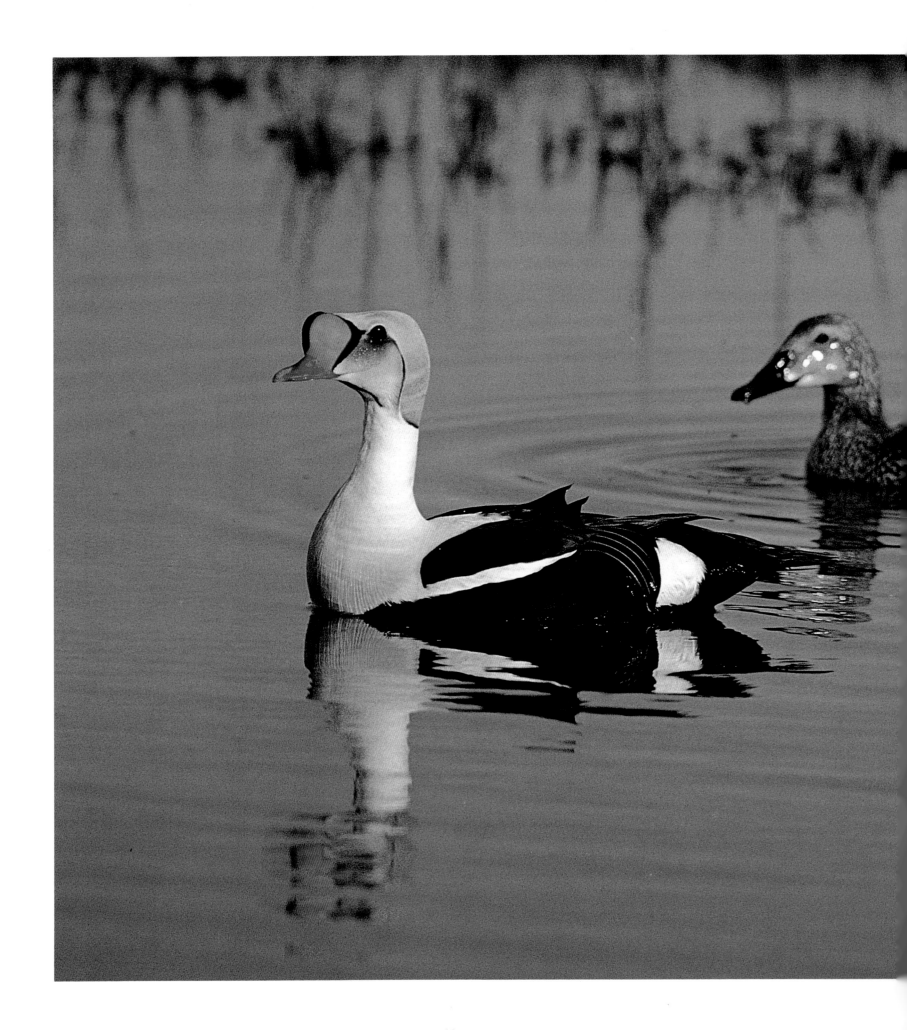

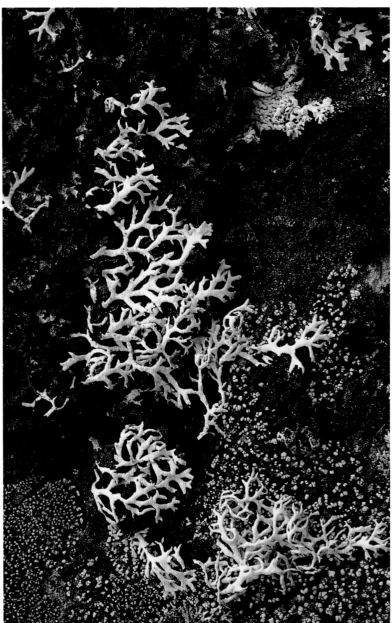

LEFT: *The male king eider is easily distinguished by its prominent forehead and garish markings. Eiderdown, the most efficient insulation found in nature, is gathered from the ducks' nests and used to make down jackets and duvets.*

ABOVE: *Lichens grow extremely slowly. It may take hundreds of years for a lichen plant to spread across a small rock the size of a baseball. Consequently, pollutants filtered from the atmosphere—including radioactive fallout—can build up to harmful levels in the plants' tissues, endangering both the lichens and animals that browse on them.*

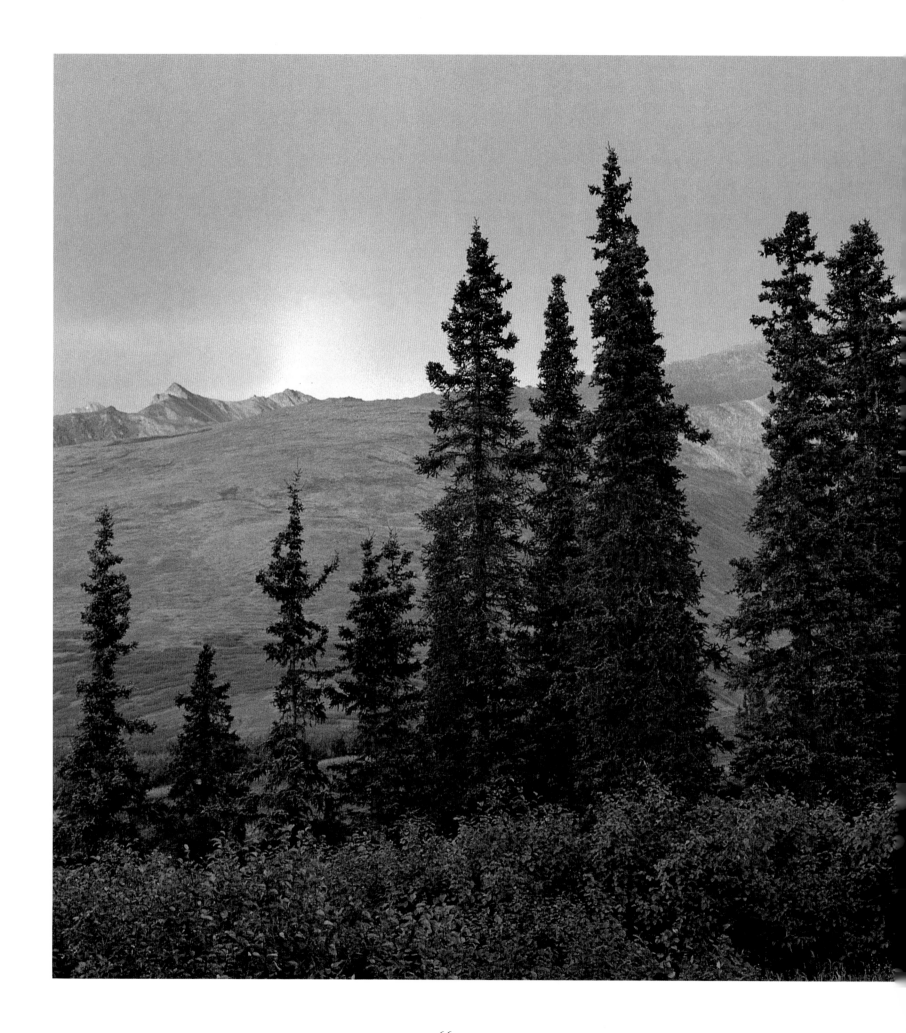

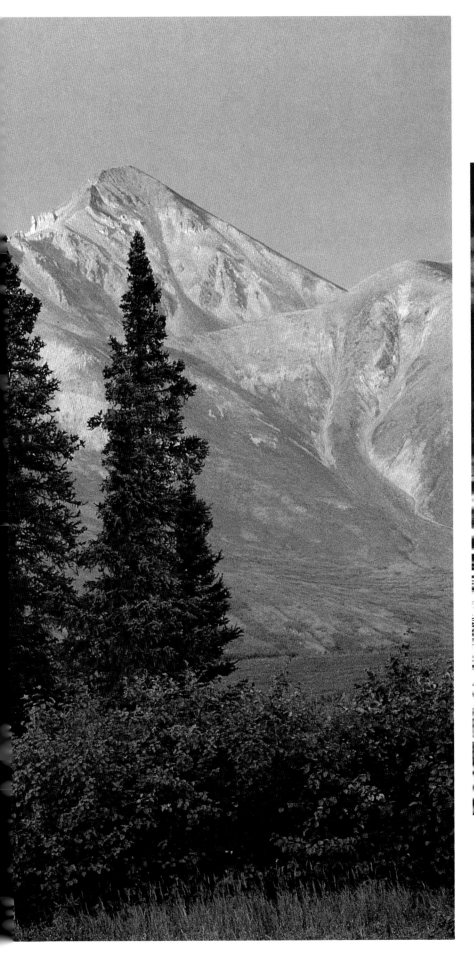

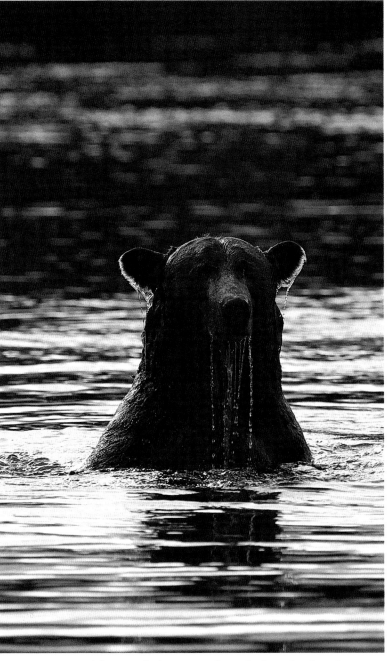

ABOVE: *The grizzly bear is at home both on land and in the water. Despite its great bulk, the grizzly is a capable swimmer, and can sprint over rugged terrain with astonishing speed.*

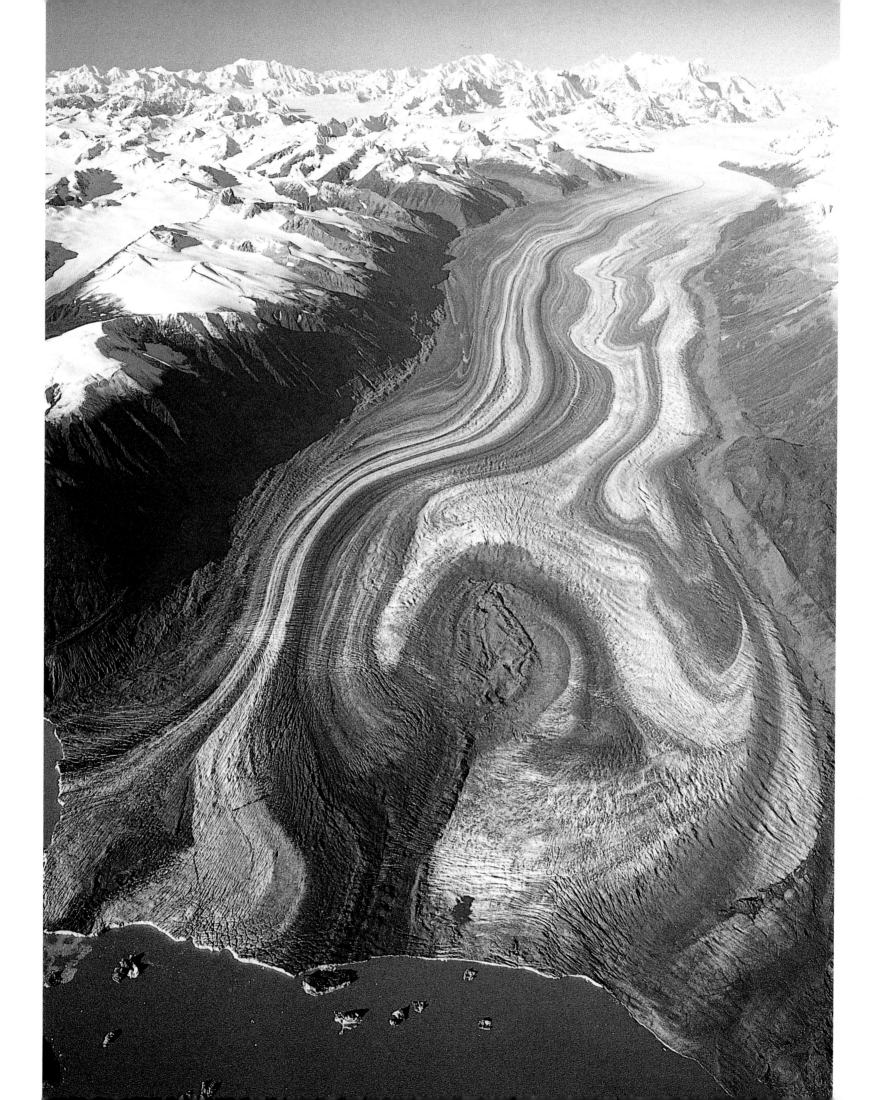

ABOVE: *The glacier's tortured surface is riven with crevasses and covered with swirling bands of rock rubble.*

LEFT: *The Lowell Glacier, an immense tongue of ice, releases icebergs into the Alsek River after flowing down from the frozen heights of the St. Elias Mountains.*

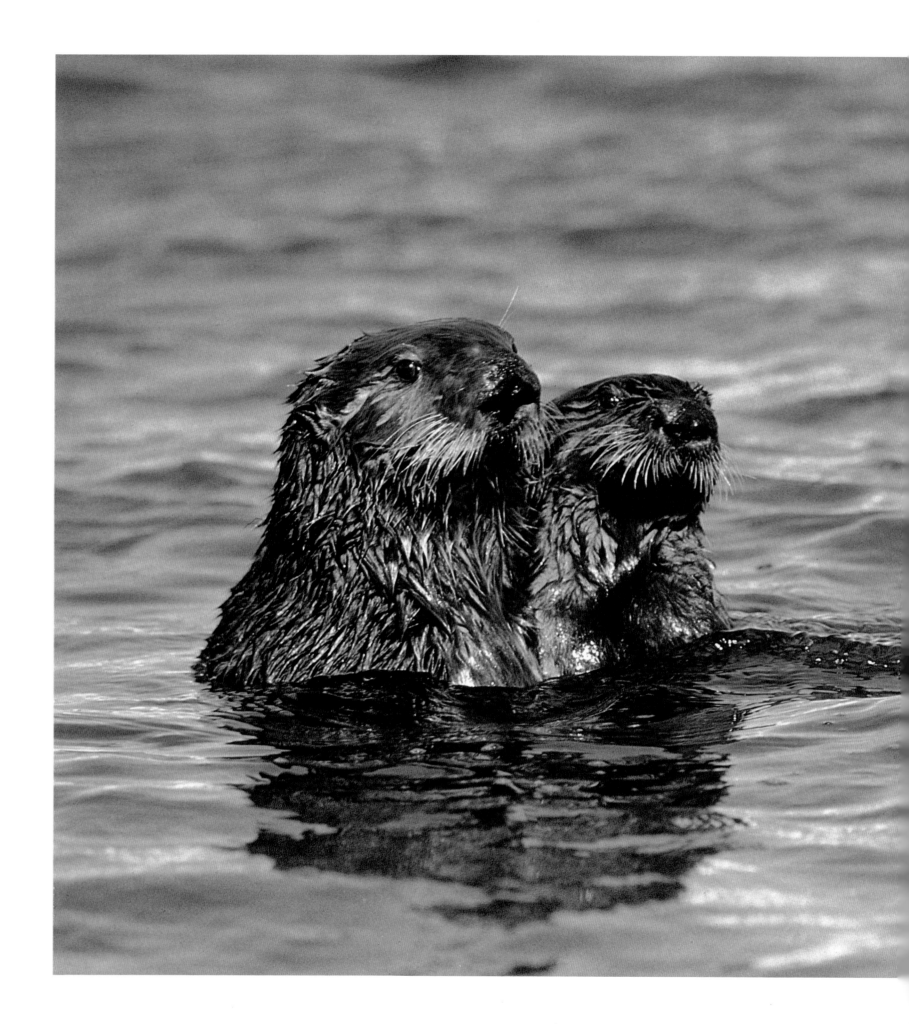

LEFT: *The sea otter's soft, rich pelt is widely regarded to be the finest animal fur on the planet. As a consequence, in the eighteenth and nineteenth centuries the otter was trapped nearly to extinction. Thanks to legislated protection, its numbers have rebounded significantly in recent years.*

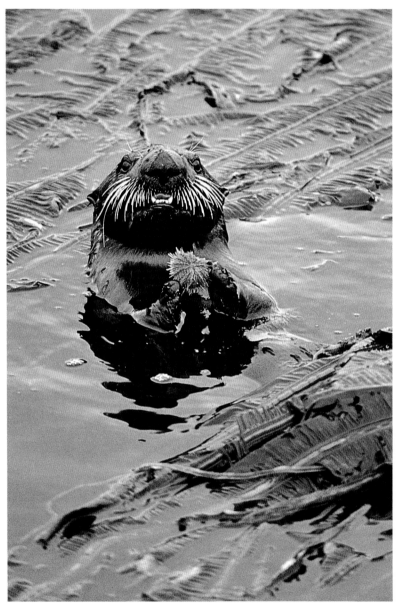

ABOVE: *A sea otter floats on its back to dine on a sea urchin. Typically, an otter will crack an urchin open by pounding it against a small rock balanced on its chest.*

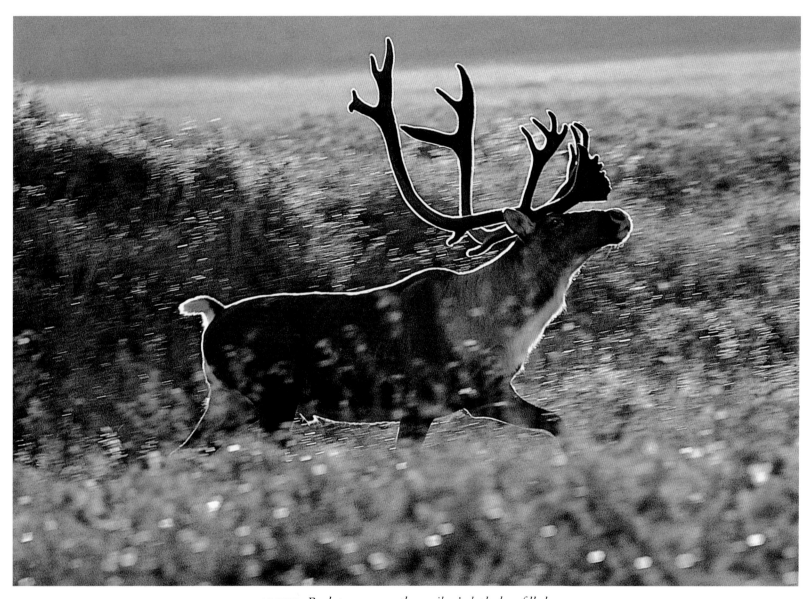

ABOVE: *By late summer, the caribou's body has filled out with a layer of fat, its pelage has grown thick and luxuriant, and its antlers have spread to impressive dimensions.*

RIGHT: *As its Latin name implies, the grizzly bear,* Ursus arctos horribilis, *has a fearsome reputation, but this huge, powerful creature is content for the most part to feed peacefully on grasses, insects, berries, roots, fish and carrion.*

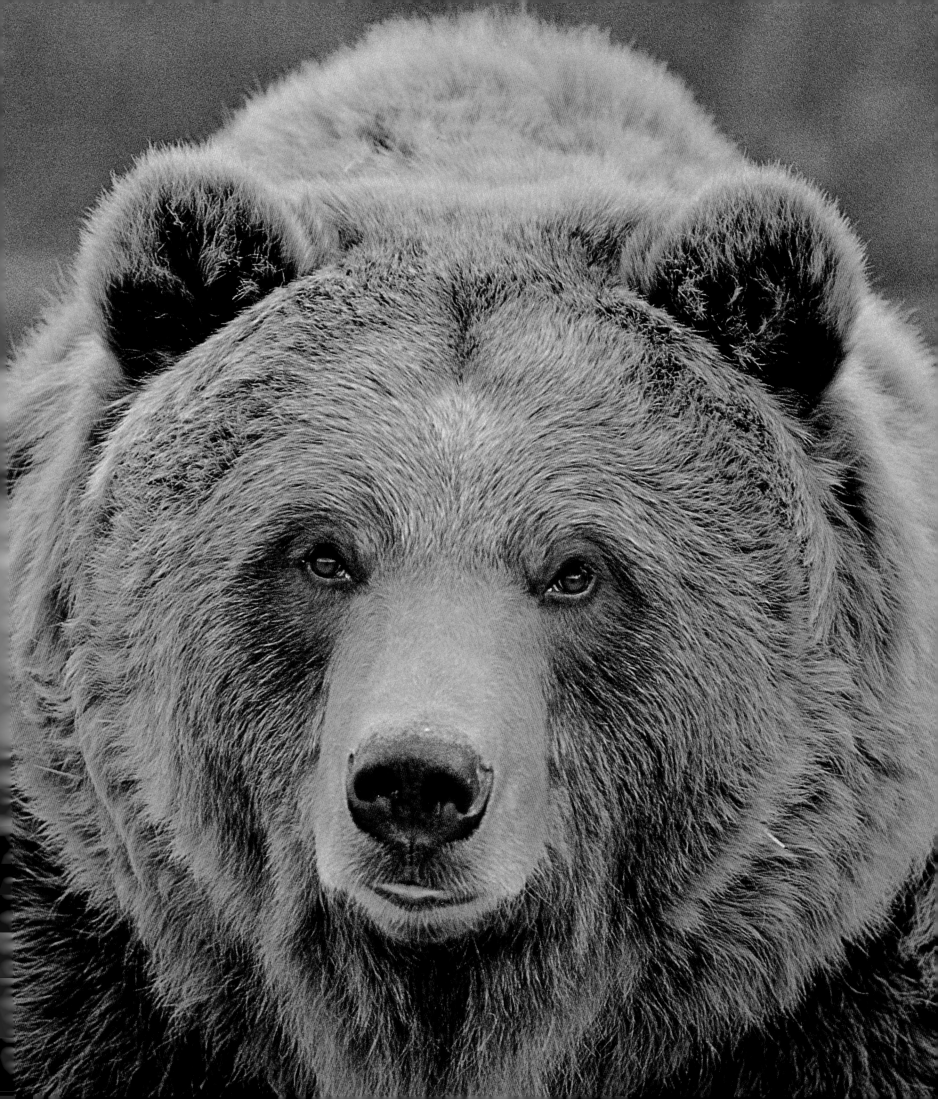

PREVIOUS PAGES: *On the damp, humus-rich floor of a rain forest in Glacier Bay National Park, ferns and bunchberry plants thrive amid rotting, moss-covered logs.*

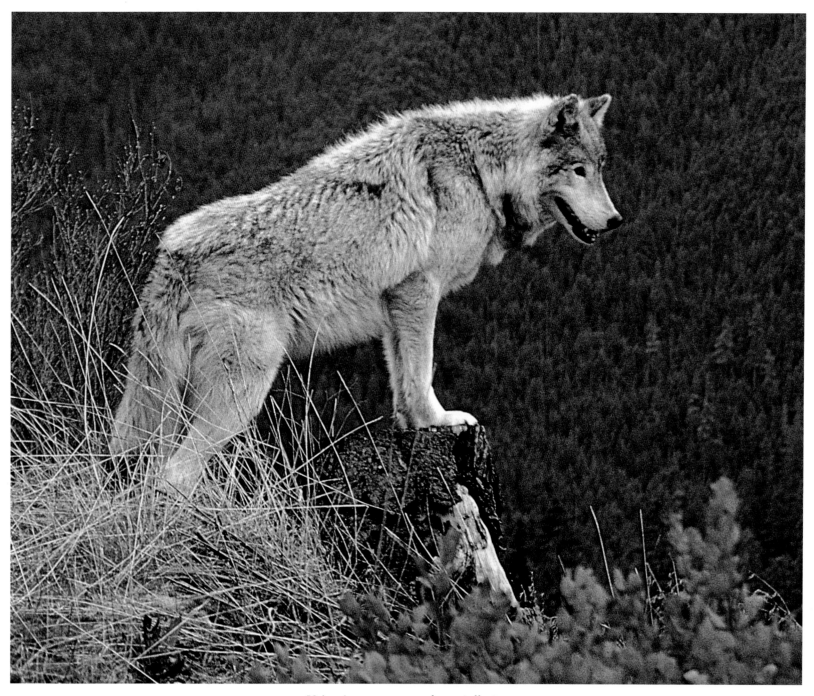

ABOVE: *Using its ears, eyes and especially its nose, a timber wolf surveys its territory. A wolf's sense of smell has been estimated to be a hundred times more sensitive than man's.*

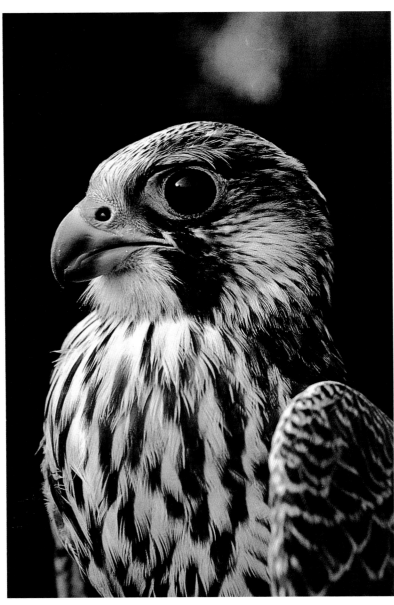

LEFT: *Peregrine falcons nest on steep cliffs, preferably at sites close to rivers. Superb flyers, peregrines hunt waterfowl and other birds by diving on them at speeds approaching 200 miles per hour and literally knocking their prey out of the sky.*

BELOW: *Scurrying across a gravel bar, a semipalmated plover forages for insects. Its call is a plaintive "chur-WEE, chur-WEE."*

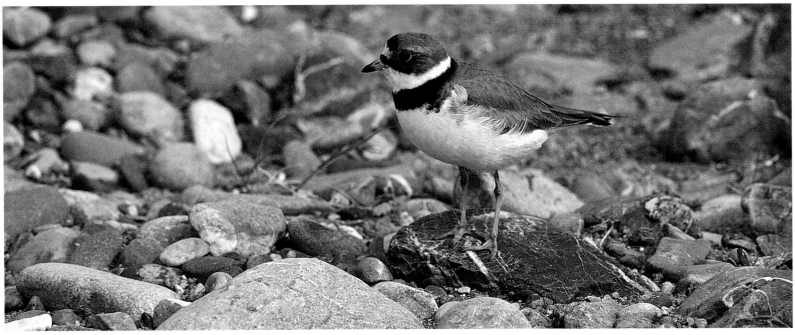

PREVIOUS PAGES: *At the height of summer, flowing melt-water carves a sinuous channel into the ancient ice of a glacier on Ellesmere Island.*

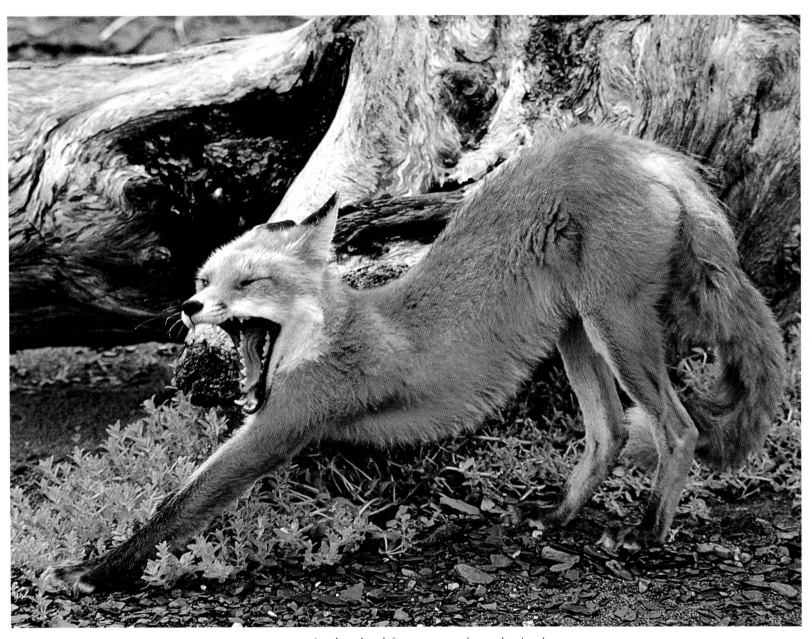

ABOVE: *A relaxed red fox yawns and stretches by the bank of Alaska's McNeil River before heading into the brush to hunt arctic ground squirrels.*

LEFT: *Stalks of purple lupine and bright yellow buttercup blossoms blanket an arctic hillside.*

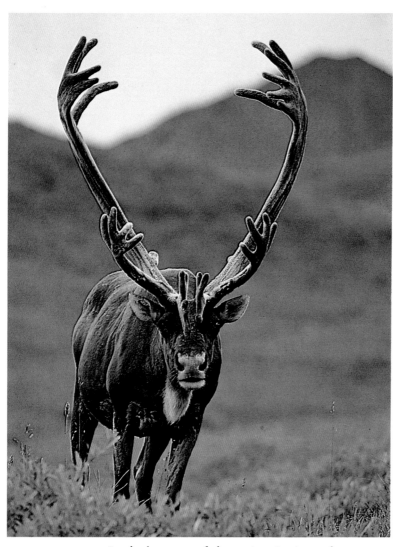

ABOVE: *In the language of the ancient Inuit people, the constellation we know as the Big Dipper is* tuktu, *the caribou, a name inspired by the animal's impressive antlers.*

RIGHT: *The Polar Inuit people who inhabit the northwest coast of Greenland call the polar bear* pisugtooq—*the great wanderer. Polar bears habitually travel hundreds of miles over the pack ice to hunt seals and beluga whales. One polar bear was found 2,000 miles from the place at which it was tagged by researchers a year earlier.*

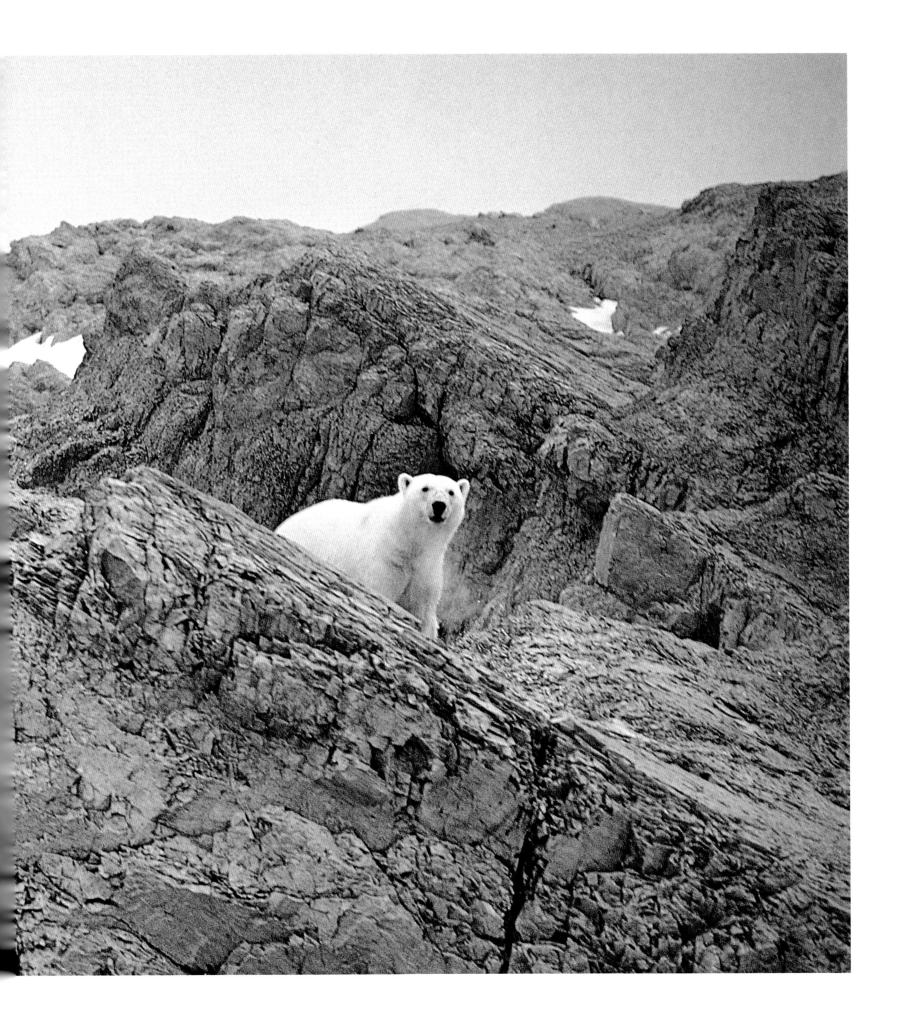

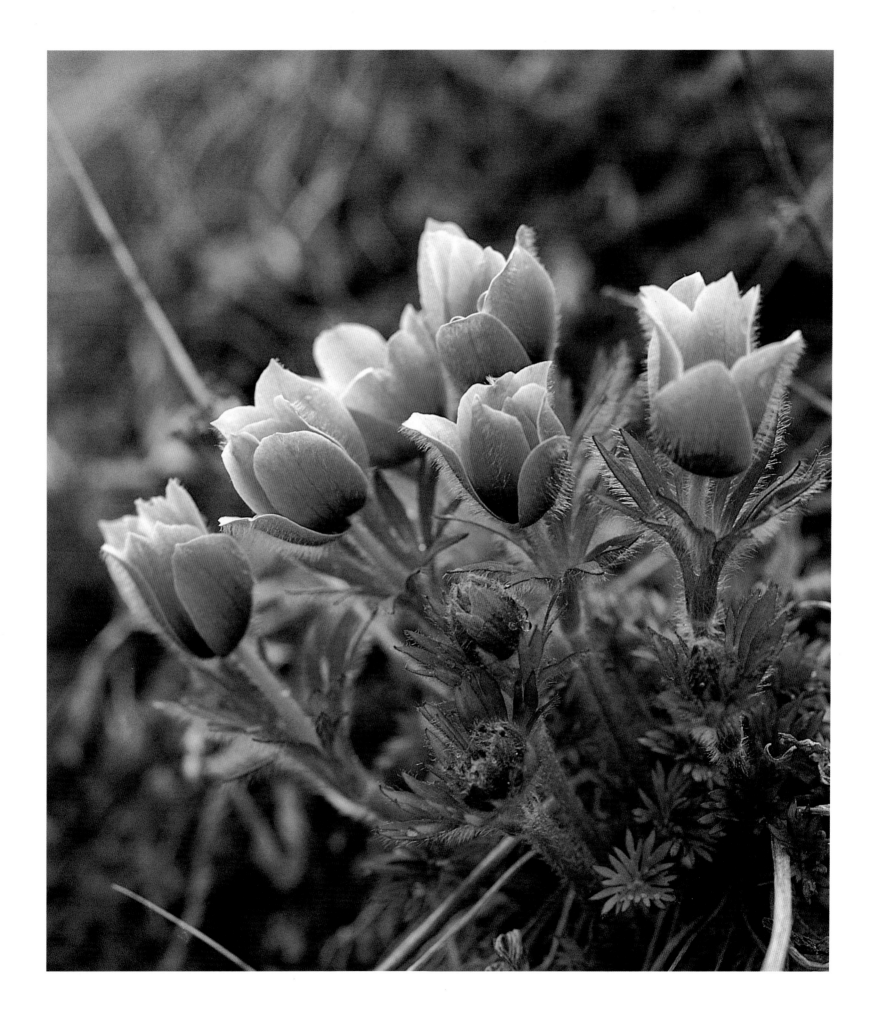

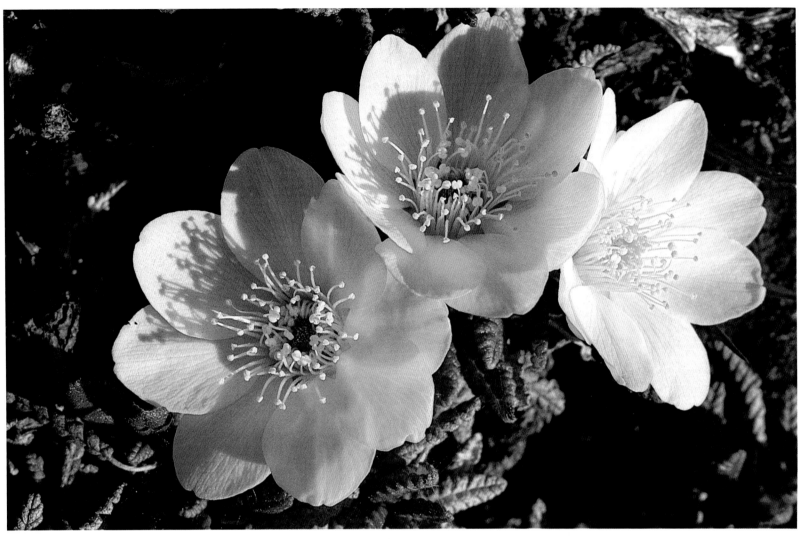

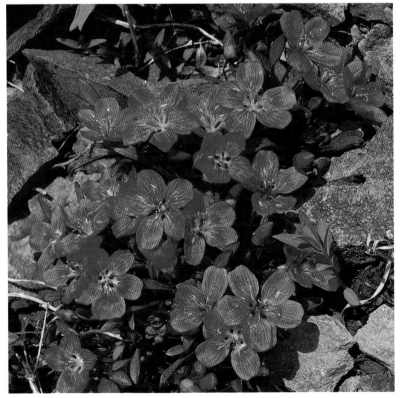

Common arctic wildflowers include the blue anemone (opposite); the arctic spring-beauty (left); and dryas (above), also known as mountain avens, a ground-hugging member of the rose family that spreads across the tundra in dense mats of lovely foliage.

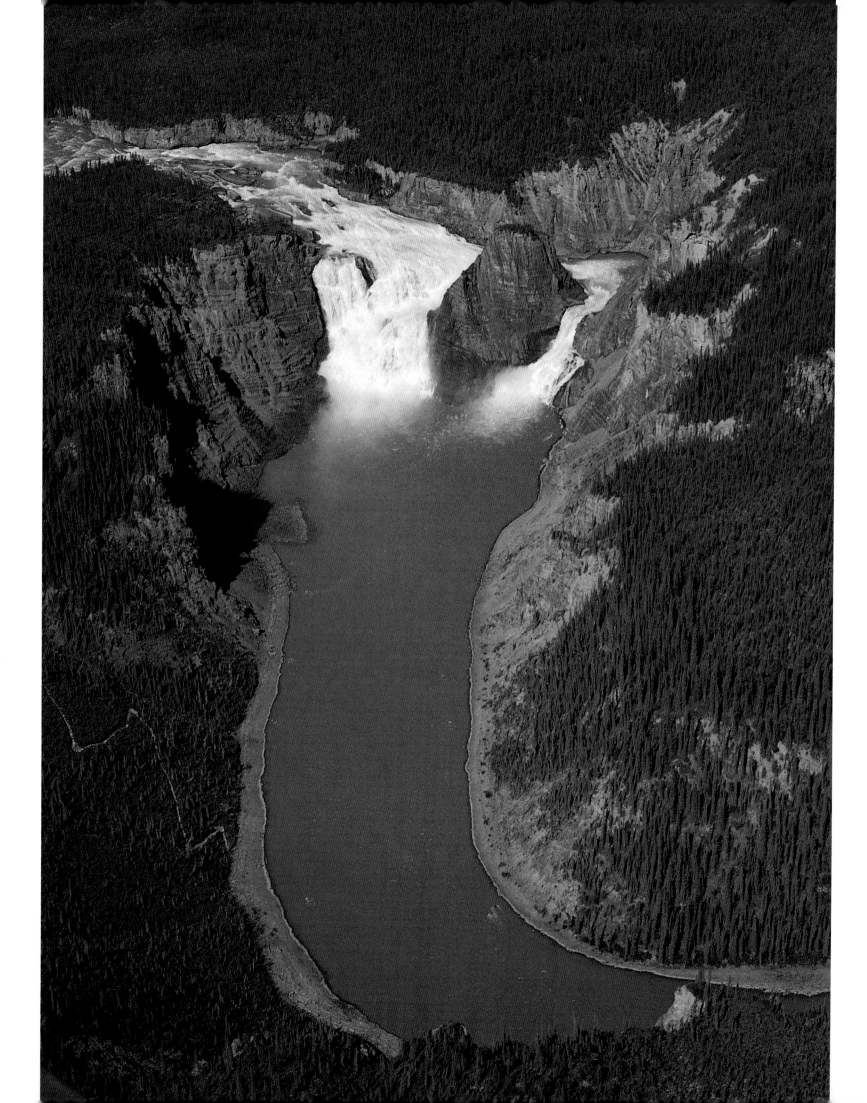

LEFT: *A short distance after flowing out of the tooth-like granite spires of the Selwyn Range, the South Nahanni River thunders over this spectacular cataract, called Virginia Falls.*

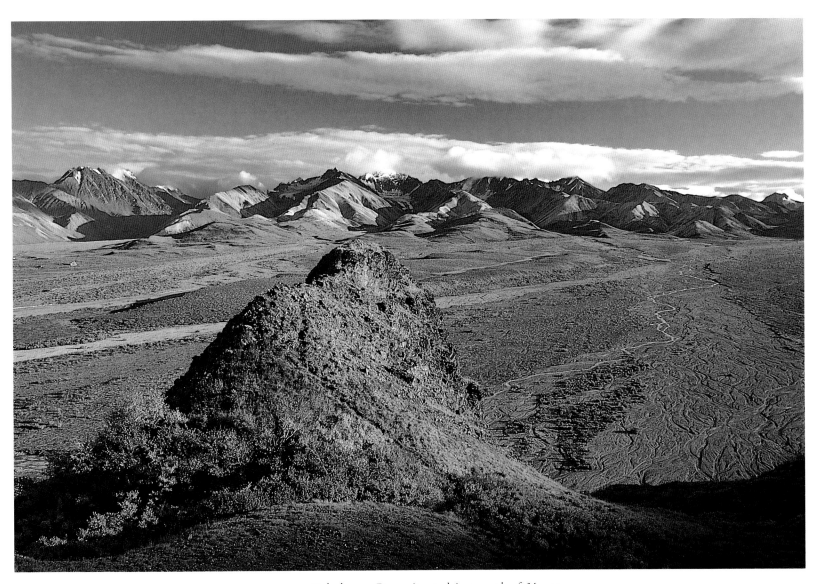

ABOVE: *Polychrome Pass, situated just north of Mount McKinley in Denali National Park, owes its name to the rich palette of colors displayed by the soils and vegetation on the nearby hillsides.*

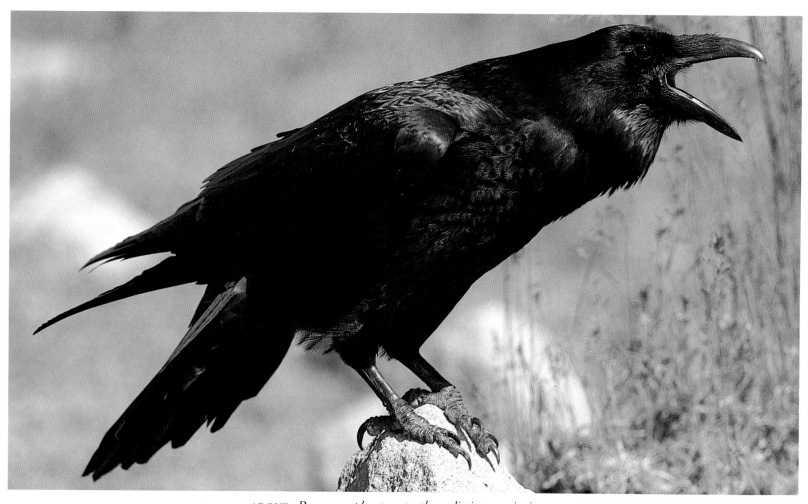

ABOVE: *Ravens employ twenty-three distinct variations of their abrasive call to communicate with each other. Extremely intelligent, they exhibit the most complex patterns of play seen in any bird.*

RIGHT: *The eyes of the great gray owl are fixed in their sockets, so the bird must move its entire head whenever it shifts its gaze. The large convex disks around the eyes direct sound waves toward the owl's hypersensitive ears.*

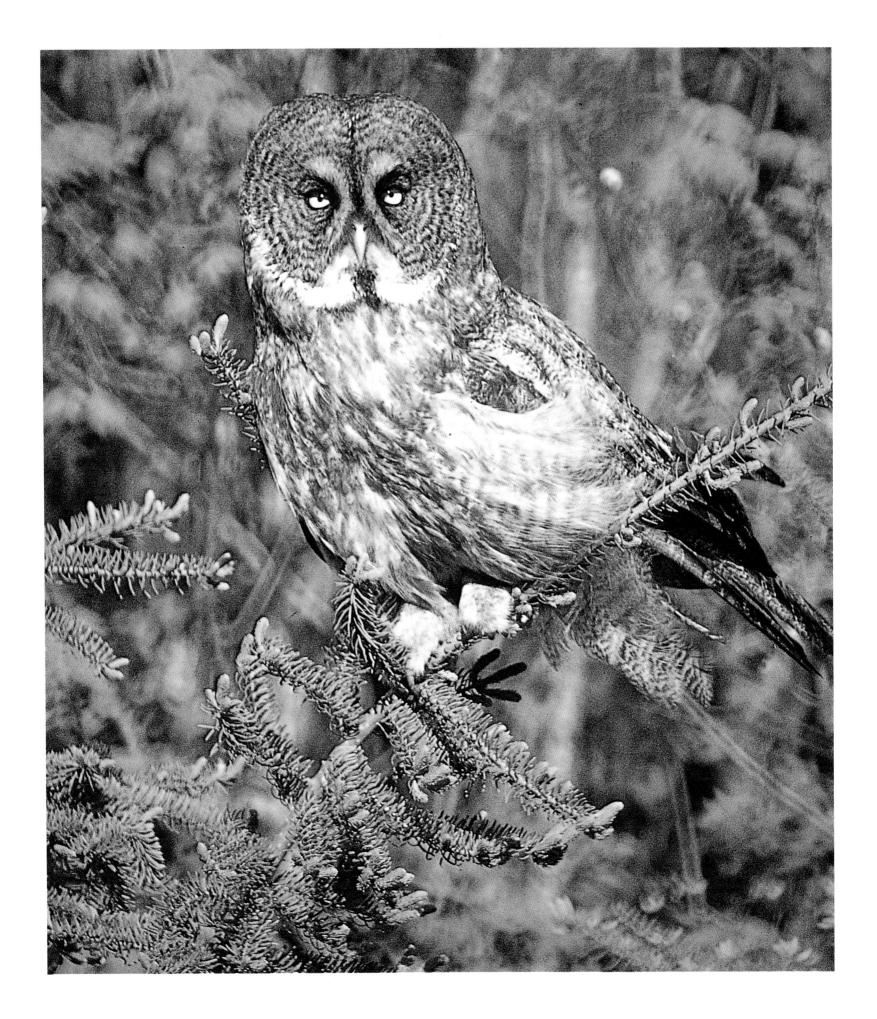

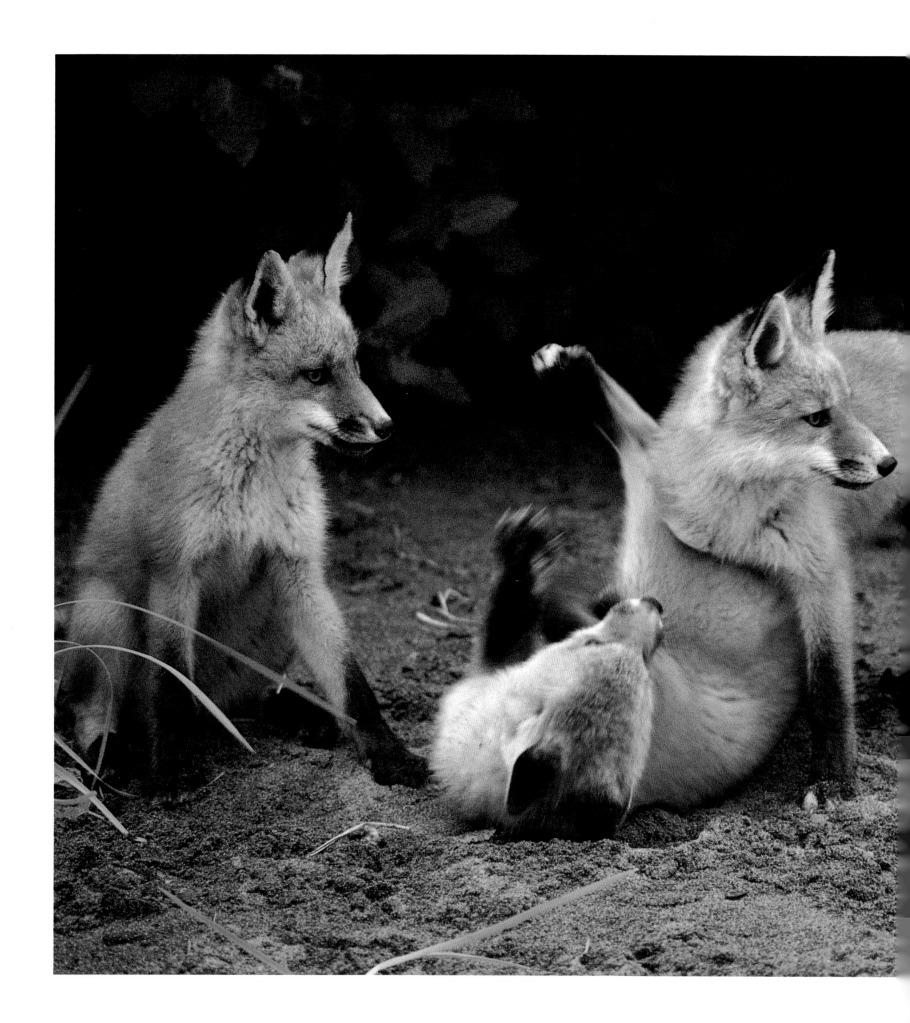

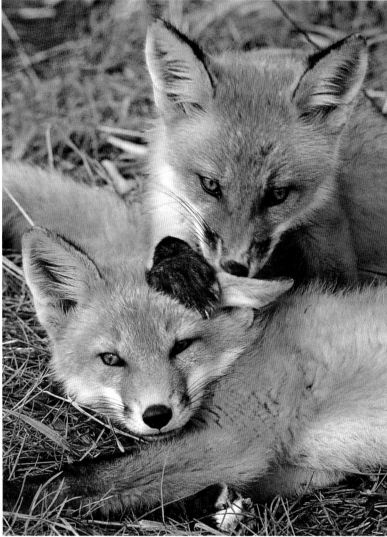

ABOVE AND LEFT: *Red fox kits at play. The mother fox is very protective of her young, and although she weighs no more than a house cat, she is adept at chasing away the huge grizzly bears that regularly approach her den.*

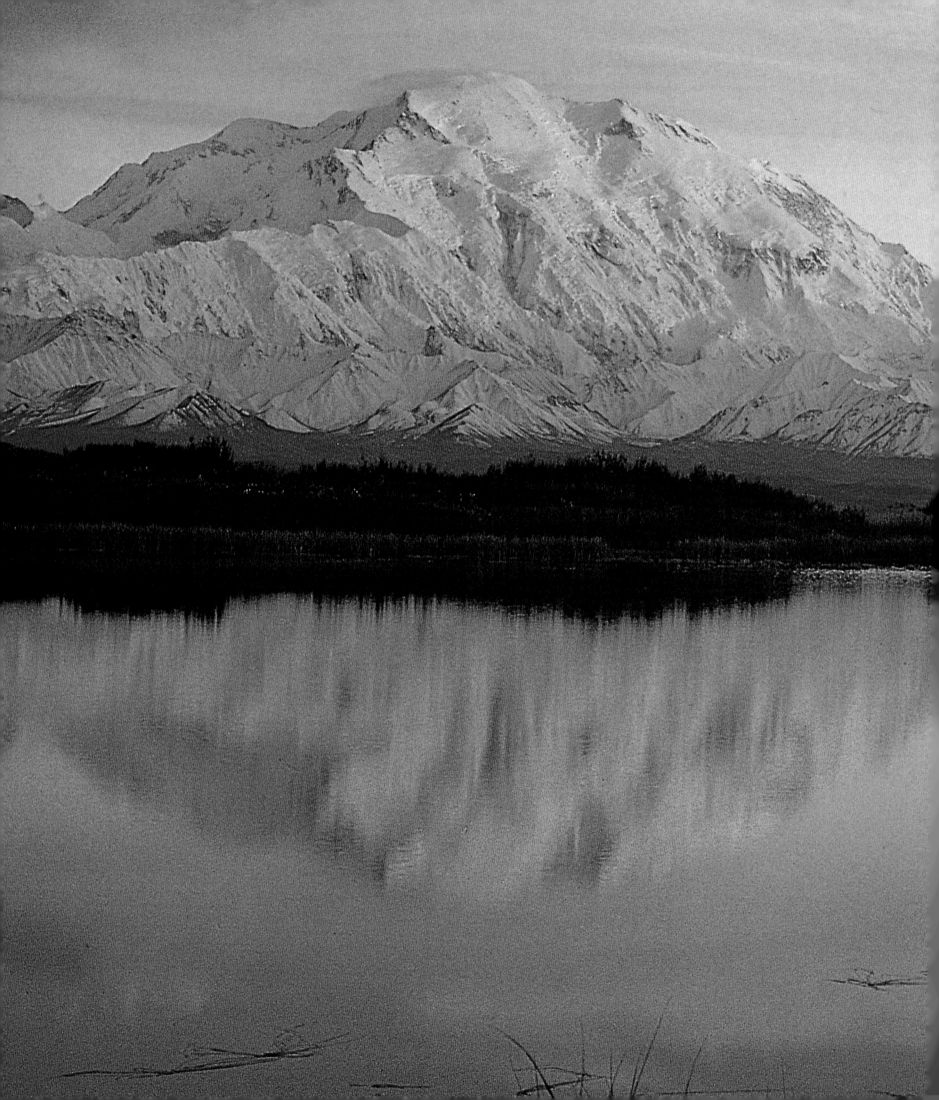

PREVIOUS PAGES: *Mount McKinley is one of the largest landforms on the face of the earth, occupying 120 square miles. The peak's north face towers more than 17,000 vertical feet above the rolling tundra at its foot. Mount Everest, by comparison, rises only 12,000 feet from the plains at its base.*

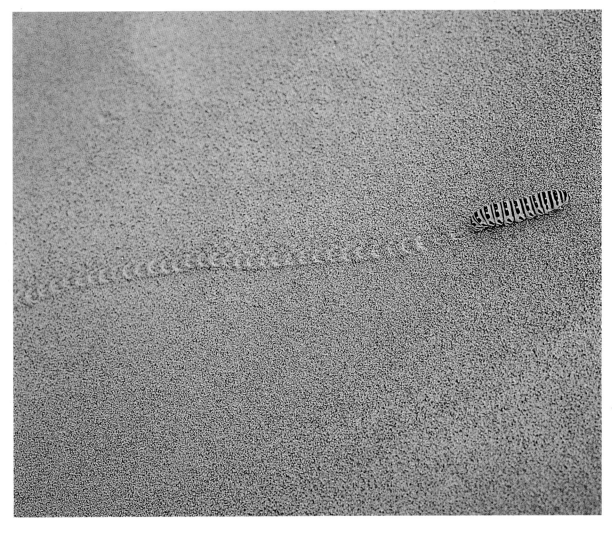

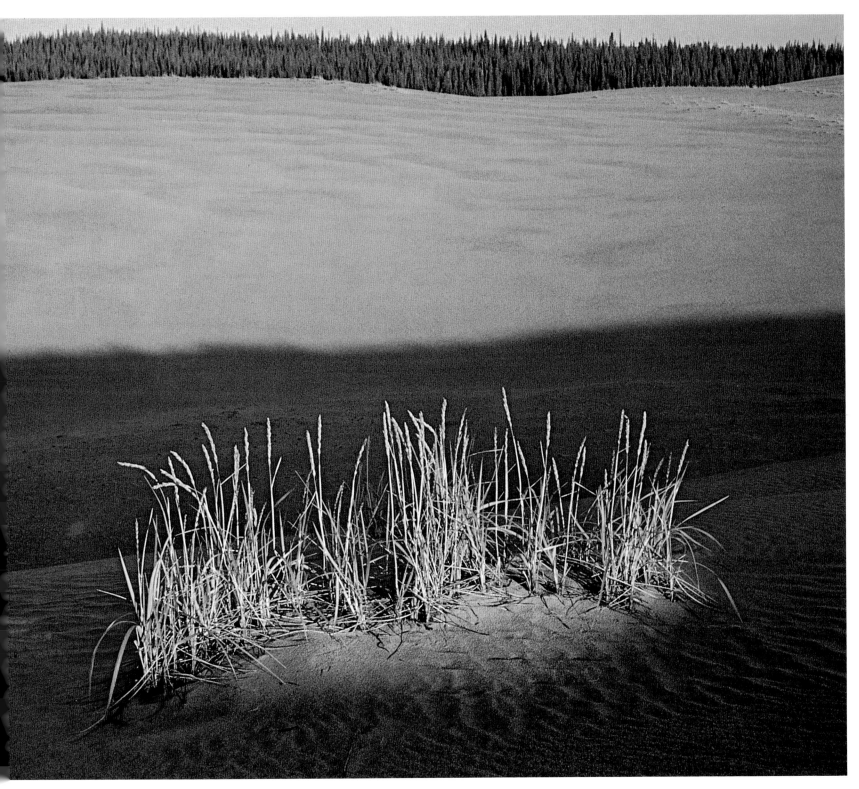

ABOVE: *Spot-lit by a summer sun that never sets, a clump of hardy grass has taken root in the shifting sands of the Great Kobuk Sand Dunes, near Ambler, Alaska.*

LEFT: *The Kobuk Dunes are an eerie expanse of fine-grained sand that covers hundreds of square miles. Here, a tiny caterpillar leaves a delicate trail as it inches across the dunes.*

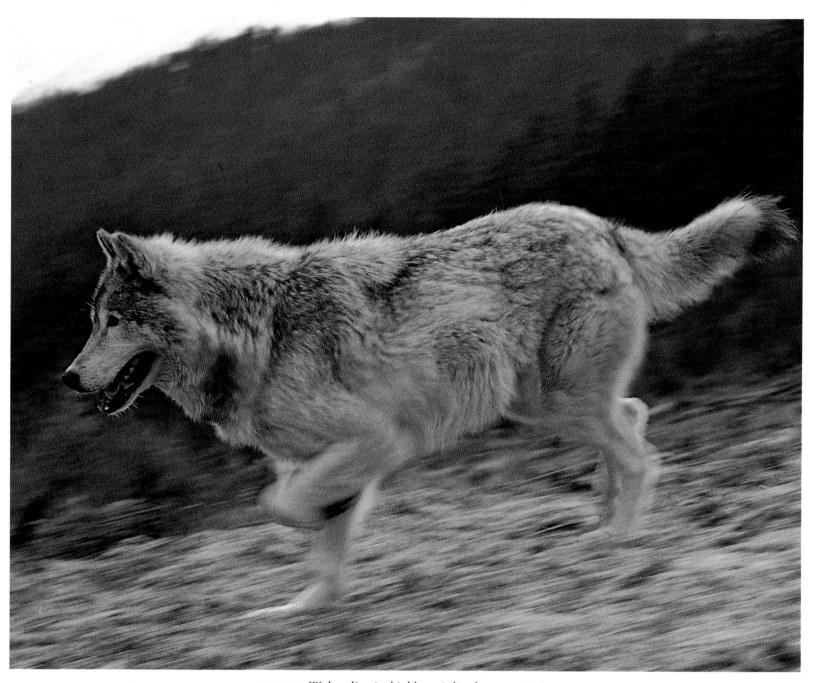

ABOVE: *Wolves live in highly socialized communities. When hunting, one or more wolves may head off to track new prey, while the rest of the pack herds previously located prey.*

RIGHT: *An Alaskan brown bear fishes for salmon in a cold, swift river. Brown bears, a subspecies of grizzly bear, live along the Alaskan coast. Because the summer runs of salmon on which they feed are so plentiful, brown bears grow larger than grizzlies, sometimes weighing more than 900 pounds.*

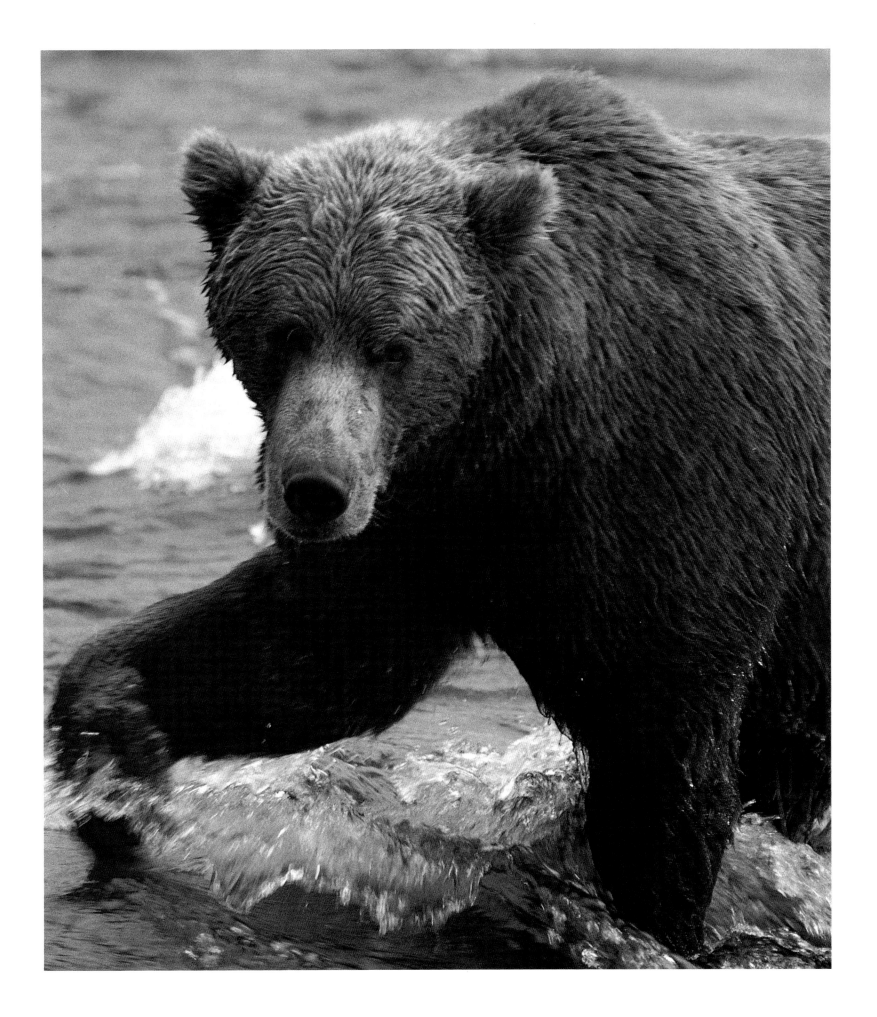

The black-billed magpie is a ubiquitous scavenger. Like its relative, the raven, it is a very clever bird. The magpie's call is a rising whine followed by a series of harsh, grating notes.

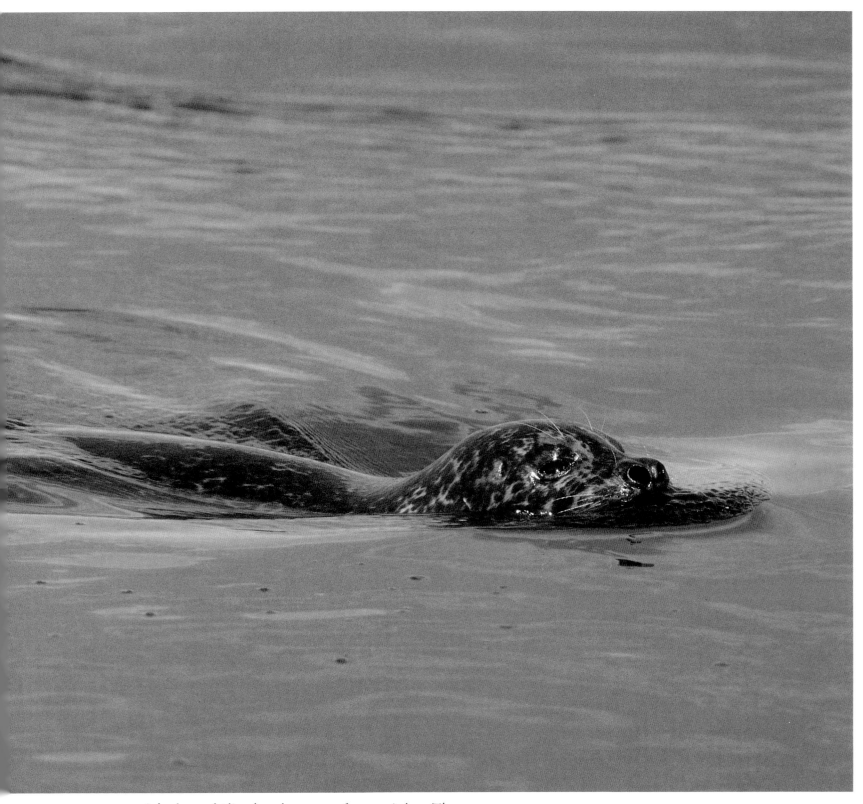

A harbor seal plies the calm waters of an arctic bay. The harbor seal is the only species of seal with a spotted coat. Most of these seals live in coastal harbors and river mouths, but some are occasionally found in inland lakes.

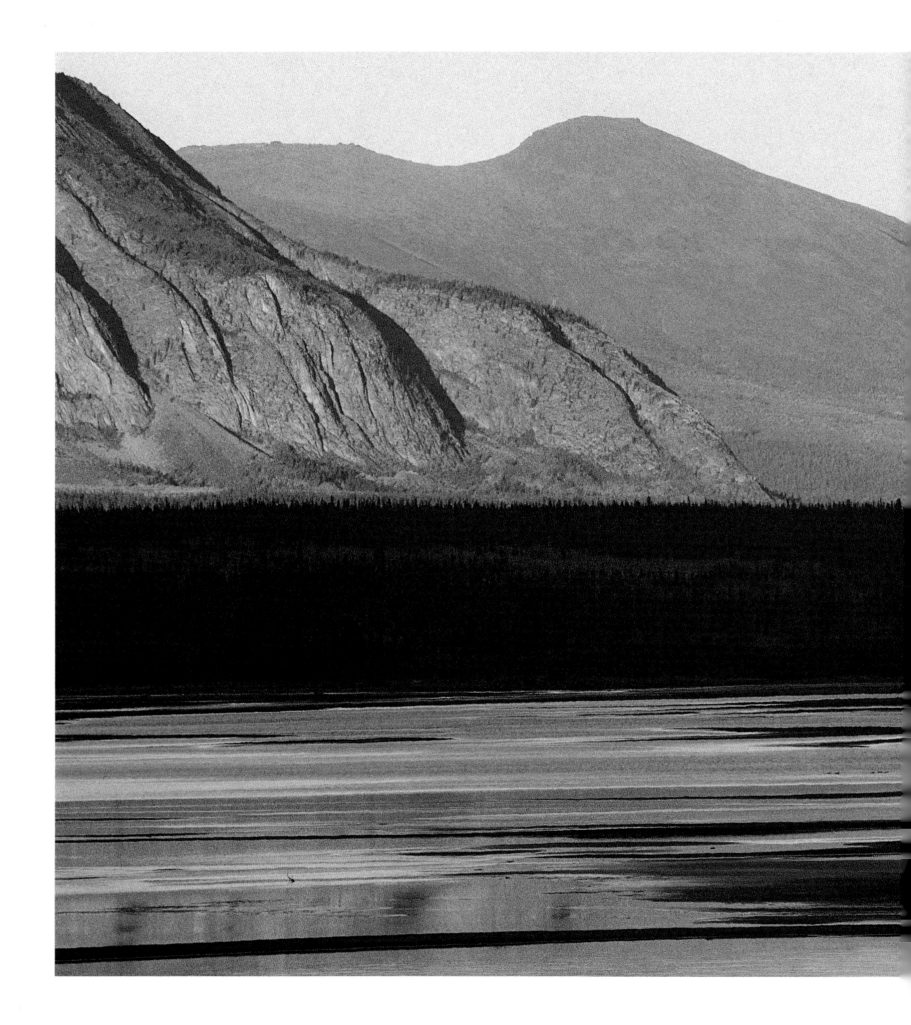

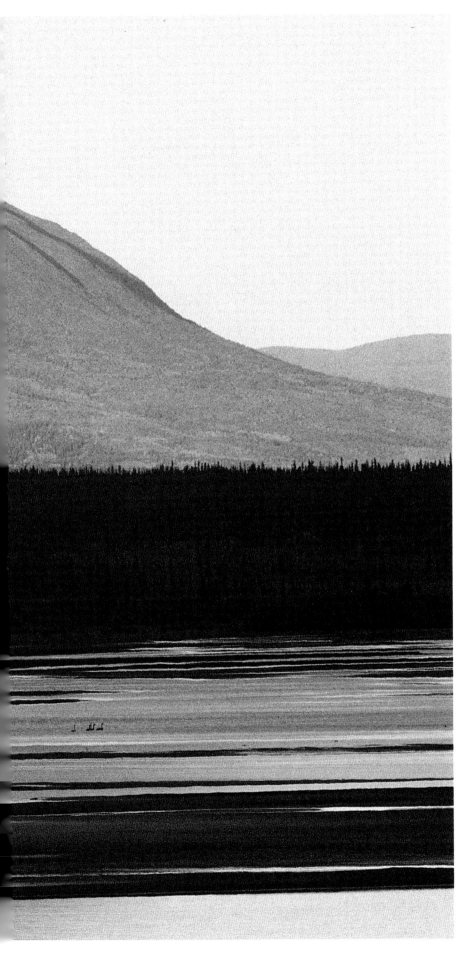

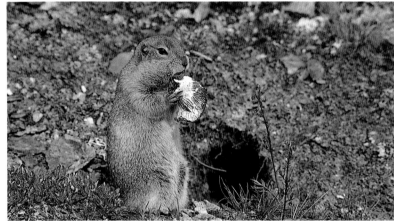

LEFT: *Flowing from the interior of the Yukon Territory to the Gulf of Alaska, the Alsek River has cut a channel through the craggy granite spine of the St. Elias Mountains.*

ABOVE: *A hungry arctic ground squirrel nibbles on a mushroom. Called parka squirrels by Alaskan Inuit who sew parkas from their pelts, ground squirrels are one of the few arctic creatures that spend the winter in a state of true hibernation.*

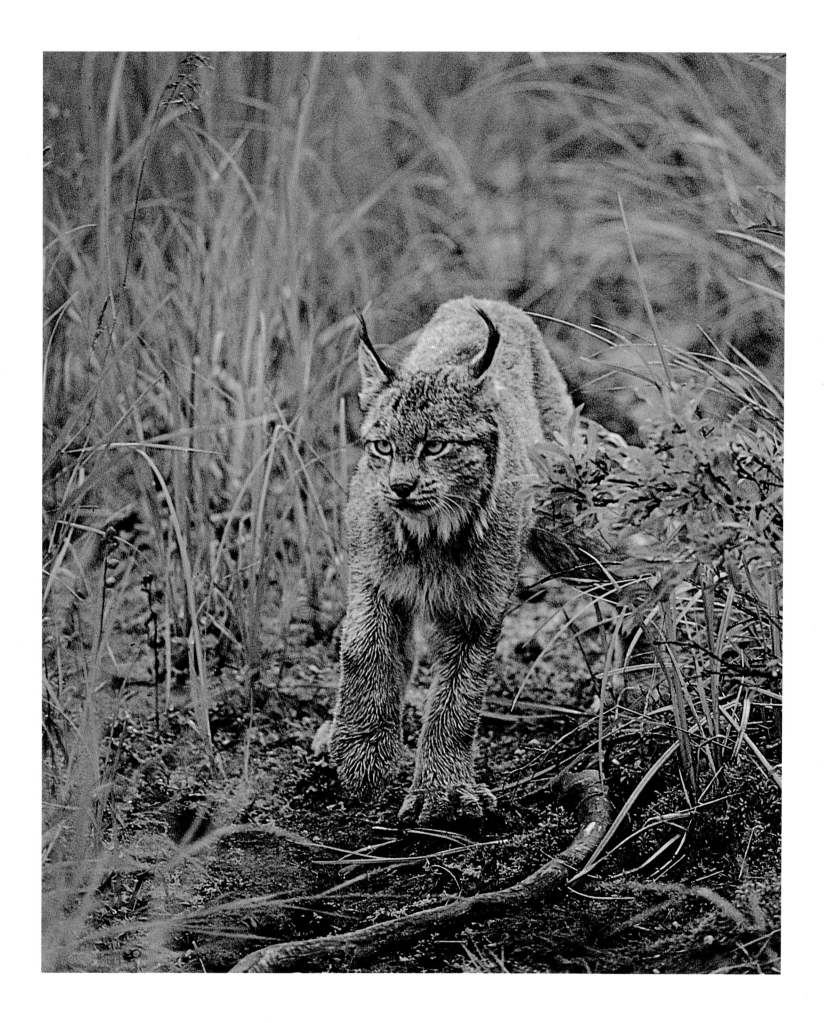

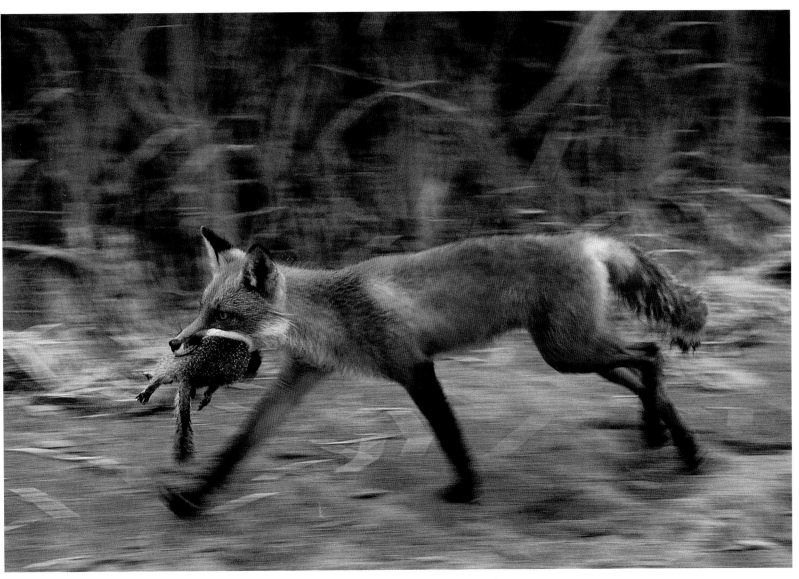

ABOVE: *A red fox hurries back to its den with an arctic ground squirrel between its jaws after a successful afternoon hunt.*

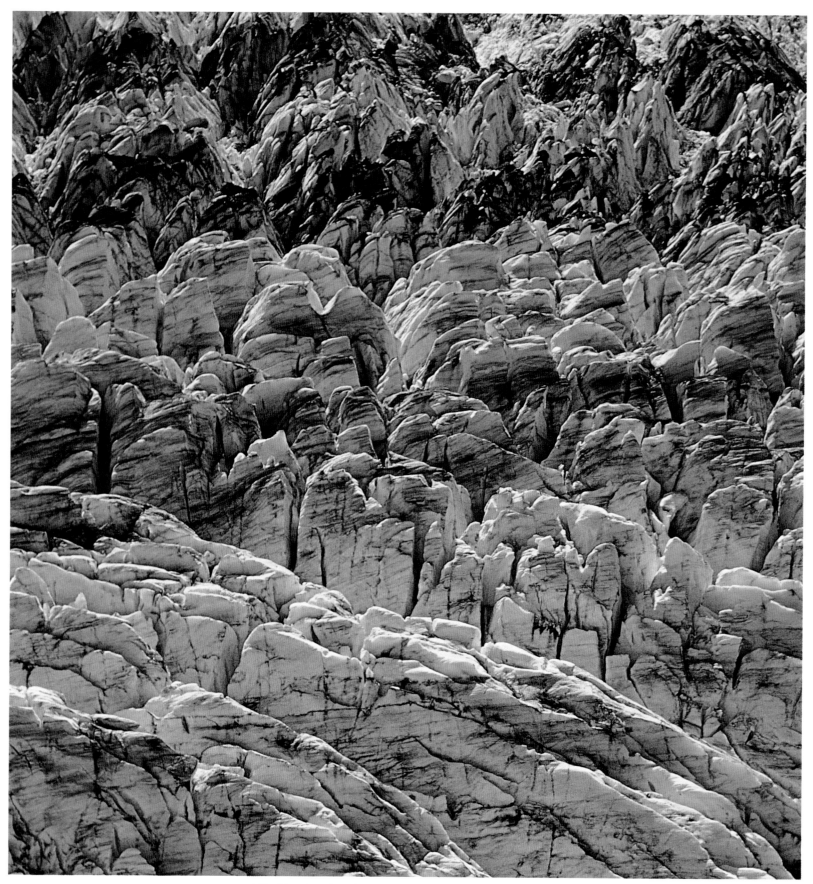

The blue ice of a glacier in the Chugach Mountains has shattered into an impassable maze of towering seracs and deep crevasses.

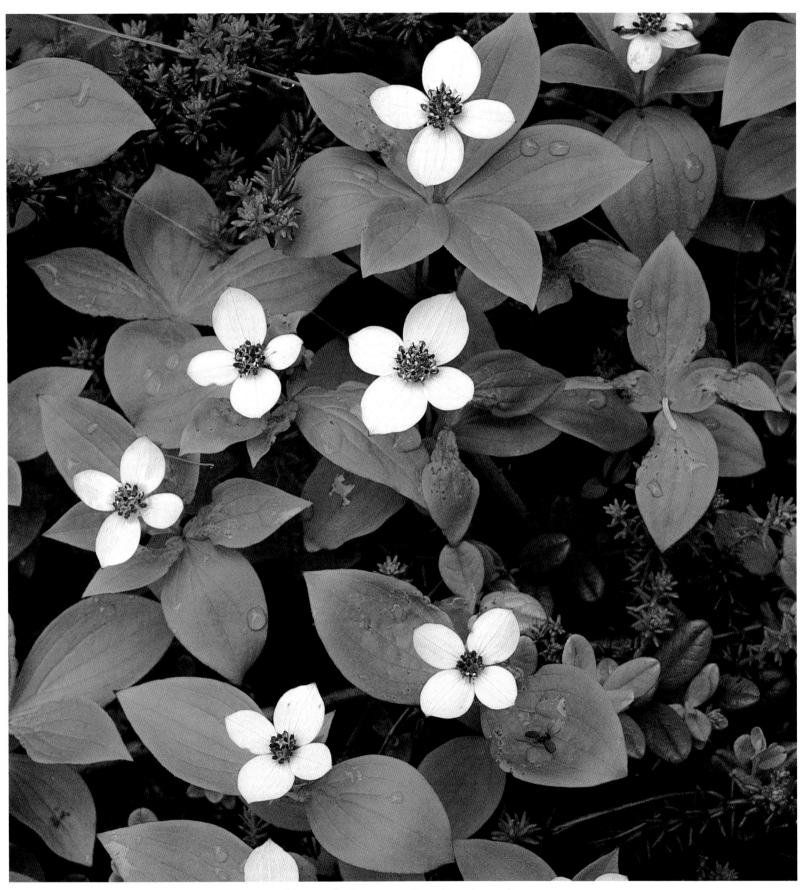

Bunchberry, also known as Canadian dogwood, carpets
the forest floor in Alaska's Lake Clark National Park.

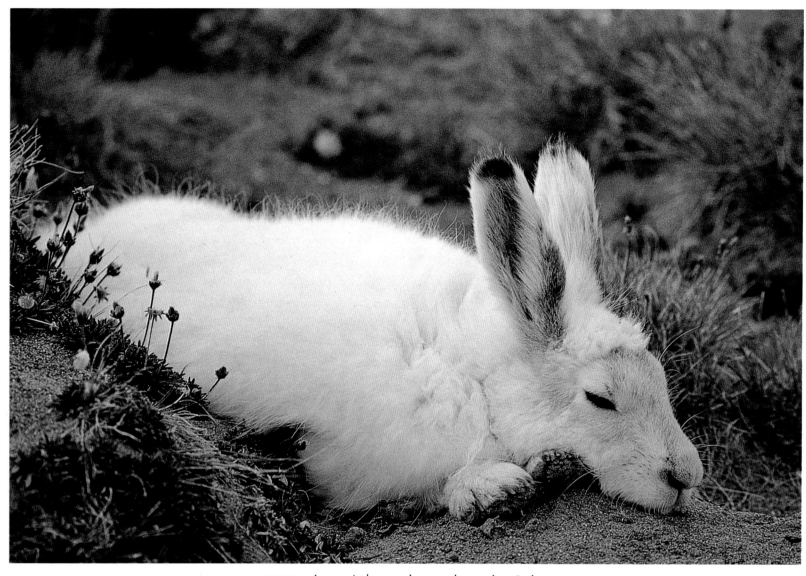

ABOVE: *An arctic hare, asleep on the tundra. It has
survived the winter by feeding on willow buds.*

RIGHT: *By summer's end, the antlers of a bull moose may
span six feet or more from tip to tip. Like antlers, the
dewlap of skin and hair dangling from the moose's throat
occurs only on males of the species.*

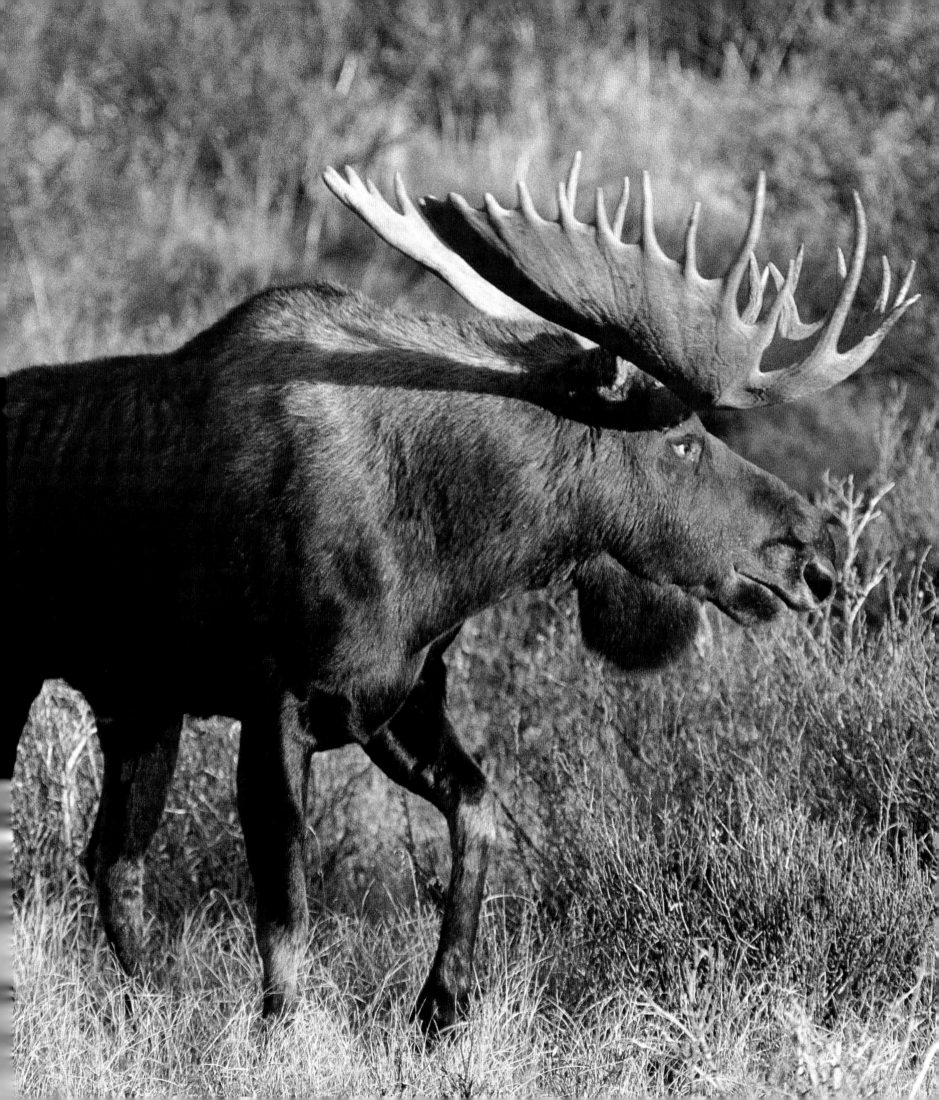

FALL

AUGUST 15

MERCY BAY — Summer is improbably brief here on the islands of Canada's High Arctic; the season is over so soon after it starts that it seems little more than a cruel tease. The sun is high and dazzling; bumblebees drone purposefully across hillsides bright with flowers; the caribou appear fat and happy; animals seem to be giving birth everywhere you look. And then one morning you wake to find the bay full of ice, three inches of fresh snow on the ground and the smell of winter heavy on the wind. Even though it's barely mid-August, that's exactly what has happened here at the camp another photographer, Fred Bruemmer, and I have made beside Mercy Bay, which squats atop a low bluff on the lonely north coast of Banks Island, overlooking M'Clure Strait.

The waters offshore bear the name of Captain Robert M'Clure, who in September 1851 steered his ship, HMS *Investigator* east along this coast while attempting simultaneously to discover the whereabouts of the missing Franklin expedition and to become the first man to sail the length of the Northwest Passage — the latter a noble, reckless quest that had already claimed the lives of hundreds of British seamen. The *Investigator* was in serious trouble as it approached Banks Island. With the onset of winter deadly pack ice had closed in around the wooden ship, threatening to crush its hull into matchsticks.

Immense, jagged ice floes, propelled by

With the first hard frosts of autumn, the leaves of the bearberry turn a remarkable shade of scarlet.

strong currents and wintry gales, pounded the ship. Below decks, thick oak timbers began to crack with a sound like gunshots. Doors sprang open. Frigid seawater poured into the bilge through widening gaps in the hull. Several times the sixty-six-man crew assembled on deck and prepared to abandon ship. "This is the end!" M'Clure wailed in despair at one point. "The ship is breaking up; in five minutes we will be sunk!"

Just as M'Clure and his men were ready to surrender hope, the ice miraculously drifted away from the ship. Not long after that the *Investigator* came upon a large, protected inlet here on the coast of Banks Island. M'Clure christened it the Bay of God's Mercy, dropped anchor, let his ship freeze fast and hunkered down to wait out the winter.

The crew survived that winter without serious incident, but the following summer was an unusually cold one, and the ice in the sheltered waters of Mercy Bay never melted. The ship stayed trapped in the ice, with no chance of escaping for at least another year. As the winter of 1852–53 closed in, most of the crew were suffering horribly from the effects of scurvy, and all were on the brink of starving. Several men began to go mad. Then, in April 1853, just as death for all looked imminent, a team of men on sledges — rescuers from HMS *Resolute* — appeared on the horizon like a mirage. When the sledge team reached the icebound *Investigator* and beheld the nearly fleshless bodies and tortured, grotesquely ulcerated faces of the survivors, a number of the rescuers were so affected they began to cry.

On this bitter morning more than a century later, as I feel the wind sting my face and watch the low pewter sky spit snow, I can't help thinking about the ghastly trials endured by M'Clure and his men here at Mercy Bay. What would I do if my radio broke, and the plane that's supposed to pick me up a week hence failed to arrive? Would I decide to make a desperate stand here, as M'Clure did, and hope for the eventual appearance of a rescue party? Or would I start trudging south through the drifts and try to reach a human settlement before my food ran out or my feet froze?

AUGUST 18

THOMSEN RIVER VALLEY — Yesterday Fred, the friend who has joined me here on Banks Island, and I moved our camp a short distance southwest of Mercy Bay into the broad, fertile valley of the Thomsen River. Last night I was just drifting off to sleep when I was pulled rudely back to consciousness by the animated yelling of Fred, whose tent was pitched a few feet behind mine. Slowly shaking off my grogginess, I heard him say something about an animal that had wandered into camp. Still only half-awake, I pictured a hungry polar bear right outside the tent, and I reached in a panic for the 12-gauge shotgun I customarily keep beside my sleeping bag when camping in bear country.

"Open the door very, very slowly," Fred was saying, speaking in a loud whisper now. With the gun in one hand, I unzipped the nylon exit with the other and was greeted not by the expected bear, but by a big bull musk-ox standing forty feet away with his head lowered, facing my tent and angrily pawing the ground.

Musk-oxen are fascinating creatures, among the strangest in all the Arctic. The Inuit know the musk-ox as *oomingmaq*, the bearded one, and prize the wool of its thick undercoat, which is softer than cashmere and eight times warmer (by weight) than sheep's wool. The animals' demeanor is inscrutable,

mysterious, almost primordial. Their bizarre, helmet-like horns and the shaggy fur that hangs off their flanks and shoulders like a dark, glossy hula skirt make *Ovibos moschatus* look a little like a cross between the woolly mammoth and the cape buffalo. In a sense, musk-oxen have stepped directly out of the Pleistocene: zoologists believe they once walked the earth with such long-departed prehistoric beasts as the saber-toothed tiger and the North American camel, and have changed very little if at all since the days of the first Ice Age.

I suppose I shouldn't have been so surprised to find a musk-ox in camp. Fred and I had spent the day just a few miles away, after all, observing and photographing a herd of forty animals grazing tranquilly among sandhill cranes, pawing through the snow to feed on the valley's lush sedges. It was a spellbinding sight.

The first time I approached them, I startled the herd, sending them into the defensive huddle for which the species is so well known. Facing outward, the musk-oxen backed into a tight, impenetrable ring, presenting a circle of menacing horns and nervous hooves that would have deterred any

number of wolves or bears. Eventually, convinced I wasn't a serious threat, the animals broke the circle, galloped a short distance away in a tight, flank-to-flank pack and returned to their foraging.

August is the peak of the rutting season. Throughout the day I had seen lone bulls roaming the tundra, intent on challenging other bulls for access to harems. Sometimes these challenges would be benign, all bluff and bellowing; other times a confrontation would lead to a charge between two animals that culminated in a full-speed, cataclysmic, head-to-head collision.

As I peered nervously out of my tent last night, I was more than a little concerned that the bull pawing the ground nearby, apparently mistaking my shelter for a rival in love, had just such a charge in mind. In addition to the pawing and snorting, he kept rubbing the musk glands on his cheeks against the inside of his forelegs. This action spread the oily musk all over his head, turning his fur into a mass of dripping dreadlocks, and giving the animal an especially sinister countenance: this dude looked *mad*.

I had no idea what to do. I aimed the shotgun at the bull, but I was very reluctant

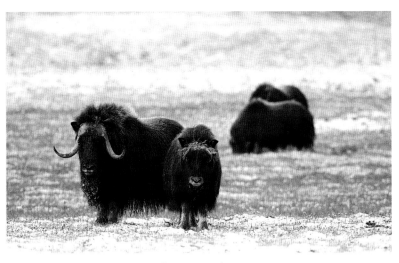

Musk-oxen and young

111

to fire. I didn't want to kill him, and I doubted, in any case, that the blast would halt the sturdy beast's momentum before he slammed into my tent.

"What should I do, Fred?" I whispered.

"Heck if I know!" he replied with what sounded suspiciously like a chuckle, his position safely behind mine apparently allowing him to see in the predicament a humor that escaped me altogether.

As it happened, our voices seemed to confuse the musk-ox. As we talked, he stopped pawing the ground and began gradually to turn sideways to the tent, like a tom-cat trying to save face while backing away from a cat fight. Once the bull was fully sideways, he inched out of camp, warily eyeing our tents all the while, until he was maybe eighty feet away, at which point he broke into a full gallop and bolted off toward the river. My heart still in my throat, I watched him run at top speed for many minutes until he finally became a tiny speck and vanished against a hillside in the dusk, miles distant.

AUGUST 20

ROUND ISLAND — Stretched out on my belly in my sleeping bag, I sip sweet, muddy coffee and gaze out the tent door into the morning fog, letting my thoughts float with the wind. I'm camped on Round Island, an extinct volcano that rises from the storm-ravaged waters of the Bering Sea. Were the weather good—an infrequent event in these parts—I would be able to see the low hills of Alaska's Nushagak Peninsula off to the east, across twenty miles of slate-green ocean; as it is, all I see is gray.

The island is a small, sharply sculpted lump of basalt and volcanic tuff, totally devoid of trees, but it's no desert: on the contrary, the land is lush, verdant, teeming with life. The shrill cries of kittiwakes fill the sky, the cliffs are crowded with murres and puffins. The day before yesterday I watched transfixed as a self-assured red fox stalked an unsuspecting mouse and turned it into a meal. All around me, knee-deep grasses—peppered liberally with blooms of lupine, for-get-me-nots, poppies and wild geraniums—ripple across the hillsides. My tent is pitched high on a ridge crest, 200 dizzying feet directly above the beach. A dramatic little place, the setting is stark and brooding: the landscape could be straight from the pages of *The Lord of the Rings*. At any minute I expect to see a hobbit scurry by through the mists.

The fog is so thick that the ocean is hidden, but I can taste salt in the wind and hear the surf pounding the shore. And between the crashing waves, almost as loud, I can hear a chorus of snorts and bellows and belches. The source of this bizarre madrigal is an army of creatures considerably stranger than any hobbit: 3,000 pinkish, ivory-tusked, 2,500-pound pinnipeds. The beach below is a wall-to-wall carpet of walruses—and every single one of them is male, as are all 9,000 of the other walruses currently on the island. They assemble here not to mate or to raise young or to joust for the control of harems. The biological imperative behind the summer-long bachelor party on Round Island has thus far eluded scientists. In the words of one marine biologist who has been here to study the beasts, "The guys just seem to enjoy each other's company."

The gals, at the moment, are loitering on ice floes far to the north, up toward the Bering Strait and beyond. In October the males will make their way north to join the females, mate and spend the winter in the ladies' company along the southern margin of the pack ice. In dunning cold and darkness, the bulls will fight savagely among themselves,

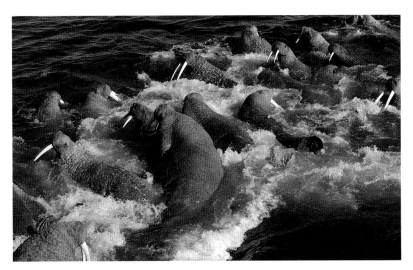

Walruses

sometimes to the death, over territory and reproductive partners. Come the following June, however, the boys will return to Round Island and again spend the summer snuggling cheek-by-blubbery-jowl on the beach, the best of chums, the winter's bloody quarrels apparently forgotten. The Arctic has never lacked for enigmas.

Toward noon, the sky suddenly begins to brighten. The sea fog evaporates without warning, revealing a luminous blue sky. In a matter of minutes the tenor of the day has been transformed. Summer is here, if only for a few moments. I decide to use the opportunity to visit the boys on the beach.

It takes a half-hour to scramble down from my ridge to the shore with my cameras. Once there, I am nearly knocked flat by the smell. The fishy, fecund odor is overpowering; it's all I can do not to gag. If the smell bothers the walruses, however, they're not letting on. Smeared with yellow-orange feces, they lie motionless on their backs, tusks skyward, basking happily in the radiant warmth of the sun. Every inch of beach from the foot of the cliff to the water's edge is covered with walruses. Now and then a muffled grunt will sound, and a head will pop up for air from

beneath the pile, sending up dense clouds of flies and initiating a minor commotion. A minute or two of raucous bellowing and tusk-jabbing follows as the pile rearranges itself, then a somnolent calm again settles on the congregation.

AUGUST 22

ROUND ISLAND — Against all odds, another lovely summer afternoon has descended on Round Island, so I'm back down at the water's edge, fraternizing with pinnipeds. The entire beach is again taken up by the walruses' blimp-like forms. Now and then a patch of flat rock or gravel will open up as a walrus enters the sea to feed, and whenever that happens, another walrus quickly emerges from the drink, undulates clumsily up from the shore in the manner of a poorly coordinated and grossly obese inchworm, and loudly claims the vacated turf.

Interestingly, when a walrus first comes ashore, the customary reddish hue is absent from its skin. Instead, the hide is a pale, milky white—very similar to the color of human skin afflicted with "dishpan hands." This paleness of the walruses' complexion reveals one of the physiological tricks this

pinniped employs to stay warm in the frigid arctic seas. In cold water, the blood vessels in walruses' blubber, flippers and skin restrict, severely reducing the flow of blood to the periphery of the body, thereby conserving heat. Once the animal is back on land, these surface blood vessels dilate, the blood flow resumes and color slowly comes back to the skin. Over the course of an hour I watch a recent arrival to the beach turn gradually from the color of a cocktail onion to the shade of weathered brick.

Just offshore scores of animals bob vertically in the waves, patiently biding their time until real estate on the beach opens up. While they wait, some of the waterborne walruses emit unearthly, surprisingly mellifluous songs that resonate over the water like distant church bells. Others sleep as they bob, suspended by basketball-size pharyngeal pouches inflated for buoyancy.

On land the walruses appear awkward, comical, profoundly inept. Once submerged, though, their clumsiness is transformed into an economical, dolphin-like grace. Walruses, in fact, are amazing swimmers. Traveling in small groups, they regularly leave Round Island to spend eight to ten days at sea, journeying 150 miles or more at a stretch in search of food. Their diet consists primarily of clams and crabs, in quest of which the walrus will dive as deep as 250 feet, and stay submerged for as long as ten minutes.

Not all walruses prefer to dine on shellfish, however. Approximately one out of every thousand animals will develop a fondness for meat, and deliberately hunt and kill seals. The native Inupiat people who inhabit the northwest coast of Alaska have a name for these rogue bulls, *angeyeghaq*, and they fear them as much as they fear polar bears. For in the eyes of a carnivorous walrus, a man is as tasty as a seal and usually a lot easier to catch. *Angeyeghaq* will not hesitate to charge a man standing on an ice floe, or to attack a small boat. A favorite *angeyeghaq* trick, an old Inupiat man named Herbie Nayokpuk once warned me, is to surface suddenly beside a boat, hook its tusks over the gunwales and capsize the vessel, dumping its hapless passengers into the freezing sea. It's a simple matter, at that point, for the walrus to wrap his massive front flippers around his victims, crush them and rip their bodies into bite-size pieces with his tusks.

Mr. Nayokpuk went on to tell me that it is easy to distinguish an *angeyeghaq* from his harmless, bivalve-eating brethren: a rogue bull's tusks will be stained dark yellow from seal blubber, and be covered with deep scratches inflicted by seals in their death throes. If you spot such a walrus, the old man cautioned, flee for your life. His words flashed into my mind as I surveyed the herd of behemoths, most of them bigger than Volkswagens, sprawled odoriferously across the rocks a few yards away. Hundreds of pairs of long canine daggers, slender and sharp, sprouted from the great beasts in front of me; my eyes darted from set to set, anxiously scanning for amber stains and crosshatches. For the length of the beach, however, I could see nothing but flawless white ivory, smooth and unblemished, gleaming peaceably in the summer sun. Beneath these tusks their owners snored on, dreaming whatever it is that contented walruses dream.

SEPTEMBER 10

ADAK — The Aleutian Archipelago — a 1,100-mile necklace of volcanic islands stretching in a graceful curve from the Alaska Peninsula to just short of the Siberian shore — has worn many different names over the years. The Russian fur traders who first discovered the

chain in 1742 christened it the Katerina Archipelago, in honor of their lusty, hot-tempered head of state, Catherine the Great. More recently, the islands have appeared on maps under the name Aleoutiennes, or Fox Islands, or Billy Mitchell Islands. Most modern Alaskans call the Aleutians simply the Chain, as in, "Joe Bob headed out to the Chain last October to work on a crab boat, came back in December with $90,000 in the back pocket of his jeans. By April Fool's Day it was gone, every last nickel; all the poor guy had to show for it was a pair of lizard-skin cowboy boots, a wrecked BMW and one real nasty hangover." Seems as if you hear that same story, with different names and subtle variations on the theme, with uncanny frequency in Alaska.

This bit of trivia about the Aleutians comes to mind because that's where I happen to be right now—more specifically I'm on Adak, an island roughly halfway out the Chain.

At the moment I'm sitting in the officers' quarters of the U.S. Navy base that's serving as my home for a week while I photograph bald eagles. Actually, I've been here two days now and have yet to photograph a single eagle, bald or otherwise; mostly I've been sitting at this table, staring out the window, watching fat, gale-driven raindrops strike the glass and trickle slowly down the panes.

It's an extremely popular pastime here on Adak. The glazed, zombie-like expression that typically comes over people's faces while they're engaged in this stimulating activity has come to be known across the Arctic as the Aleutian Stare.

This stare is so prevalent in these parts because the archipelago has the worst weather in the world, bar none. Many places, of course, claim to have the worst weather in the world, but no less an authority than the U.S. Coast and Geodetic Survey's *Coast Pilot* —a publication renowned for its meticulous, conservative rendering of the facts— cites the Aleutians as the rightful holder of the title.

Rain falls on Adak some 265 days out of every year, and most of the rainless days are characterized by a pea-soup fog that rolls in

Adak Island

from the ocean like a thick, suffocating blanket. The Chain as a whole, in an average year, sees just eight days of sun.

Which reminds me of a couple of other nicknames the Aleutians sometimes go by: Cradle of the Winds and Birthplace of the Storms. Both are apt. The Chain forms a porous border between the frigid waters of the Bering Sea and the relatively warm currents of the Pacific Ocean. The abrupt confluence of these two bodies of water—and the disparate air masses above them—gives birth to a series of low-pressure cells that go spinning across the Gulf of Alaska like huge, malevolent Frisbees. These notorious Aleutian Lows churn the ocean to a froth and send giant swells surging toward the Hawaiian Islands, creating the world-famous twenty-five-foot breakers that challenge surfers at Waimea, Makaha and the Banzai Pipeline. As the storm systems spawned over the Chain are pushed to the southeast by the jet stream, they bring rain to Vancouver and Seattle, cause heavy snow to fall from northern Alberta to New Mexico and ultimately determine the winter weather across much of the North American continent.

As one might imagine, before the newborn storm systems depart for the mainland, the Aleutian low-pressure cells stick around long enough to make their presence felt on the Chain itself—with a vengeance. It's a rare day on the islands when the wind isn't blowing at least twenty miles per hour, and it's not uncommon for the breeze to whistle through at 100 miles per hour or more. In October 1977 the wind was pegged at 120 miles per hour, fifty-foot waves pounded the beaches and barometers at Adak dropped to 27.35 inches of mercury, the lowest barometric pressure ever recorded anywhere on the face of the earth.

The rough seas and inhospitable weather have kept the archipelago sparsely populated. Of the 279 islands that make up the Chain, only eight or nine have human settlements—the most remote villages in the United States. The same conditions that have kept people away, however, have attracted birds to the Aleutians by the bushel. Five million murres, puffins, auklets, kittiwakes, sanderlings, fulmars and petrels—one-quarter of all the breeding seabirds in Alaska—nest along the Chain's craggy volcanic shores.

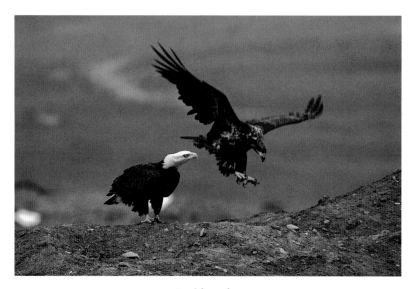

Bald eagles

116

There used to be even more birds on the Aleutians—many, many more. Despite the scarcity of humans, the alarming recent decline of avian species can be attributed directly to—big surprise—the actions of *Homo sapiens*. The demise of the birds provides a lesson in how easy it is to upset the delicate ecological balance of an island—any island, whether it is Arctic, equatorial or somewhere in between.

For millennia, birds evolved on the Aleutian Islands without having to fret about land-based predators. This situation changed abruptly in the eighteenth century with the arrival of the Russian otter hunters, who inadvertently carried Asian rats to the Chain in the holds of their ships. Since there are virtually no trees in the Aleutians, a great many birds nest on open ground or in burrows; to the rats, the eggs and hatchlings in these unprotected nests were like a limitless free lunch. The beady-eyed rodents proliferated and swarmed over the islands, eradicating entire colonies of seabirds.

The arrival of the rats was inconsequential, though, compared with the introduction of the foxes. In the early twentieth century, it seems, some enterprising sourdoughs decided they could get rich by turning the islands of the archipelago into teeming fox colonies; the foxes, they surmised correctly, would thrive on a diet of defenseless seabirds, and after multiplying could be trapped for their pelts. By World War II mating pairs of red, blue and arctic foxes had been dropped off on almost every island in the Aleutians. In the end, the fox-farming scheme proved to be only marginally profitable for the farmers, and absolutely disastrous for the birds.

Not all the birds on the Chain have suffered from the presence of humans, however. The eagles of Adak are a case in point. Approximately 2,000 people live at the Navy base on Adak. They are fed three hearty meals a day, and lots of leftovers wind up in the trash. As a consequence, the local dump offers a smorgasbord of delicacies the island's population of bald eagles finds irresistible. These stately raptors, proud symbols of all things American, flock to the Adak dump like flies to honey. Such a large number of eagles makes for spectacular photographs. Or, rather, *would* make for spectacular photographs, if the rain would only stop long enough for me to take my cameras out.

SEPTEMBER 11

ADAK – The surrounding ocean acts like an immense, highly efficient thermostat, so the weather over the Chain, bad as it is, never gets very cold; even in winter the temperature seldom drops much below 30°F. To tell the truth, I wish it *were* colder here. I love those dry, crisp, twenty-below days when crystals of powder snow glint in the sun, and you can feel the bite of winter in your nose hairs. What gives me trouble is this kind of weather, this Aleutian weather: the low, steel-gray skies; that hellish wind that drives the rain right through your clothes. The worst thing about this climate is that it can keep you indoors for days at a stretch, and I'm not at my best when there's a roof over my head. It saps my spirit, turns me sullen and ornery, makes me feel like a prisoner. It makes me want to crawl under the covers and stay there until the sun comes out.

SEPTEMBER 12

ADAK – The sun still isn't shining. Since no rain happens to be falling at the moment, though, I've decided to walk the hills. With each step I feel the depression of the preceding days evaporate. Muscular black clouds scud across the sky like stampeding buffalo. The chest-high grass on the surrounding

hillsides ripples in the wind like waves on a bright-green sea. The mountainous landscape, barren of trees, looks naked, raw, freshly created. Which, in relative terms, is precisely what it is.

All the islands of the Aleutian Chain are the peaks of submarine volcanoes, and forty-six of them are still active. Lava periodically spews violently forth from one or another corner of the Chain, creating earth where formerly there was none. Just east of Adak, in fact, the snout of a volcano emerged from the waves recently enough to be remembered by living Aleuts. The Aleuts—the native people who first settled the Chain—named the new island Kasatochi, which translates, "That wasn't there yesterday." With so few people around, not many Aleutian eruptions are witnessed by human eyes, and the lives of islanders are seldom threatened. On April 1, 1946, however, an earthquake that registered 7.4 on the Richter scale rocked the eastern end of the archipelago, generating a 100-foot tsunami that obliterated a lighthouse on Unimak Island, killing the five Coast Guardsmen stationed there. The great wave then went rocketing off across the Pacific at 500 miles per hour; when it crashed onto the north shore of the Hawaiian Islands, it killed 159 people, injured 163 others and destroyed property to the tune of $25 million.

It is sobering to contemplate the geothermal pressure-cooker roiling a few miles beneath my boot soles, but on this particular morning there's not a whole lot of shakin' goin' on. The drama today comes from above rather than below. The sky is a swirling kaleidoscope of mist and light. Dark, ominous puffs of water vapor race from horizon to horizon. Gaps between the clouds open briefly and then close, unleashing shafts of brilliant sunlight that momentarily pierce the gloom. Without warning, a tongue of dense fog appears over the crest of a nearby ridge and slithers quickly, noiselessly down the slope above. Before I can say "Yo!" the ground-hugging white serpent has swallowed me whole, engulfing me in billows of weightless cotton. Within seconds I am dripping wet. A minute later the cloud is gone, headed out to sea, leaving a smile on my lips and my eyebrows bathed in dew.

I round a rocky shoulder and find myself looking down at the mouth of a wide, shallow creek. Even from this distance I can see the shadowy forms of salmon—thousands of them—holding nearly motionless against the fast current, pausing on their way upstream to spawn and die. A number of these fish are likely to meet their end before they spawn rather than after, for the air above the creek is thick with bald eagles that have temporarily abandoned the rich offerings of the town dump for the opportunity to dine on fresh *saumon du jour*.

While I watch, a juvenile eagle—still gangly and mottled brown, without the stately white head that distinguishes the adult birds—breaks formation, swoops down to the creek and plunges its talons into the back of a fish. A moment of truth follows, because it can be difficult or even impossible for an eagle to release a fish once its talons are firmly planted; if the salmon in question proves too heavy to lift—and certain species of Pacific salmon can weigh fifty pounds or more—the eagle may have a serious problem. Furiously pumping its wings to lift the still-flopping fish out of the stream, after four or five seconds this eagle manages to labor back into the air, then flies off, out of sight, with dinner.

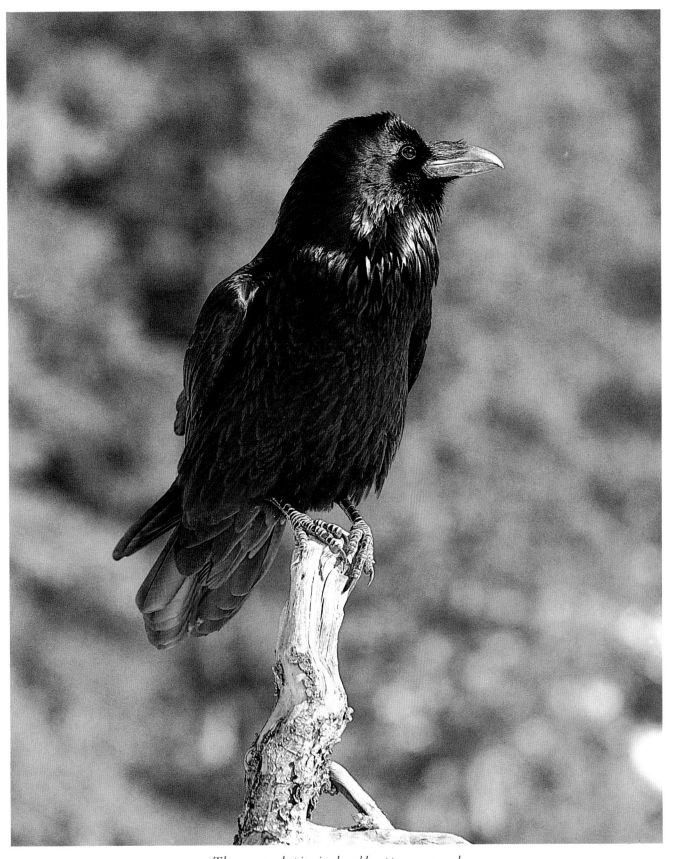

The raven, despite its humble appearance and undistinguished plumage, is revered for its cunning and resourcefulness in the mythology of all native northern peoples.

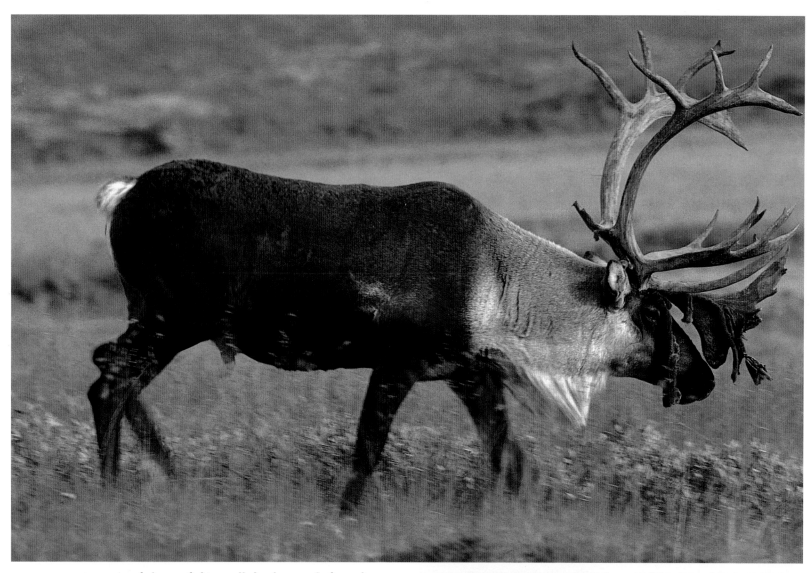

ABOVE: *A soft layer of skin, called velvet, peels from the antlers of a bull caribou in early fall, revealing bare, bone-like tissue that is pink with blood.*

RIGHT: *A pika labors to haul a large load of leaves back to its "haystack" in preparation for the long winter ahead. Although pikas look somewhat like lemmings, they are actually much more closely related to rabbits and hares.*

OPPOSITE: *A mother barren ground grizzly and her cub forage for berries and roots on the tundra. By late autumn the bears wear a thick layer of subcutaneous fat to tide them through until spring.*

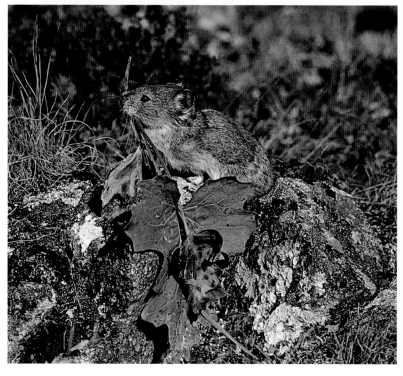

FOLLOWING PAGES: *The snow-plastered ramparts of the Kluane Mountains loom above a lowland stand of black spruce and aspen. Soon the low country will be buried in snow as well.*

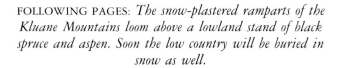

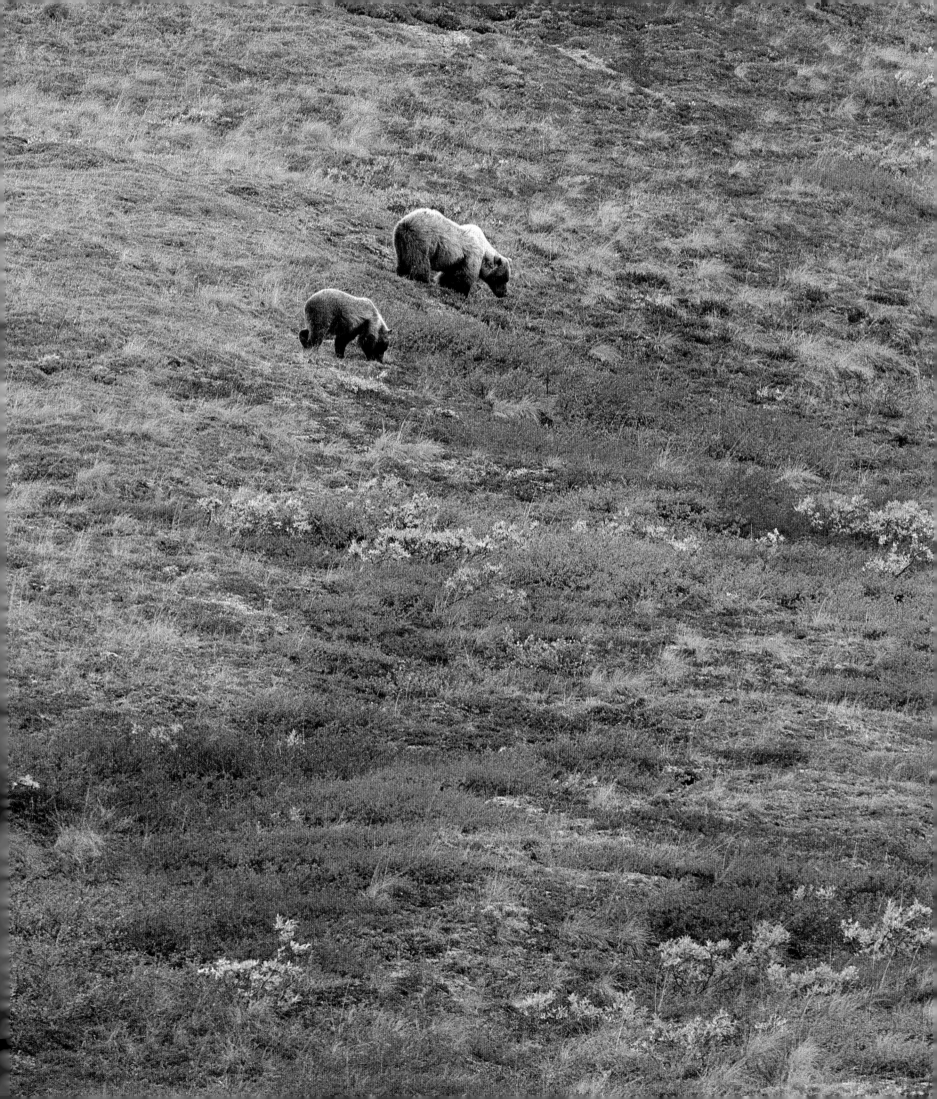

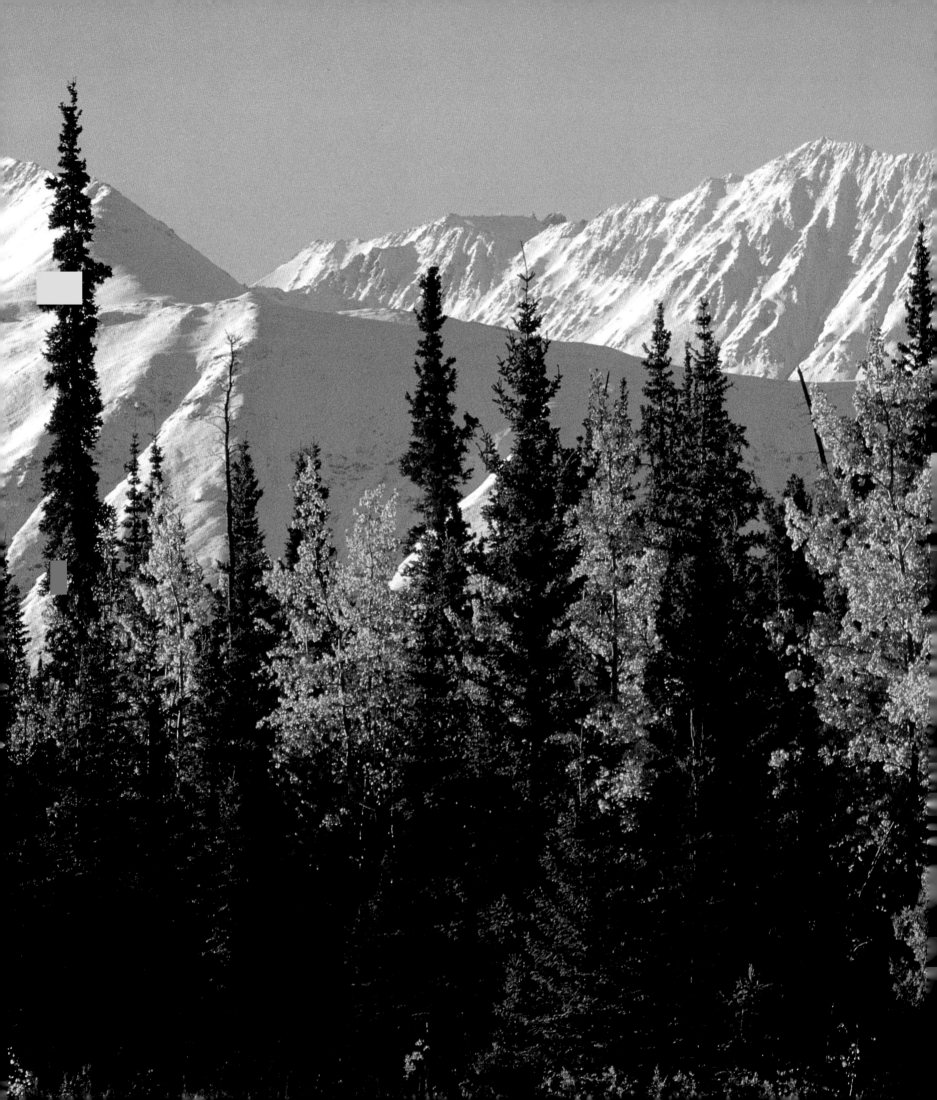

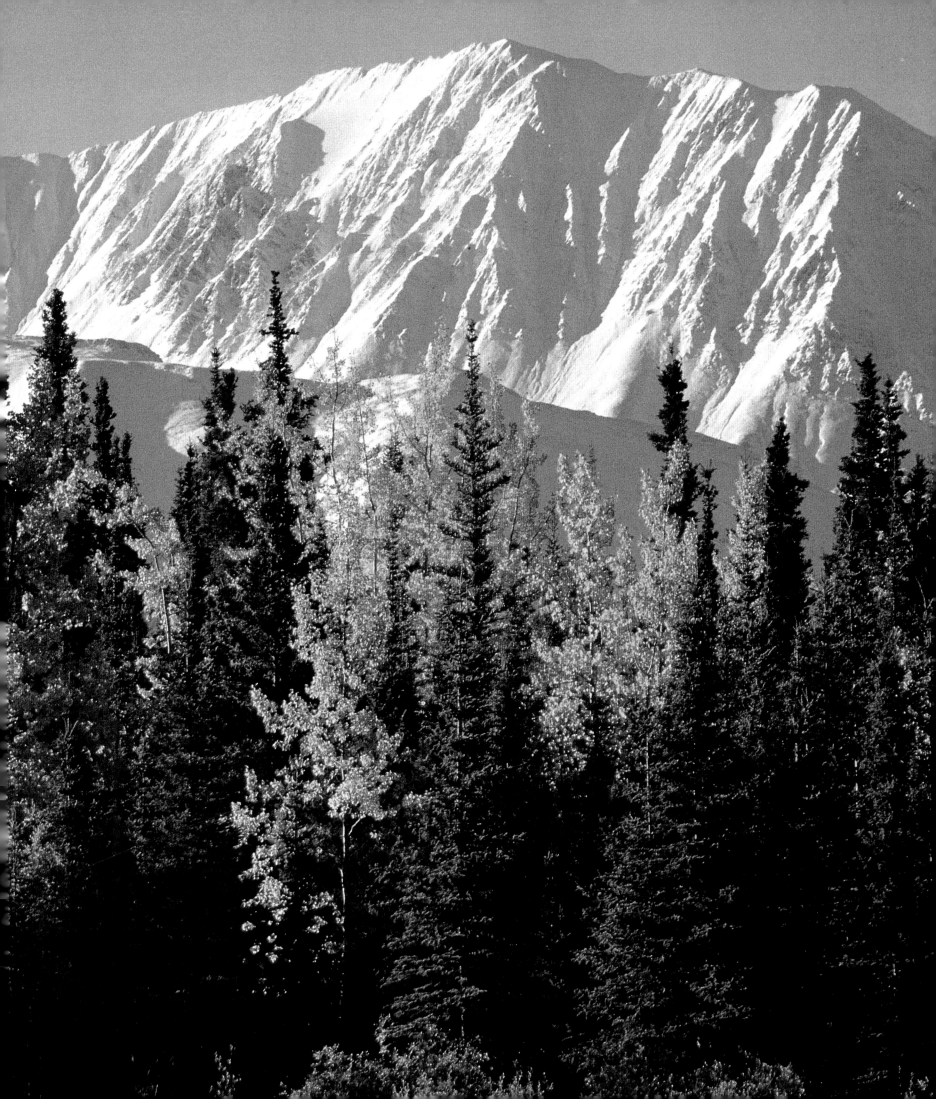

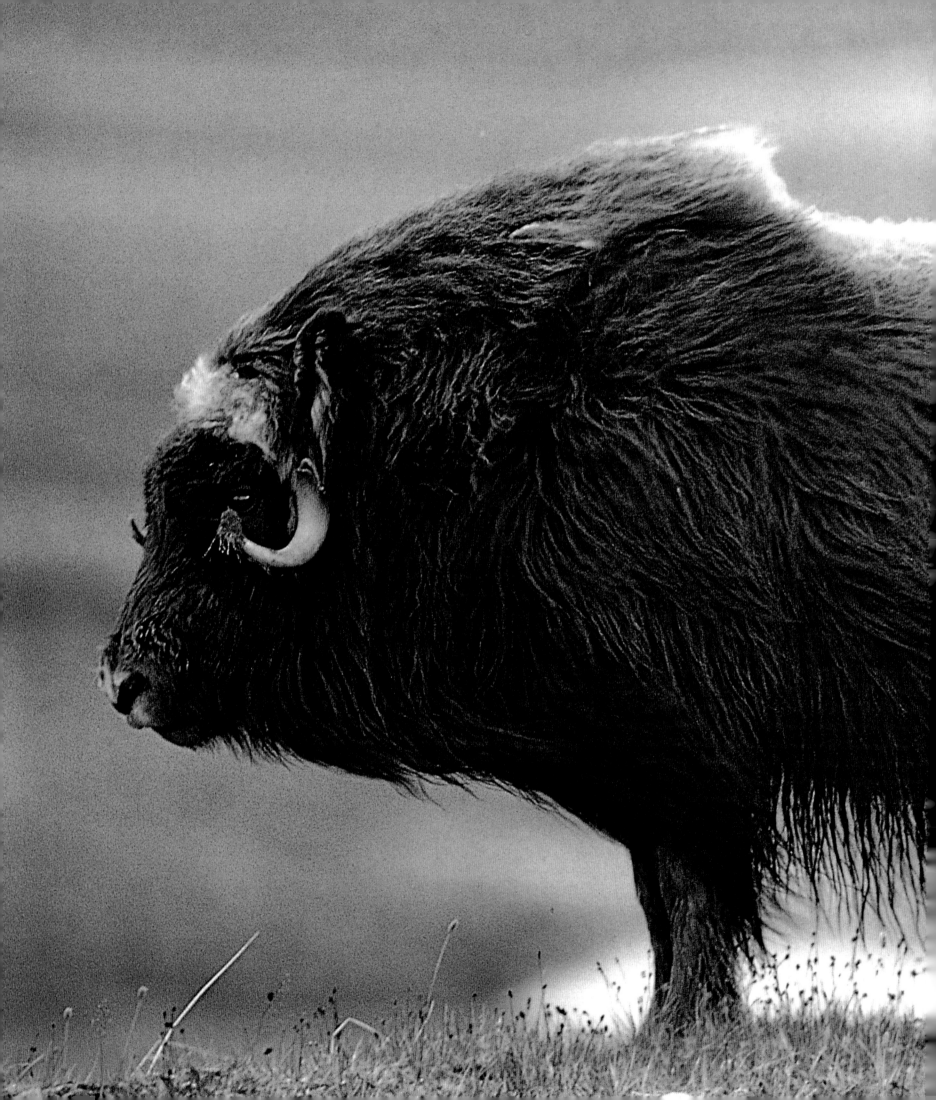

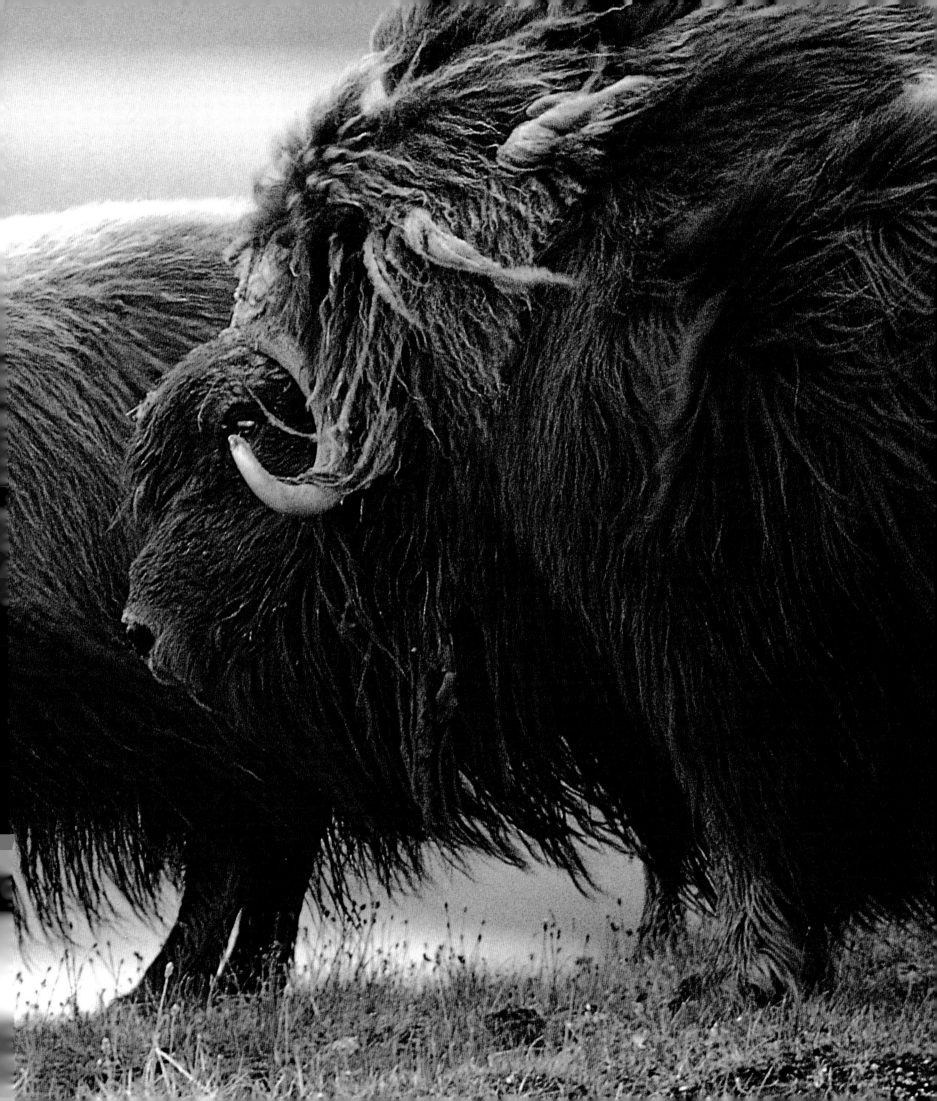

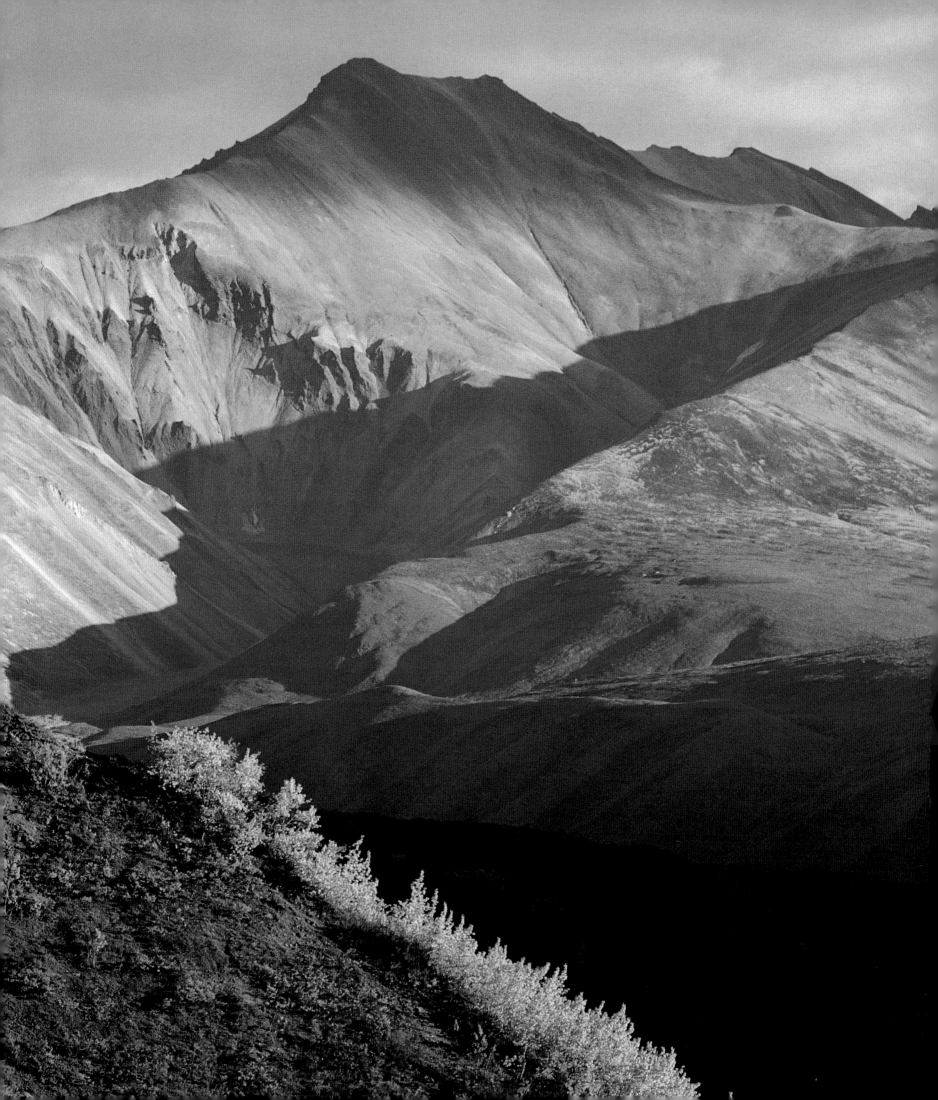

ABOVE: *A dead spruce tree, probably killed when a porcupine stripped it of its bark, stands sentinel in the scrubby forests of Alaska's Lake Clark National Park, just west of Cook Inlet.*

FOLLOWING PAGES: *Dark clouds descend ominously upon the Ogilvie Mountains in the western Yukon Territory, obscuring their upper slopes. In the fall, such storms can come up very quickly, bringing heavy snow and blinding whiteouts.*

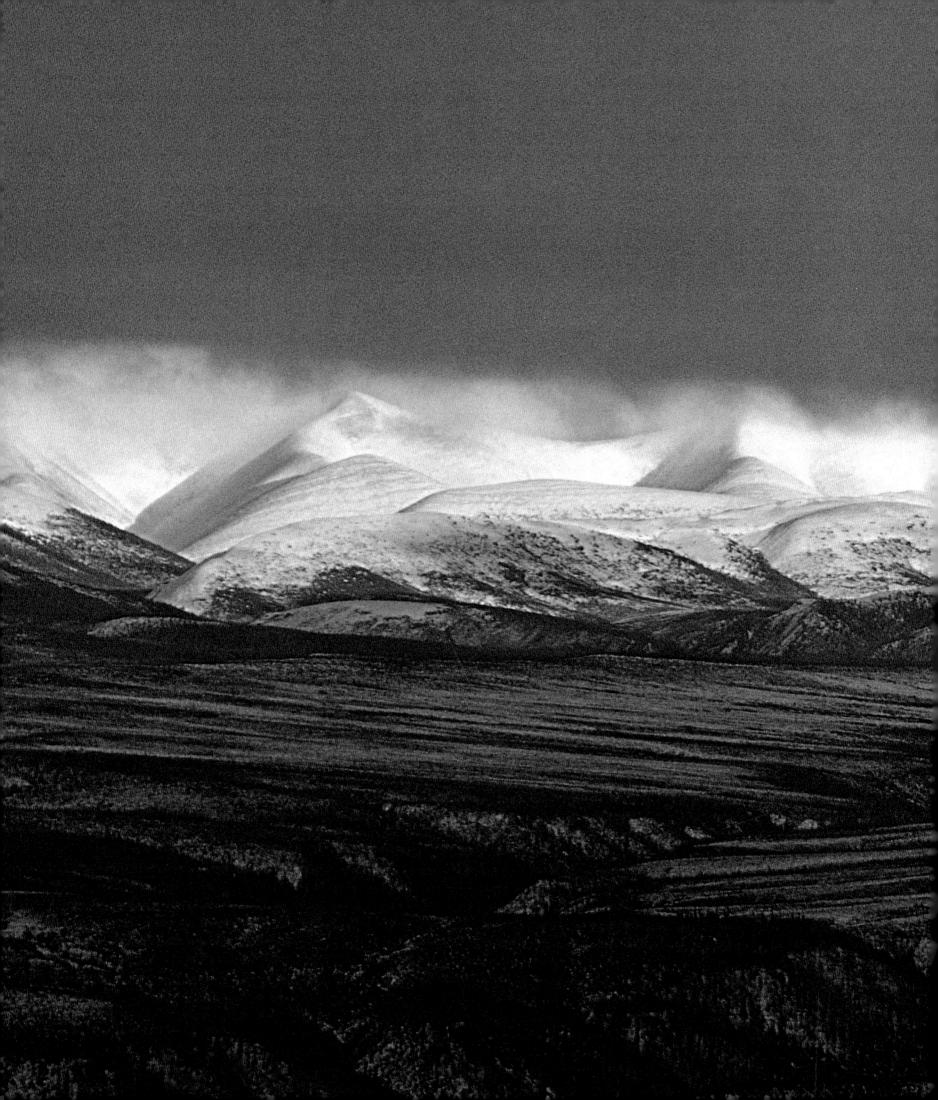

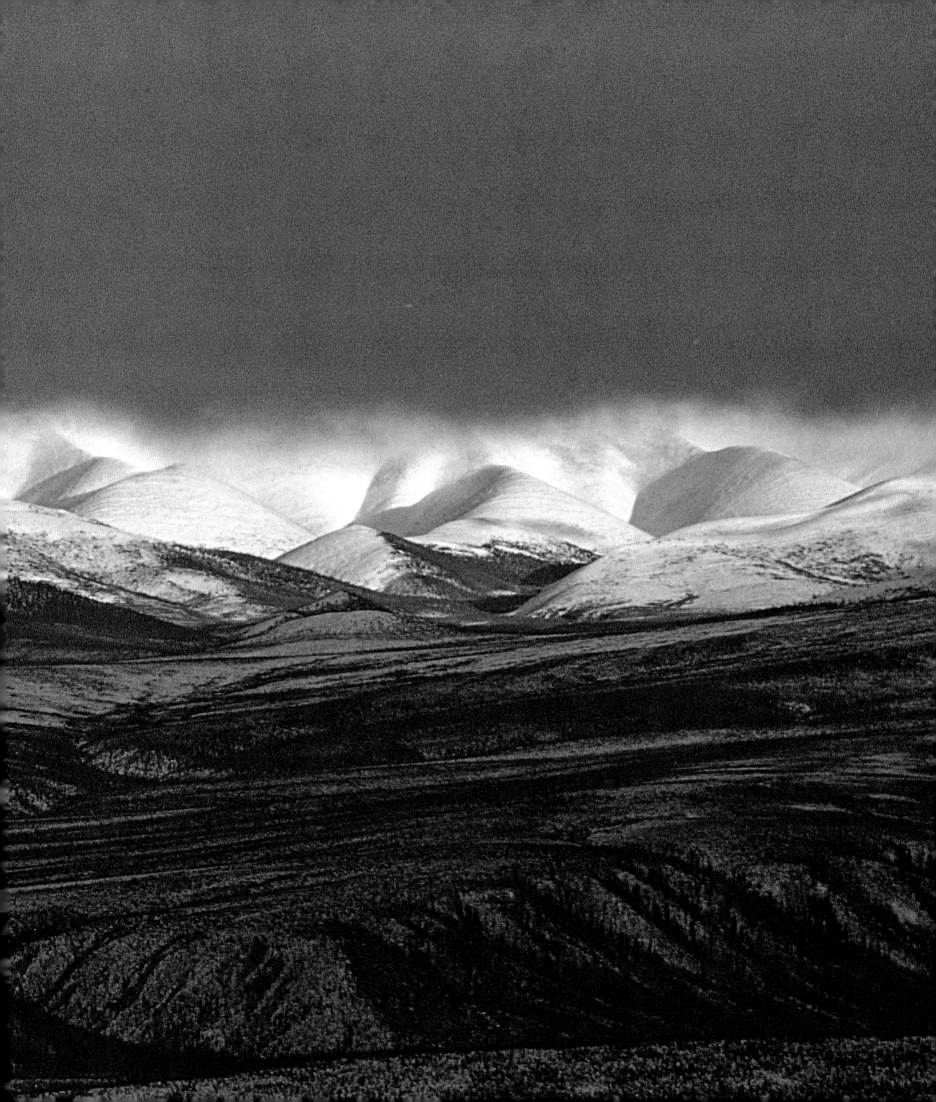

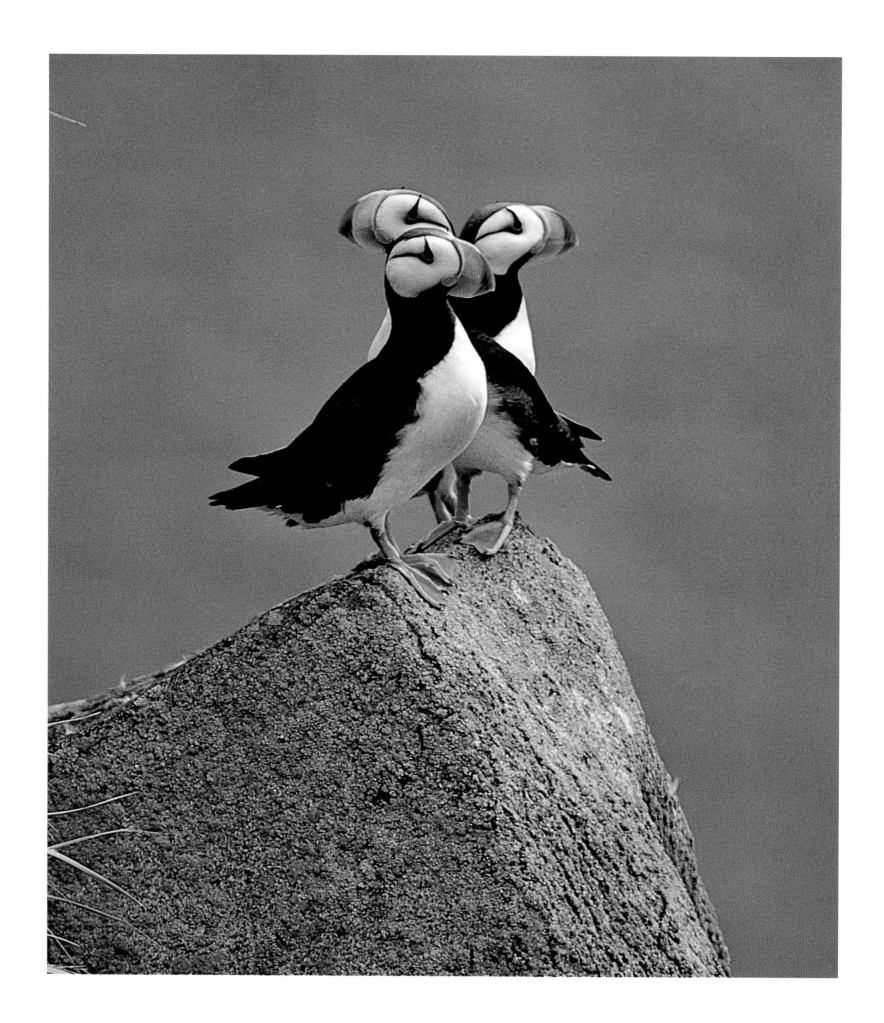

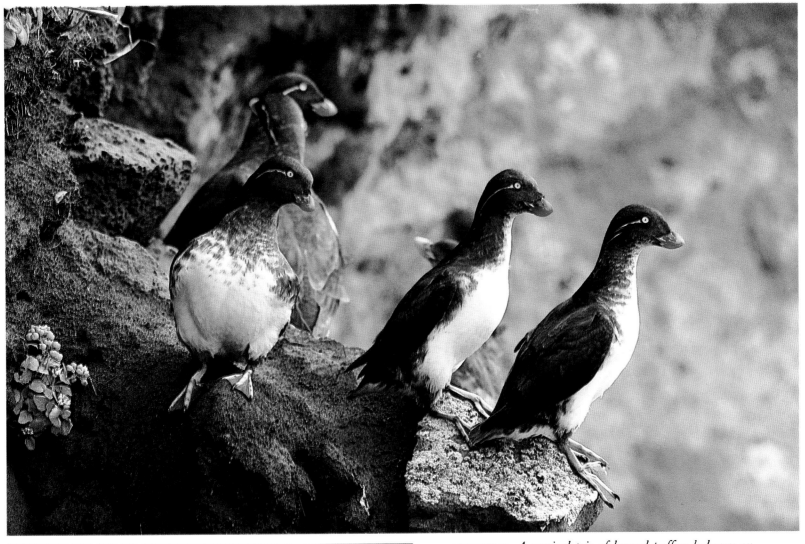

OPPOSITE: *A comical trio of horned puffins balances on a granite boulder. Part of a teeming puffin colony, they live in earthen burrows dug into the side of a nearby bluff.*

ABOVE: *Like puffins and crested auklets, parakeet auklets are members of the alcid family. Superb swimmers, they spend long periods far offshore, and use their wings to "fly" swiftly underwater in pursuit of small fish.*

LEFT: *Crested auklets are distinguished by their rakish head feathers. They build their nests under rocks like these, frequently in the company of parakeet auklets.*

FOLLOWING PAGES: *On Banks Island, sapphire-colored ice floes drift in and out of Mercy Bay like waterborne phantoms, sometimes beaching themselves in the shallows when the wind shifts.*

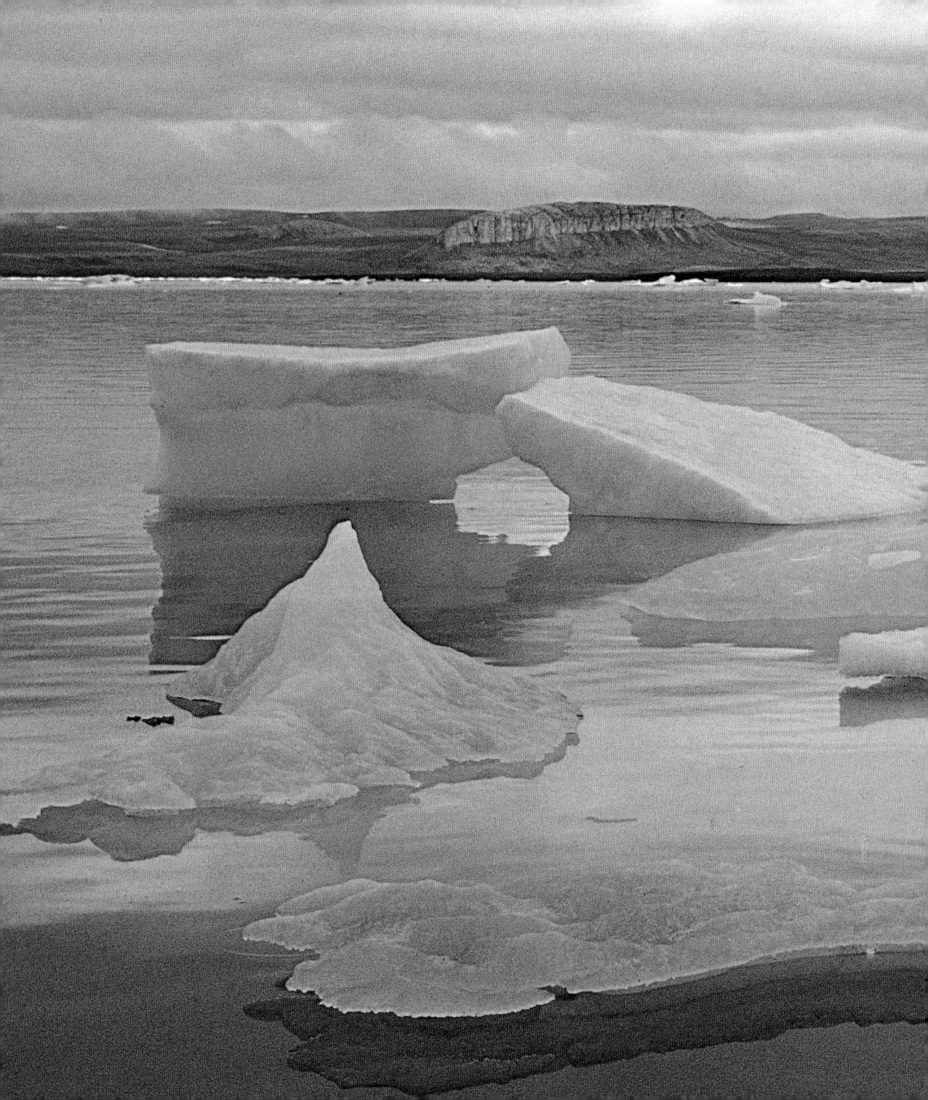

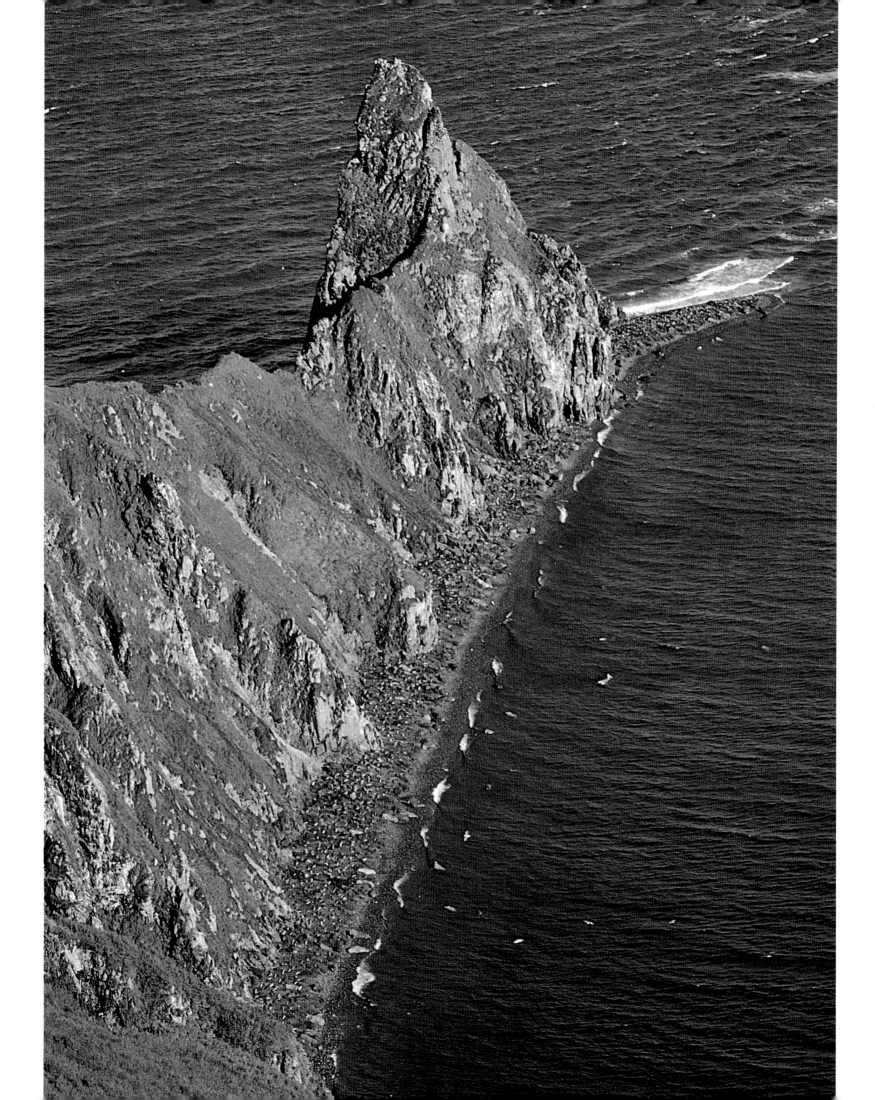

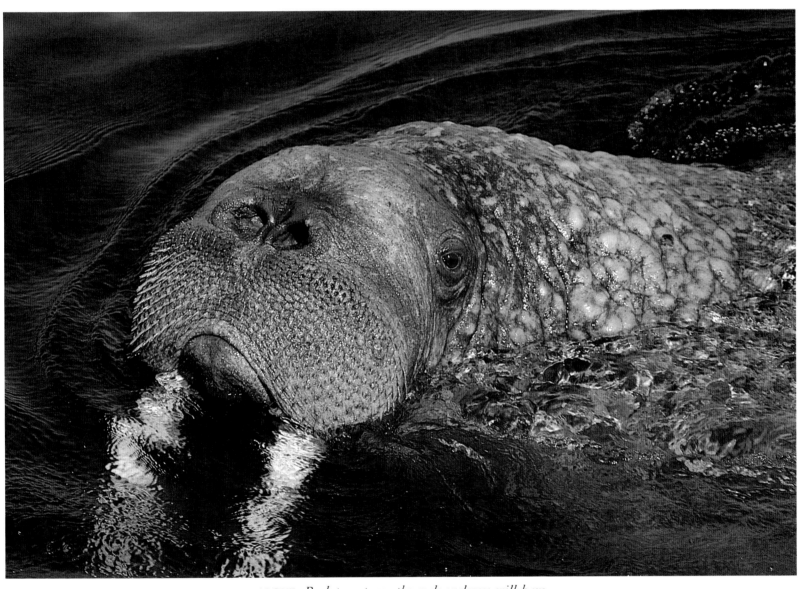

ABOVE: *By late autumn the male walruses will have embarked for points north, to join their mates along the edge of the winter icepack.*

LEFT: *Basking in the sun, thousands of male walruses cover every square foot of beach on the rugged northwest tip of Round Island.*

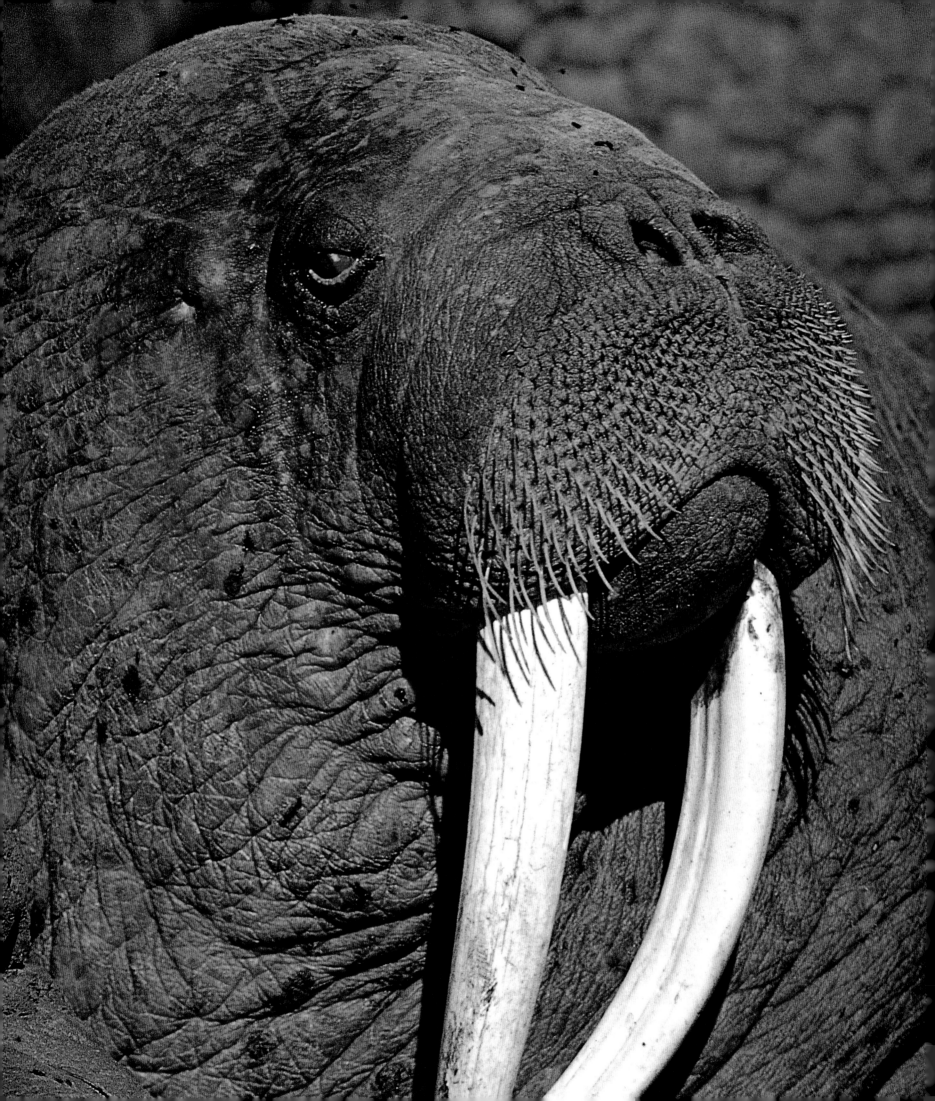

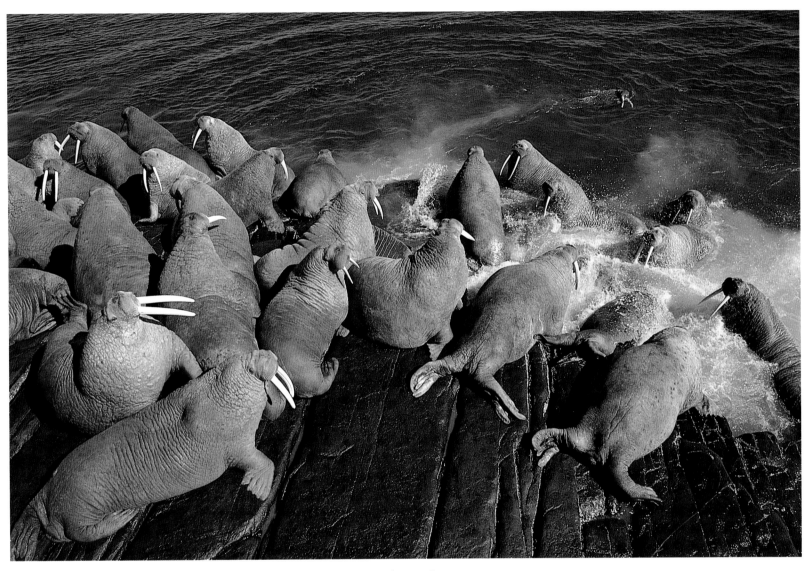

ABOVE AND LEFT: *Walrus tusks serve many purposes. Walruses use them as weapons, as symbols of rank in the community, and, when the sea is frozen, to chop out breathing holes in the ice. Walruses apparently do not use their tusks to dig clams—the pinnipeds' favorite food—as is commonly believed.*

FOLLOWING PAGES: *As the days begin to grow short, immense flocks of snow geese leave the High Arctic and head south, bound for winter havens as far south, in some instances, as the Gulf coast of Mexico.*

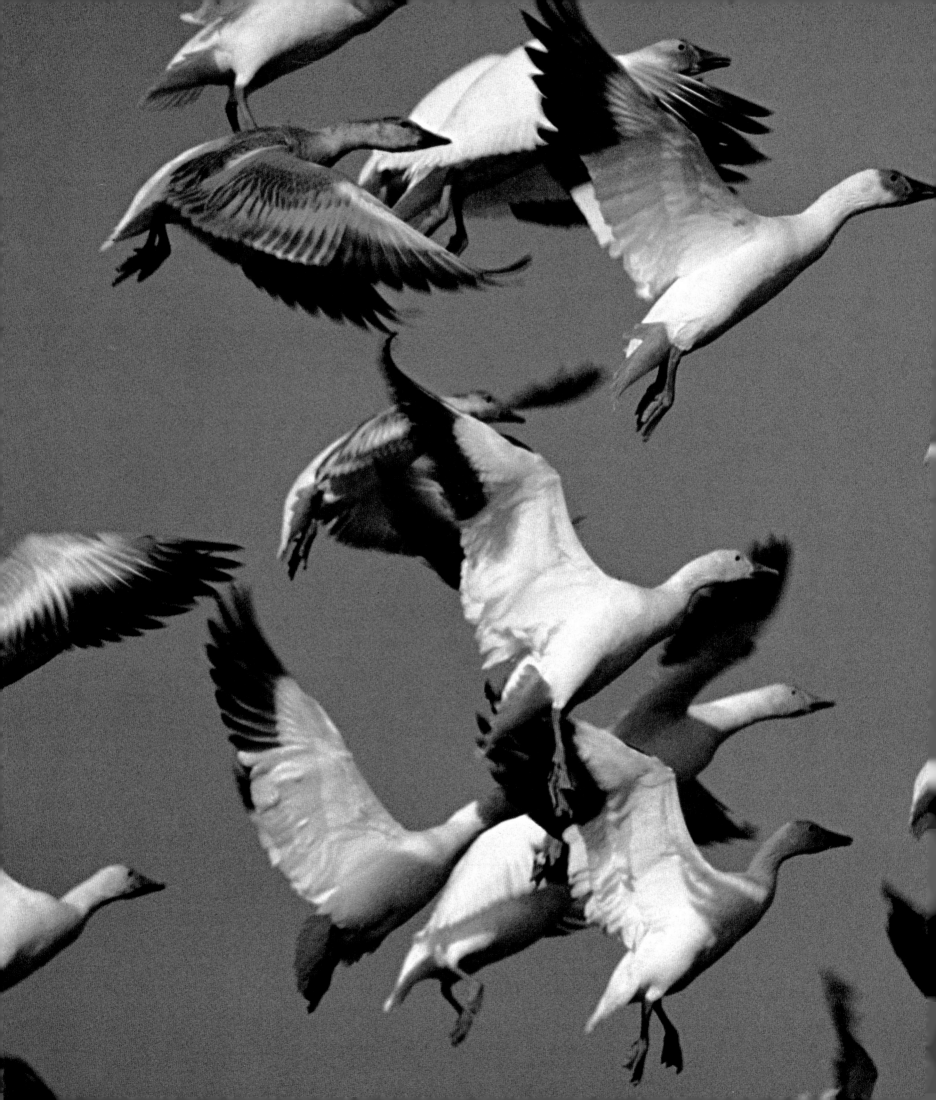

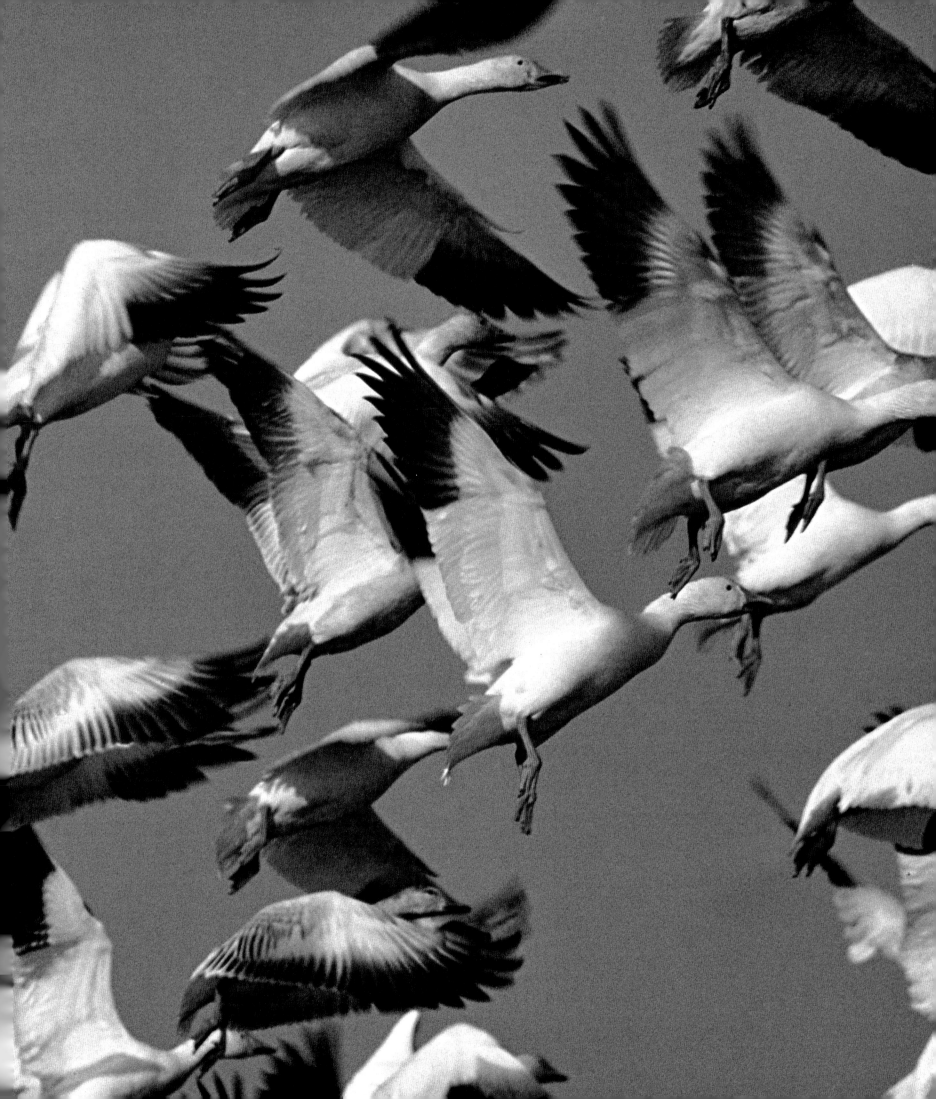

Spooked by a fox, a flock of ptarmigan takes to the air
with staccato wing beats. Their brownish summer
plumage is fast becoming pure white, heralding the
approach of winter.

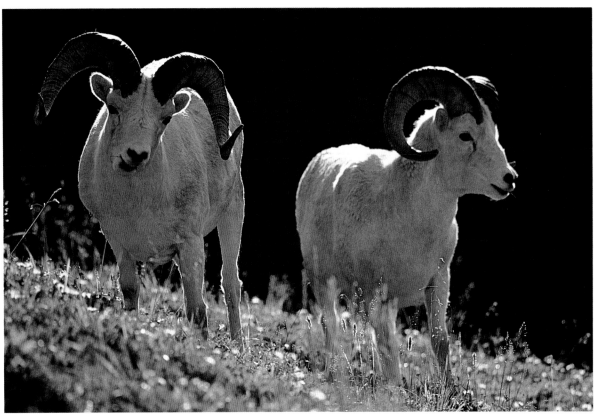

A pair of Dall sheep grazes on a sunny hillside. When winter comes, the sheep will seek out food on exposed ridge crests where high winds blow grasses and sedges clear of snow.

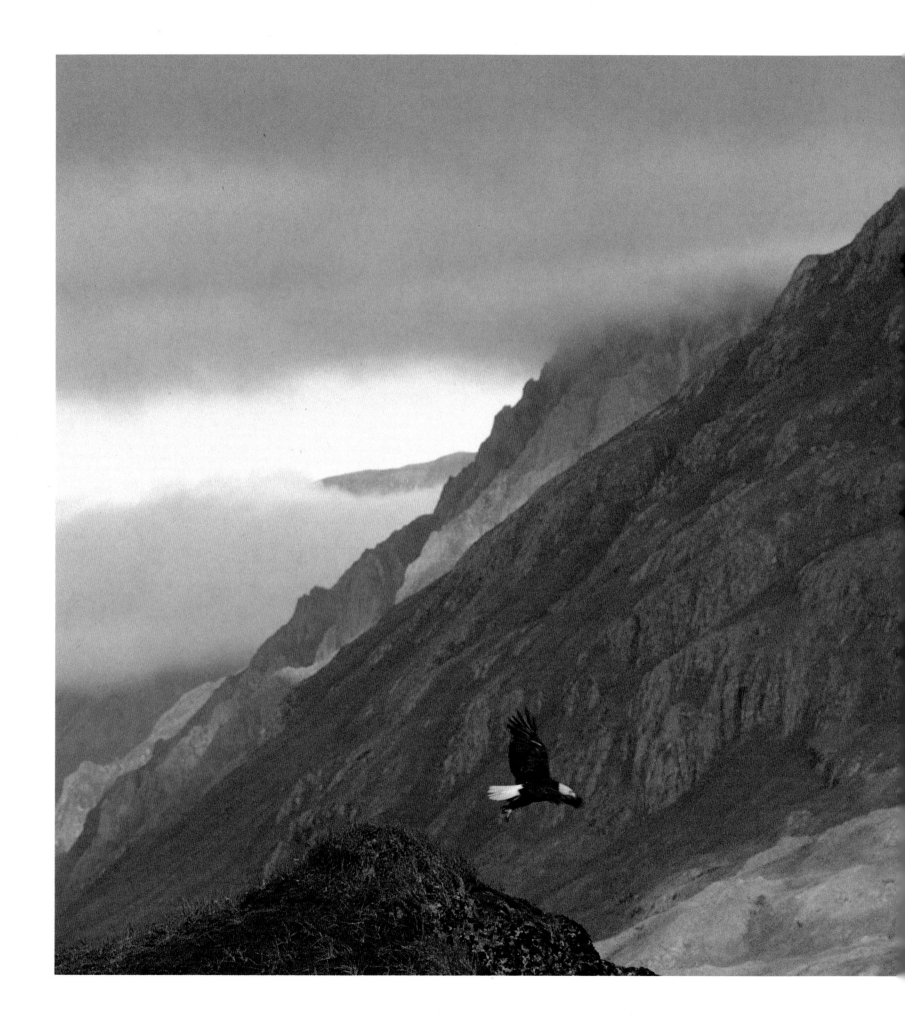

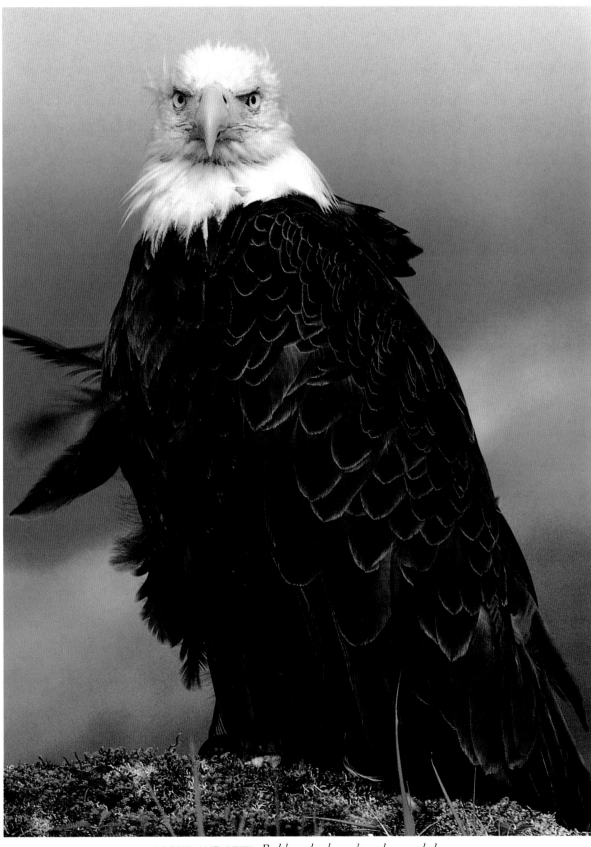

ABOVE AND LEFT: *Bald eagles have broad, rounded wings adapted for soaring. By seeking out thermals and mountain updrafts, eagles can stay aloft for hours with minimal effort.*

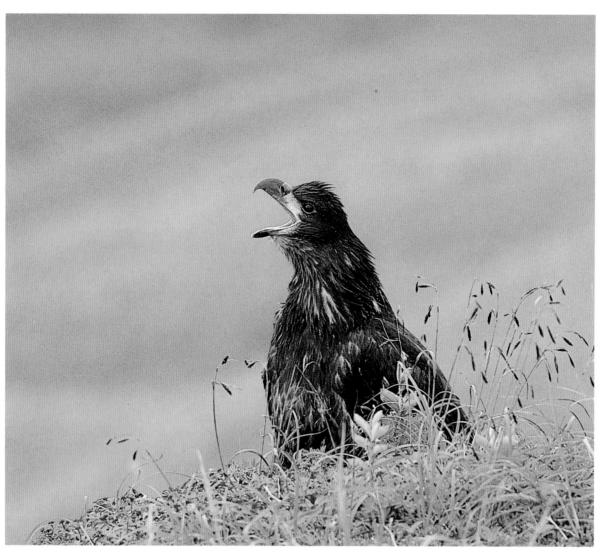

ABOVE: *Immature bald eagles keep their brown, mottled feathers and black bills until their fourth year.*

RIGHT: *The distinctive hooked yellow bill, white head and white tail feathers of the bald eagle do not appear until the birds are fully grown.*

FOLLOWING PAGES: *On the autumn tundra, the bright red fruit of lowbush cranberries accents a minimalist tableau of lichens, kinnikinik, mushrooms, moss and spruce cones.*

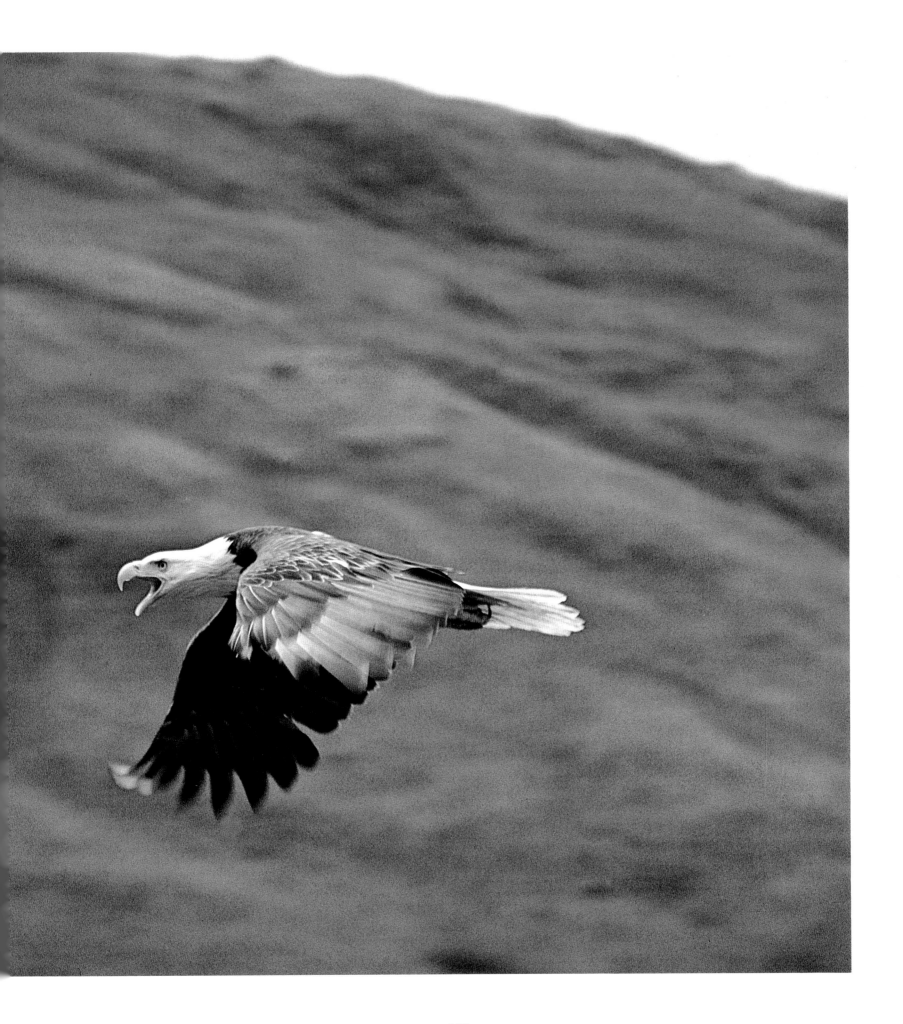

BELOW AND RIGHT: *Young male polar bears are often seen wrestling and playing together, but adult bears are generally solitary hunters, and will not hesitate to attack and eat young, defenseless members of their own species.*

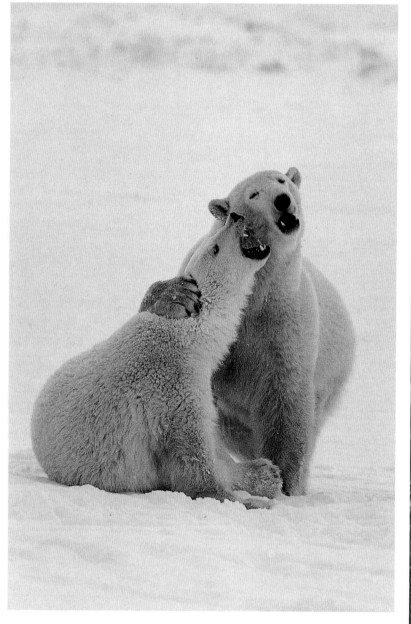

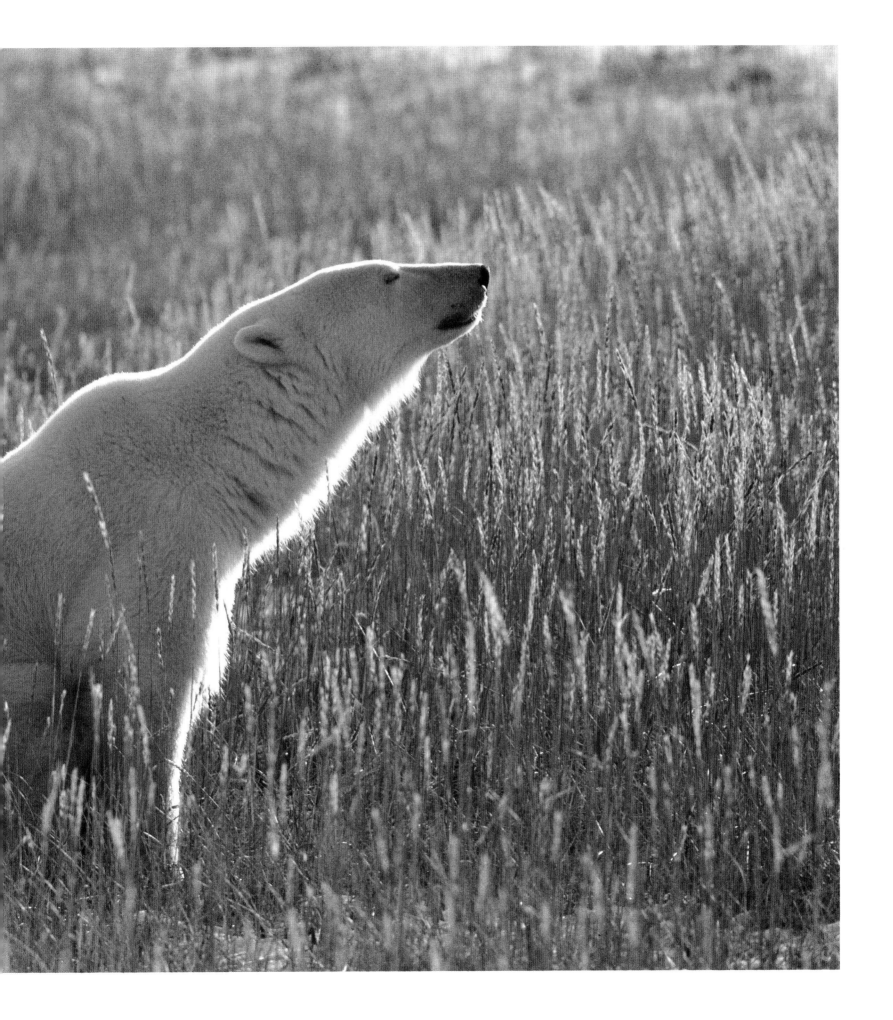

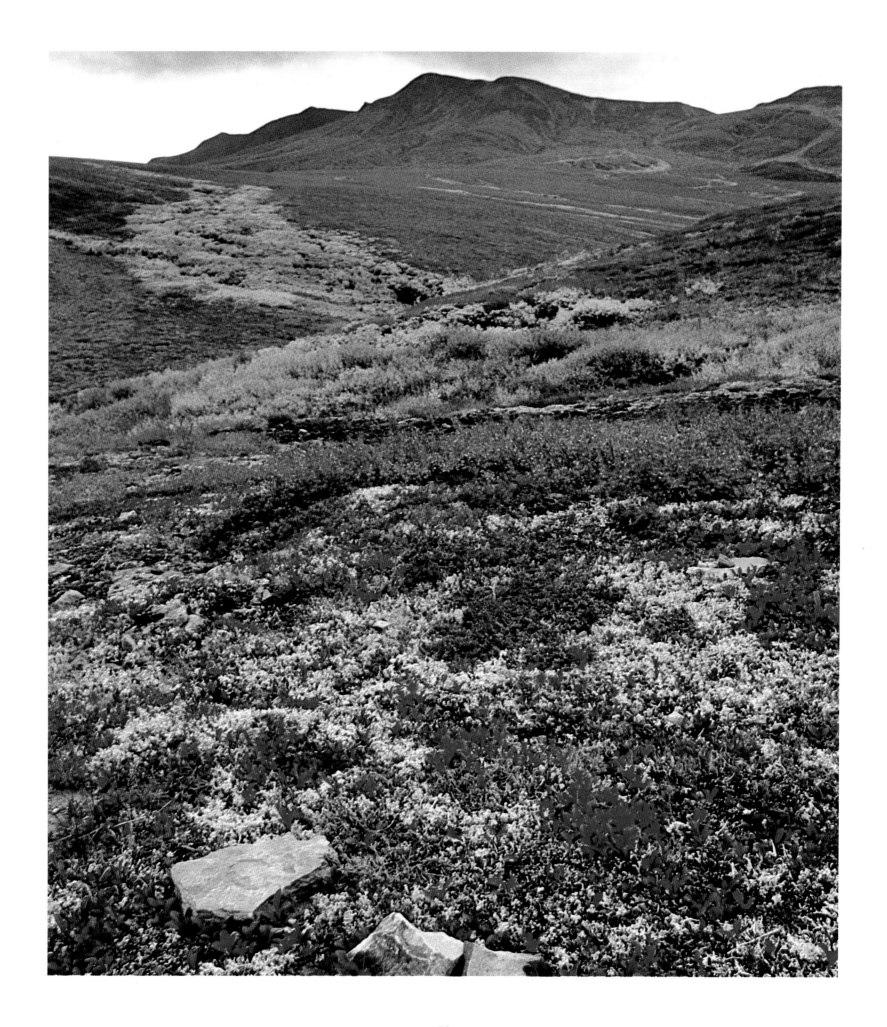

PREVIOUS PAGES: *Oldsquaw ducks float in close formation on a high arctic bay. The species owes its name to its loud, persistent vocalizations.*

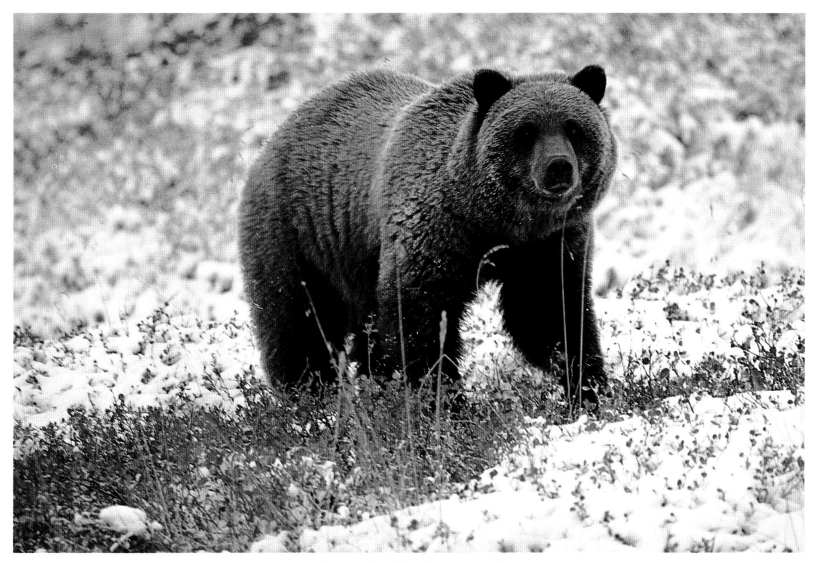

ABOVE: *Showing the effects of a summer of incessant eating, this barren ground grizzly will soon hole up in its den in a state of dormancy (not actual hibernation) until spring.*

LEFT: *The striking colors of fall tend to be short-lived on the tundra: for only a few weeks—or sometimes considerably less—does the vegetation blaze red and gold before the first autumn blizzards transform the tundra into a colorless landscape of snow and ice.*

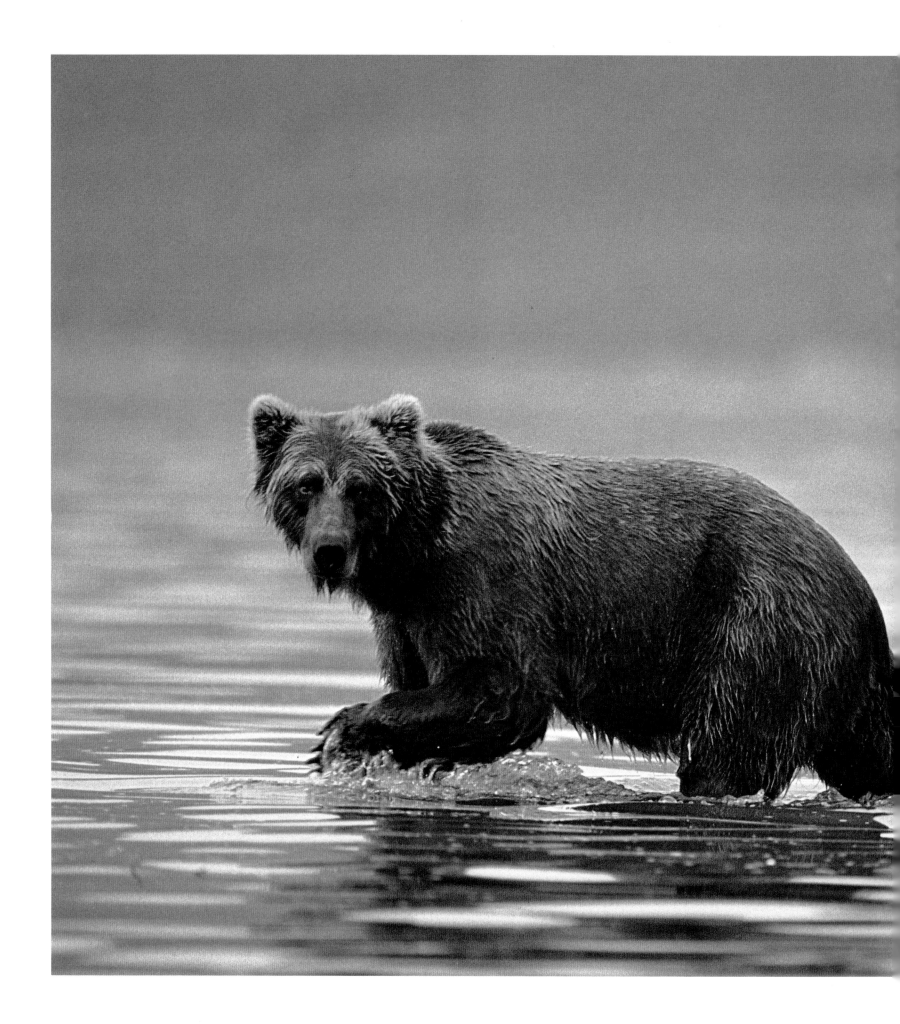

LEFT: *A brown bear wades along the southwestern Alaska shore, scavenging in the shallows for the last remaining carcasses of spawned-out salmon.*

ABOVE: *Using its unique criss-crossed beak to good effect, a female white-winged crossbill extracts seeds from a spruce cone. Unlike most of their avian cohorts, crossbills do not migrate south as winter approaches, but remain in the boreal forest year-round.*

FOLLOWING PAGES: *At autumn's end, beneath the gloom of gathering storm clouds, the last straggling flocks of Canada geese leave the Arctic in noisy, honking formations.*

155

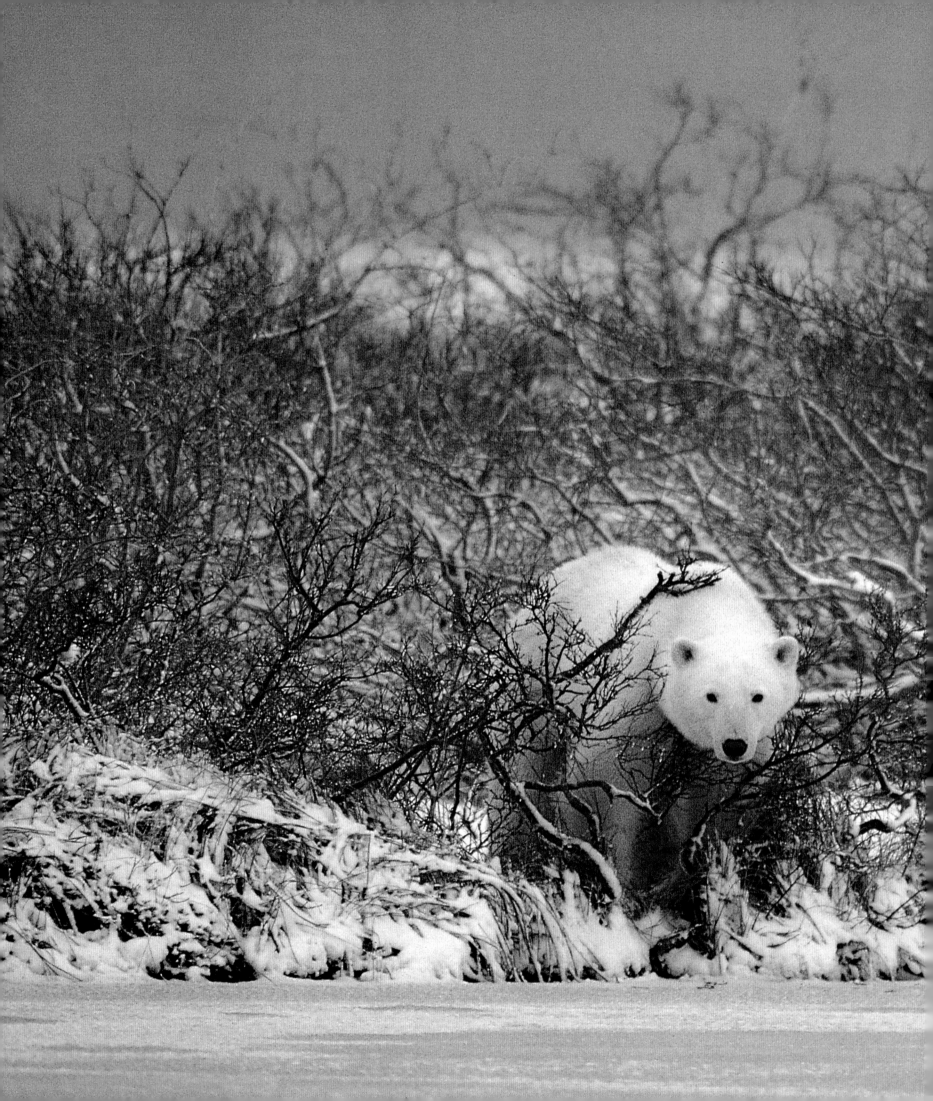

WINTER

OCTOBER 14

RICHARDSON MOUNTAINS — To the Vikings who inhabited the Scandinavian Arctic a thousand years ago, a year held just two seasons: summer and winter. To them, spring and fall simply did not exist. Winter, on the Viking calendar, began every year on the Saturday in October that fell between the 11th and the 17th of the month. Vikings traditionally marked the occasion by drinking themselves stupid on ale, and making sacrifices to Frey, the Norse god of fertility.

Today is Saturday, the 14th of October, and if the weather is any indication, the Viking calendar has lost little accuracy over the last millennium. Shortly after noon, the sky began to close in, and an ugly blizzard howled up the Peel River valley from the Beaufort Sea. That wouldn't ordinarily bother me so much, but I'd promised Annie Henry I'd give her a ride up the Dempster Highway from Dawson City to Fort McPherson. When we left Dawson, the road wasn't bad, but now the storm is bearing down hard and the driving is getting sketchier by the minute.

Annie and her husband, Joe, friends of mine, are an elderly Loucheux Indian couple — Joe is eighty-three, Annie eighty-one — who were born and raised in Fort McPherson and have lately been living in a cabin twenty-three miles up the Dempster from Dawson. Annie wants very badly to see her friends and relatives in Fort McPherson before winter arrives in earnest and keeps her cabinbound, so

Near Cape Churchill, Manitoba, a hungry polar bear picks its way through dense thickets of alder.

against all my instincts and better judgment, we push on up the gravel highway in my van.

We talk as we drive—about the weather; about the Henrys' incredibly rich lives; about the epidemics of diphtheria and pneumonia that swept through the region ravaging entire villages when the Henrys were kids; about the mixed impact of the road that now links the previously isolated communities of Inuvik, Arctic Red River and Fort McPherson to Dawson City and the outside world.

Halfway to Fort McPherson we pull off the road to check on one of Annie's dearest friends, a widow who lives alone in a drafty, uninsulated, twelve-by-sixteen-foot shack a half-mile from the Dempster. We walk up to the cabin and find the friend sitting in the open doorway of her home, smoking her customary pipe, while the storm dusts her red cotton skirt with snow. When we leave, after chatting for an hour or so, the woman is still sitting in the open doorway. As we climb back into the van, Annie thanks me for driving her up here before the snow gets deep; she says she doesn't expect she'll get another chance to see her friend, at least not in the company of the living.

NOVEMBER 2

CAPE CHURCHILL — A dark, colorless afternoon in northeastern Manitoba, hard by the edge of Hudson Bay. The mercury has slipped to −6°F, and a bone-chilling wind is screaming out of the north across the half-frozen sea. The landscape, which is rolling and rock-littered here at Cape Churchill, has gone completely monochromatic: everything —sky, earth, ice, bay—is shaded in stark, funereal tones of black, white and gray. It's the sort of day that makes you want to find a tight little cabin somewhere, pour a generous shot of whiskey into a steaming mug of coffee and crank the stove up full blast.

Unless, that is, you're *Ursus maritimus* — Nanook, as the Inuit call him: the white bear, the ice bear. The polar bear. If you're a polar bear, you couldn't be happier about the weather. You hope it gets even colder, and the wind keeps howling out of the North. You're impatient for the vast bay to finish freezing over so that you can travel across the ice and hunt seals. For the polar bear, winter is the best of seasons: a time to feast and grow fat.

Many arctic species are well on their way south right now, migrating to escape the murderous cold; others are entering dens to lie low for the winter. The polar bears of Hudson Bay, in contrast, have just concluded their season of fasting and dormancy. Although pregnant females will remain ashore in maternity dens, waiting to give birth in December or January, Churchill's male polar bears and nonexpecting females are preparing to go *north* for the winter. Scores of bears have now gathered on the low gravel eskers along this shore. Every autumn for centuries they have assembled at Cape Churchill because the waters off this promontory are among the first of the season to freeze.

These bears reluctantly came ashore last July, following the disintegration of the ice pack in Hudson Bay. Although not in the least fazed by extreme cold, polar bears have a poor tolerance for heat, so, to stay cool, as soon as they arrived on land they excavated sleeping pits deep into the sandy earth, sometimes all the way down to the permafrost. They spent much of the four months that followed curled up in these dens in a torpid state of estivation, eating next to nothing, slowly metabolizing their stores of thick blubber. And now, as winter begins to tighten its white-knuckled grip on the

North, the bears are abandoning their summer dens, anxious to return to their true home — the frozen sea.

By any measure, polar bears are extraordinary creatures. They roam the featureless winter ice pack, hundreds of miles from shore, hunting seals, and can swim at a speed of six miles per hour for fifteen or sixteen hours without rest; throughout the history of the Arctic, sailors have been astounded to come across solitary polar bears swimming in the middle of huge bodies of water like Baffin Bay. Now and then Greenland polar bears will hitch rides on icebergs across thousands of miles of open ocean to arrive on the normally bear-less shores of Iceland or southern Newfoundland.

Late in the afternoon at Churchill a big male appears a little way up the beach. He raises his long, pointed muzzle to sniff the breeze. An arctic fox comes up close behind him, scooting along with its characteristic side-winding trot, hoping to scavenge scraps of any prey the white bear might kill. There are no seals here, however, so both go hungry for the moment. Now and then, whenever the fox moves close, the bear makes a light-ning-quick lunge at the fuzzy little canid, but the fox is quicker and dances effortlessly out of harm's way.

The ringed seal — the most abundant large mammal in the Arctic — is the polar bear's meal of choice. The bear is a picky eater, though. After killing a seal it will usually eat just the skin and blubber, leaving the rest of the carcass for the foxes, gulls and ravens. This time of year, however, having eaten little all summer, the bears are sufficiently hungry to eat whatever they can get their massive paws on. It isn't unusual for bears to break into cabins looking for food while they wait for the sea ice to form. Upon entering a human habitation, one of the first delicacies the bears are likely to seek, curiously enough, is motor oil, perhaps because it smells slightly like blubber. Polar bears have been known to slurp down more than a dozen cans of 10W-30 at a single sitting.

After loitering on the beach for a while, the solitary male ambles back inland with the arctic fox following. He propels his 800-pound bulk with a floppy, loose-jointed, pigeon-toed shuffle, placing each rear foot precisely in the pizza-sized paw print just

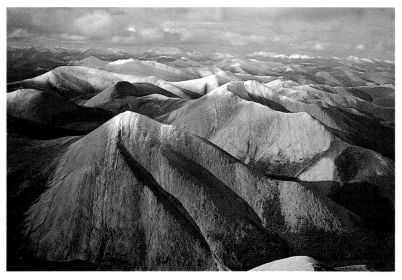

Richardson Mountains

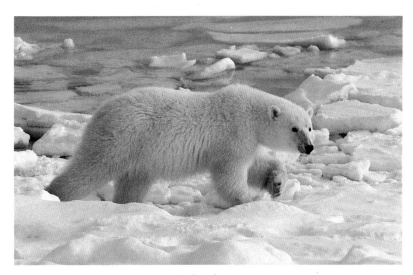

Polar bear

vacated by the front foot a split-second earlier. The bear's thick coat is the color of aged ivory, and seems to glow softly, as if lit from within.

The six-inch-long guard hairs that give the pelage its luxuriant cast are actually colorless, with a hard, shiny finish. Under a magnifying glass, they look like strands of plastic. Zoologists studying polar bear fur with electron microscopes recently discovered that these hairs are hollow: they function in the manner of tiny fiber-optic tubes—miniature conduits for light—that collect solar energy, then funnel it beneath the pelage to warm the bears' pitch-black skin.

By and by, crossing a frozen pond, the big male encounters a mother bear with a pair of yearling cubs and begins to harass them. At one point, trying to protect her young, the mother runs at the big male with her head down and lips curled back from her teeth. This bluff charge succeeds momentarily, but during the few seconds she is separated from her offspring, one of the cubs wanders off. With the quickness of a cat, the big male pounces on the cub and takes the youngster in his jaws.

The mother runs back to try to save the squealing cub, nipping at the attacker, even attempting to pull the youngster away with her own jaws, but the male is much larger and wins the tug-of-war easily. Blood spatters the snow. The squealing stops. The mother, deciding to cut her losses, hurries off with her remaining cub, leaving the male bear and the fox to feed on the cub's sibling.

DECEMBER 21

TOMBSTONE RANGE — It's 11:00 P.M. on the shortest day of the year at a cabin in the southern Yukon Territory, not far from the confluence of the Yukon and Klondike Rivers. The cabin isn't big, but it's as tight as a drum, built from skinny blond logs. It stands on a south-facing hillside of black spruce and aspen at the edge of the Tombstone Range, a compact knot of spectacular granite fins and towers that rise above slopes of open tundra and thick scrub alder. This is gold-mining country, Jack London country, Robert Service country.

The sun retreated beneath the western mountains more than ten hours ago. When I open the door of the cabin—a hunting shack built by a friend—a tongue of fog slides in across the floorboards like spilled milk, an

indication of the difference in temperature between the Yukon night and the snug, kerosene-lit interior I'm leaving behind. Outside, the air is sharp and brittle, and as hard as iron. As I close the door behind me, I feel the winter tighten around my shoulders, sting my ears, burn the back of my throat.

To the north, the aurora borealis lights up the sky. I settle on the steps of the porch, let my mind run where it will and watch the heavens shimmer. The temperature is −40— the point at which the Celsius and Fahrenheit scales converge. There hasn't been a hint of wind all day, and I'm wearing every article of clothing I have, so I should be able to fend off the cold and hang tough out here for a little while, anyway.

A half-hour ago, when the northern lights commenced, all the chickadees in the surrounding trees started to sing at once. As they did so, their breath sent little puffs of steam—amazing, perfectly formed cumulus clouds in miniature—floating off into the darkness. Just a few minutes ago one of the chickadees got confused and flew into the front window, stunning itself. I picked the bird up and held it in my hands until it revived and flew away. It astounds me that a creature so tiny and frail—the bird weighed less than one ounce, and its legs were as insubstantial as toothpicks—could generate enough warmth to endure a forty-below night like tonight.

The chickadee appears to make a mockery of one of the most oft-quoted principles of zoology. Bergmann's Rule states that species adapted to cold northern climes tend to be larger than species in warm climes because animals with a low surface-area-to-volume ratio—that is, those animals whose internal body volume is great in relation to the area of skin they present to the elements—enjoy an obvious advantage in retaining heat. Ap-

parently unaware of Bergmann's famous rule, the minuscule chickadee manages to survive temperatures as low as 70°F below zero by fluffing up its feathers, huddling in woodpecker holes, periodically inducing bursts of intense shivering and temporarily lowering its internal body temperature by as much as 12°F, in the manner of a reptile or some other cold-blooded creature. Ornithologists admit, however, that these strategies alone do not convincingly explain how the tiny birds can do so well in extremely bitter weather. Nor, for that matter, are scientists entirely sure why chickadees are wont to sing when the aurora borealis puts on a show.

At the moment gossamer sheets of light —ranging from the palest blue to a deep, apocalyptic red—are rippling across the sky like pleated curtains in a soft summer breeze. Norse Vikings believed the northern lights were the flames of Vulcan's forge. An old Indian couple who live in the next valley once told me the lights were the spirits of unborn children at play in the heavens. According to the wife, "If you sing real pretty, you can call the lights down to you—you can bring 'em right down to the ground."

In truth, of course, the aurora seldom drops lower than eighty or ninety miles above the surface of the earth. The phenomenon is caused by a violent solar wind discharging billions of watts of electricity into the upper reaches of the earth's ionosphere. When you stop to think about it, though, the idea of a solar hurricane blowing in from a distant star isn't any less preposterous than the notion of a blast furnace stoked by gods, or infant spirits dancing over the treetops.

Every now and then, in the pauses between the calls of the chickadees, I pick up a faint swishing and crackling noise far overhead, not unlike the sound of bedsheets flapping on a clothesline: the aurora is so intense

tonight that I can hear it. For many years scientists vehemently denied that the northern lights made any noise at all, despite anecdotal reports to the contrary from Inuit, sourdoughs and polar explorers. Recently, however, some members of the scientific community have reversed themselves on this question. The eerie noise I hear drifting down from above, it pleases me to think, may not be a figment of my imagination, after all.

JANUARY 4

VALDEZ – The Arctic is a peculiar, through-the-looking-glass kind of place. Things are seldom as they seem. The North toys with one's sense of perspective, and is apt to make hash of one's most confident assumptions.

For instance, it is not uncommon to find oneself reduced to blithering incomprehension by what seems like the uncountable profusion of caribou, or dovekies, or red salmon, or arctic hares. There appear to be so many animals—on the tundra, in the sky, in the sea—that nothing could ever reduce their numbers.

This is a particularly dangerous misconception. A handful of arctic creatures *are* extraordinarily abundant. But it is important to bear in mind that, overall, the number of different species in the Arctic is but a tiny fraction of the number found in most temperate zones. There are more than 3,000 species of mammals on this planet, but only about forty of them live in the Arctic, and almost half of those are sea mammals. There are 30,000 varieties of fish in the world, but only 100 in the Far North. Fewer than ten bird species live here year-round, and no reptiles or amphibians exist in the Arctic at all.

As my friend Fred Bruemmer, who is a respected arctic naturalist/writer/photographer, put it, "The harshness of the arctic cli-mate, the poverty of its soil, the exceedingly long and dark winters are all inimical to life." Life, indeed, is an extremely fragile, terribly precious commodity in the North. Throughout history, mass extinctions have been the rule rather than the exception. A number of northern species are hovering on the brink of extirpation. Many others, if not yet on the brink, are in serious decline.

One of the species in trouble is our own. Anybody who's spent any time in the Arctic over the past few decades has witnessed a disturbing trend among the once-proud communities of native peoples. Their cultures have been torn asunder by alcohol, by the obliteration of traditional ways, by the threat to the animals around which their hunting lifestyle has revolved for millennia, by the relentless sledgehammer intrusions of the twentieth century.

Predictably, young members of the Indian and Inuit societies have suffered the most from the recent upheavals in their cultures. And just as predictably the frustration and depression among the young has spawned in them a deep-seated rage. The hair-trigger racial tension I've felt in Barrow, Kaktovik and Whitehorse between whites and young natives is every bit as intense, if not yet as widespread, as any I've felt in Watts or Harlem.

Sadly, the disintegration of the native cultures has indirectly accelerated the demise of a number of threatened species of arctic fauna. Until recently, the Inuit depended utterly on the animals of the North for their own survival. Whales, seals, bears, caribou, walrus, salmon and arctic char provided the Inuit with food, shelter, clothing, locomotion, weapons and tools of all kinds. Animals, to the Inuit, were life itself. The Inuit's total dependence on the creatures of the North instilled in them a deep respect, a reverence for

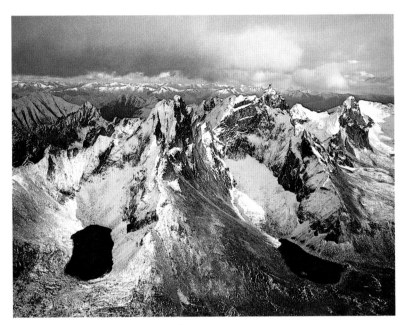

Tombstone Range

their prey. Wasteful hunting was considered to be a most grievous sin.

The arrival of Europeans, and later of white Americans and Canadians, marked the end of the intense spiritual ties from which the Inuit's respect for the animals was derived. The introduction of such civilized refinements as guns, snowmobiles, outboard motors and material acquisitiveness ensured the end of their traditional methods and mores. Lately, with the emergence of a new generation of northern residents even further removed from the time-honored ways, overhunting has become a renewed threat.

These days, it is not unusual to see immense heaps of walrus skulls stacked up in native villages; the walruses are killed for their ivory tusks, which fetch up to $40 or $50 a pound (a price that has been going up now that public concern has reduced the supply of ivory from African elephants). A group called Friends of Animals estimates that hunting to supply illegal ivory markets results in 10,000 to 12,000 walrus deaths each year in Alaska alone. So many decapi-

tated Alaskan walrus carcasses have washed up on Russian beaches, in fact, that the Soviet Union recently filed an official protest about the matter with the U.S. State Department.

In the long run, though, the threat to arctic fauna posed by overhunting pales in comparison to the threat posed by the destruction of the animals' habitat — the destruction of the arctic environment — through the accelerated construction of roads, pipelines, cities, mines, offshore drilling platforms, military bases, subdivisions, airports. Overhunting by a handful of isolated Inuit, after all, is much easier to curb than our own gluttonous consumption of oil and other natural resources.

No less an authority than Dome Petroleum — once among the biggest oil producers in Canada, a company not generally given to crying wolf over environmental hazards posed by the petroleum industry — warned several years ago that "the issue of an uncontrolled oil blowout or massive spill resulting from a tanker accident may be viewed as the

single greatest threat to the well-being of the Arctic environment."

Needless to say, Dome's warning proved disconcertingly prescient in the early hours of Good Friday 1989. At 12:04 A.M., the 987-foot supertanker *Exxon Valdez*, carrying fifty-million gallons of heavy North Slope crude, inexplicably strayed from the shipping lanes in Valdez Arm, gashed open its hull on the rocks of Bligh Reef and spilled eleven-million gallons of that poisonous cargo into the crystalline waters of Alaska's Prince William Sound.

JANUARY 5

VALDEZ – Valdez is not unfamiliar with catastrophe. In 1964 every building in metropolitan Valdez had to be dismantled and moved to firmer ground after the most powerful earthquake ever recorded in North America obliterated the port and dropped the town's shoreline a full six feet, instantaneously drowning thirty-three residents.

The community stands at the head of a narrow, spectacularly positioned fjord. Just beyond the backyards of the homes at the edge of town, the mile-high peaks of the Chugach Range bristle like shark's teeth in row after jagged row. During the summer months hundreds of waterfalls pour off these rain-drenched escarpments; now, however, these falls hang frozen in midcascade, their tumbling mists transmogrified by the cold into icicles the size of skyscrapers—towering pillars and curtains of fragile-looking ice that glow in translucent shades of aquamarine and sapphire in the low winter light.

There seems to be ice, in fact, everywhere you turn in Valdez. The wind, which regularly funnels down nearby Keystone Canyon at hurricane strength, has scoured the surface of Robe Lake down to a steel-hard shield of frozen water. The fat, blue tongues of several glaciers thrust well into the city limits. Thanks to the frigid temperatures and the damp marine air, even the downtown streets are glazed with a carapace of black ice.

Ironically, although the land here becomes a natural ice factory every winter, the waters of Valdez Arm remain free of ice all year. And that oddity of climate—the fact that Valdez is the northernmost ice-free port in the North American Arctic—explains why the Trans-Alaska Pipeline goes to Valdez instead of somewhere else, which explains why supertankers like the *Exxon Valdez* go to Valdez instead of somewhere else, which explains why Prince William Sound, and not some other body of water, was the unfortunate receptacle for all that spilled oil in 1989.

The hard-rock knuckles of Bligh Reef, upon which Captain Hazelwood's ship impaled itself, rest fifty feet beneath the waves about eight miles west of the Indian community of Tatitlek. The shoal was named for the infamous William Bligh, the nautical tyrant cast adrift into history by the crew of the HMS *Bounty*, although in 1778, when the reef was christened, Bligh was still just a navigator under the command of Captain James Cook. Cook, at the time, was exploring Prince William Sound as part of his historic, pioneering tour of the Alaskan Coast. It is worth noting that the deeds of Bligh and Cook later provided the inspiration for Samuel Taylor Coleridge's incomparable poem "The Ancient Mariner." Writing about the Valdez oil spill in the frantic days that followed it, the Alaskan journalist Grant Sims pointed out that the foundation for this timeless piece of verse was Coleridge's belief that "at the core of all tragedy is the one mistake that places a man beyond redemption."

Before the oil spill, the waters around

Bligh Reef, like those throughout Prince William Sound, teemed with life. Millions of pink salmon amassed here every August. Killer whales churned into the shallows to hunt harbor seals. Terns, cormorants and kittiwakes wheeled overhead. Sea otters paddled leisurely by on their backs, dining on crab or wielding small stones with their sensitive paws to crack apart clams balanced on their bellies. The wreck of the *Exxon Valdez* changed all that in the blink of an eye.

Within two weeks of the spill thick black goo had spread over a stretch of Alaskan shoreline equal in length to the entire coast of California, killing most of the creatures it touched. Seabirds that landed in the sludge immediately began to founder, and soon found themselves unable to take off again. Otters succumbed by the hundreds when the oil robbed their thick fur of its buoyancy and thermal insulation. Storms splattered oil far above the high-tide line, on some islands coating spruce and hemlock trees to a height of twenty or thirty feet.

I find it extremely sobering to think that this whole gargantuan, deadly mess origi-nated from the hold of a single ship—and that the slick represents less than one-quarter of the oil within that ship at the time of the accident.

JANUARY 17

NIUKLUK RIVER — January occupies the meanest, darkest heart of the Arctic winter; it's the one month that even lifelong residents of the North seem to have a hard time handling. When I was in Valdez last week, one of the town's two physicians, a Harvard-educated family practitioner named Andrew Embick, told me bluntly that "Alaskans tend not to do well in January. Many are unemployed this time of year, and the paucity of available activities, the short days, the lousy weather all lead people to spend a lot of time cooped up indoors. One effect is that we have a baby boom every October; the other is that people get unhappy, drink way too much, beat their husbands or wives. We have one or two suicides in town every winter. The darkness does evil things to the mind."

Not even the aboriginal Arctic peoples had an easy time handling the dark season.

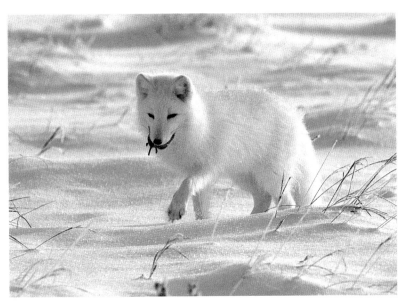

Arctic fox with lemming

"The oral literature of the Eskimo," reports Barry Lopez in the book *Arctic Dreams*, "is full of nightmare images from the winter months, images of grotesque death, of savage beasts, of mutilation and pain. In the feeble light between the drawn-in houses of a winter village, you can hear the breathing of something with ice for a heart."

Research by behavioral psychologists has recently shed some light on the difficulties we humans have during the dark winter months. Neurotransmitters in the eye, when triggered by the sun's rays, stimulate the hypothalamus, pineal and pituitary glands to release a flood of mood-enhancing hormones through the brain. Without a certain minimum daily exposure to bright sunlight, the hormones stay locked up, one's spirit takes a nosedive and a black, bottomless depression begins to permeate the soul, a sickness of the mind called *perlerorneq* by the Polar Inuit who inhabit Greenland's Thule region.

To maintain one's sanity through the arctic winter, it is important to get outside and make the most of the scant hours of sunlight that do exist. That, however, requires both discipline and planning. Here on Alaska's Seward Peninsula, a part of the state that lies just below the Arctic Circle, the sky is fully illuminated for only a few hours a day at this time of year; if one takes a nap at the wrong time, or gets overly absorbed by the game shows and soap operas that everyone in these parts seems addicted to (thanks to the ubiquitous TV satellite dishes that sprout like fungus behind half the cabins in the North), one is apt to miss the day's meager offering of sunlight altogether.

Today, at least, I did not miss the daylight. Setting out from the settlement of White Mountain in midmorning, I began snowshoeing south down the frozen channel of the Niukluk River, a modest, unassuming stream that winds beneath hills resembling the pates of balding men: bare and exposed across their rounded summit domes, with scraggly, embattled stands of spruce and willow clinging to the lower reaches of the south-facing slopes. The air was crisp. The sun was low but brilliant, slanting directly in my face. Eighteen inches of unconsolidated powder snow covered the ground, but those who had come this way before me had packed a wide, solid track down the center of the river, making for easy travel. The frozen bed of the Niukluk, it seems, is the major highway in these parts, and sees considerable traffic: perhaps as many as three or four people on the average day.

The trail on which I walked was corrugated with snowmobile tread marks; almost all winter travel through this country is now done on gasoline-powered snow machines. I was surprised, therefore, when I heard barking in the distance. A few minutes later a heavily bundled, red-bearded man driving a team of sled dogs whizzed by in the direction of Nome. I figured the guy was training for the Iditarod race.

In the early decades of this century, the gold-rush years, sled dogs served as the cars, trucks, tractors and ambulances of the bush for six months out of every year. (Travel was actually less problematic in the winter than in the summer, when mushing was impossible and vast tracts of the North turned into a huge, leg-sucking, mosquito-infested swamp.) That began to change on July 4, 1913, when the first heavier-than-air flying machine in Alaska—after arriving in a crate aboard a steamship—was assembled and launched from the baseball field in Fairbanks with a man named James Martin at the stick. Martin circled the ballpark for nine minutes at an altitude of 400 feet, then landed to the wild cheers of a rowdy sourdough crowd. In

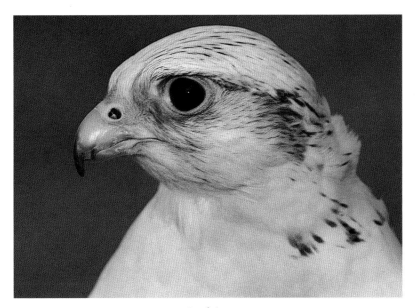

Gyrfalcon

the decade that followed this modest debut the airplane remained a seldom-seen novelty in the Arctic, but by the mid-1920s residents of the North found themselves relying more and more on the bush pilot, and less and less on the dog musher. The airplane rapidly transformed the region, forever altering concepts of distance and inaccessibility. Thanks to the success of the flying machine, alas, the last blank spots on the Arctic map were soon filled in.

The sled dog had one final moment of glory, however, in the winter of 1925. That year a diphtheria epidemic had spread across the North. When a particularly virulent outbreak erupted in Nome, storms kept the airplanes on the ground. It turned out to be dogs, not pilots, that managed to carry a twenty-pound package of diphtheria serum from Nenana, just west of Fairbanks, all the way to Nome. Relaying the medicine for 170 nonstop hours through a raging blizzard, dog teams delivered the serum to Nome in time to save hundreds of lives. The route the mushers took across the forbidding Alaskan Interior was a miners' track called the Idi-

tarod Trail, the final leg of which was the same frozen bed of the Niukluk over which I snowshoed today.

Despite the heroics of the Iditarod serum run, dog mushing went into sharp decline in the decades that followed it. By the 1970s snowmobiles and three-wheeled all-terrain vehicles had all but completely replaced the sled dog in even the most remote Inuit villages. Anxious to save the tradition of dog mushing from extinction, in 1973 an old musher named Joe Redington organized a sled dog race to commemorate the life-or-death run to Nome in 1925. Thus did the modern Iditarod Trail Race come into being. The annual, 1,100-mile contest from Anchorage to Nome, entered by an average of fifty dog teams, requires between ten days and one month to complete.

The Iditarod race unexpectedly captured the imagination of the Alaskan people in a big way, and sparked a renaissance in dog mushing not only across North America, but in Europe, as well. The Iditarod is now the most widely followed sporting event in Alaska. Interestingly, four out of the last five

races have been won by women, which hasn't gone over well among many of the male residents of a state that has been awash in machismo for its entire history.

The original serum run in 1925 was considered such a courageous humanitarian deed that a statue was erected in a corner of New York's Central Park to honor those responsible. Fittingly, it was a rendering of one of the brave dogs, rather than one of the men involved, that was chosen to grace the monument: Balto, the leader of the team that pushed through a violent blizzard to deliver the serum to Nome in the nick of time.

The canine immortalized in bronze in North America's largest city — broad of shoulder, noble in countenance, with a handsome feathery tail curling back toward his head — possesses the classic features of a purebred Siberian husky, which was the breed favored by the original sourdough dog mushers. The dogs that zoomed past me on the Niukluk, like most sled dogs these days, were a decidedly more motley-looking bunch, however. Sled dog racing has become big business (first prize in the Iditarod race is

$50,000), and modern mushers have discovered that floppy-eared, funky-looking mixed breeds — mutts whose blood is a rich genetic gumbo begat by huskies and hounds, setters and spaniels, German shepherds and wild wolves — have proven to be vastly superior when it comes to pulling a sled fast and far.

JANUARY 27

PARKS HIGHWAY — More than a few people wrongly assume that the largest land animal in the Arctic is either the polar bear or the grizzly. In fact, the moose holds the title: a mature Alaskan bull moose may weigh upward of 1,700 pounds, stand seven feet tall at the shoulder and boast an antler spread of nearly seven feet, as well. To sustain this kind of bulk, such a brute must consume more than sixty pounds of willow twigs daily.

Not only are moose beefier than bears, they can also be almost as ornery, especially during the fall rutting season. Some years ago in the Brooks Range, I watched a truculent bull chase a pair of fishermen in a canoe across a sizable body of water called Takahula Lake. The fishermen thought it was

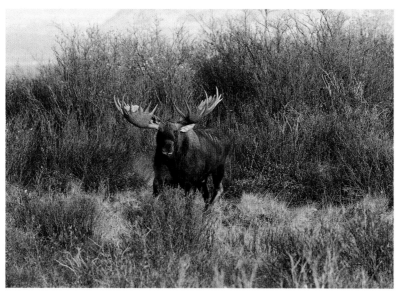

Bull moose

funny when the moose first started swimming toward their canoe from a distant shore, but as the huge rack got closer, then closer still despite the men's frenzied paddling, their amusement turned to stark terror. Fortunately, for some reason the moose unexpectedly called off the chase in midpursuit and turned around, sparing the fishermen what promised to be an ignoble end.

The moose's instinctive combativeness is an asset when one of the beasts is attacked by a hungry wolf or bear, but the big deer's belligerent nature has not proved to be very adaptive in confrontations with men. Many of these encounters occur on plowed highways and train tracks, over which moose like to travel in the winter months when deep snow makes travel over stretches of countryside exhausting. In Alaska, during years of heavy snowpack, as many as 300 moose will typically die in collisions with cars on the Kenai Peninsula alone. In the winter of 1984–85, 384 moose were killed standing their ground against the locomotives of the Alaskan Railroad.

Occasionally in a moose-machine encounter, though, the moose manages to give as good as it gets. I witnessed one such instance this morning.

I was driving the Parks Highway, the main road between Fairbanks and Anchorage, when I came upon a bull moose ambling down the middle of the thoroughfare. Since the moose looked a mite perturbed and had no avenue of escape — the road at that point was a deep, narrow trench plowed between vertical-walled snowbanks — I pulled over and stopped to let the big guy move on down the road, just to be on the safe side.

An impatient young man in a small Toyota who arrived on the scene a few minutes later, however, was not so prudent. He roared right up to the moose's heels and im-

mediately started honking the car's horn. At this time of year bull moose are without their antlers, but that doesn't mean they lack weaponry. The moose turned on the Toyota without hesitation and commenced an assault on the car's front end with a series of lightning-quick kicks. The driver quickly realized the error of his ways and threw the car into reverse, but by the time the Toyota was out of hoof range, it was missing both headlights, and its hood resembled a piece of badly executed origami.

FEBRUARY 2

BLACK RAPIDS GLACIER — I left my van on the Richardson Highway about four hours ago, crossed the frozen braids of the Delta River, stepped into the bindings of my cross-country skis and pointed them toward the head of the Black Rapids Glacier.

Glaciers support less life than any other Arctic biome; beyond the strange pink blooms of algae in the summer glacial snowpack, in fact, and occasional swarms of hapless butterflies swept high onto alpine slopes by the wind, glaciers are apt to be devoid of living things altogether — except, that is, for the reliable raven. I am reminded of the raven's northern ubiquity when one of the shiny black birds soars down out of the western twilight with a shrill "Caw! Caw! Caw! Caw!", executes a flashy barrel roll and then touches down on the lip of a nearby crevasse to look me over.

It makes no sense that this bird should be here. The temperature is 24°F below zero. Below the raven's Jimmy Durante-like beak it wears a necklace of white rime where the moisture from its breath has apparently frozen on its feathers. Despite the horrible cold, despite the remoteness of the setting, the bird appears completely at home and positively ebullient. "Caw! Caw! Caw!" it

screeches again, cocking its head at a mocking angle. The raven seems as surprised and amused to find me in this unlikely place as I am to find it.

It may be ridiculous to imagine that a bird could possess enough intellectual and emotional sophistication to experience what we think of as ebullience, surprise or amusement, but then again, maybe not. Ravens belong to an astounding family of birds called the Corvidae (crows, jays, rooks and magpies are also corvids), which have the largest brains, relative to body size, of any avian family. Ravens communicate with each other by means of more than twenty distinct calls complex enough to constitute a primitive language. In intelligence tests designed to measure things like clock-reading ability, learning facility and aptitude at counting, corvids excel. The British ornithologist Sylvia Bruce Wilmore insists that they are even "quicker on the uptake" than cats or monkeys.

Ravens engage in elaborate courtship rituals that involve much dancing and head-bobbing, and they generally mate for life, which can be a long time: ravens in captivity have lived to the age of twenty-nine. The female lays four to six eggs in late winter, usually in a nest built on the face of a cliff. When the eggs hatch, both parents spend a full month doting on their progeny, although as many as two-thirds of all raven fledglings die, anyway. Interestingly, unlike the populations of many northern species, the numbers of ravens seem to remain remarkably stable, neither increasing significantly during good years nor dropping markedly during hard ones. Ravens, apparently, are too smart to be seduced by the boom-or-bust mentality to which the lemming, the caribou and so many generations of arctic gold prospectors and oilmen have fallen prey.

The hardiness and intelligence of ravens cannot be overstated. Their inky black plumage, which would seem to be an extremely unadaptive evolutionary stratagem in an almost uniformly white world (after all, how many black ptarmigans, arctic foxes, polar bears or snowy owls does one find in the North?), is in fact a highly efficient sponge for solar radiation. (In one experiment, white finches that had been dyed black required twenty percent less energy to stay warm than their naturally white brethren.) I once sat in the mouth of a snow cave at 17,000 feet on Mount McKinley, on a May afternoon when the wind chill approached 100°F below zero, and watched a raven casually hanging around while some climbers cached a satchel of food ten feet away. After a few minutes the climbers left, driven away to a lower, more protected camp. As soon as they were out of sight, the raven hopped over to the buried cache, dug away the six inches of snow that covered it, unzipped the food bag with its beak — as if operating a zipper were the most natural thing in the world for a raven — and immediately began chowing down on a package of smoked salmon.

The raven's intelligence is matched only by his fondness for play. Ravens commonly engage in games of catch in midair, and have been known to lie on their backs and juggle stones or twigs between their bills and their feet. I once saw a raven perched on a wire let itself fall over backward — in the manner of an avian Buster Keaton — and then hang upside down from one foot, then the other, just for grins. Ravens regularly perform spectacular aerobatics that seem to have nothing to do with courtship, swooping and twirling like stunt pilots for the sheer joy of it. It's no wonder that the raven figures so significantly in the mythology of every aboriginal arctic tribe.

By and by I bid the raven on the Black

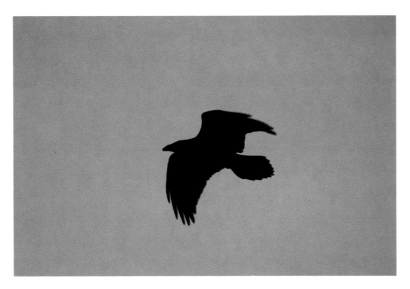

Raven

Rapids Glacier farewell, and resume kicking and gliding across the hard, wind-scoured snow. I get to thinking about some maps of the North I'd been looking at last night in my cabin near Fairbanks. After downing a few beers, I'd pulled out my entire collection of arctic quadrangles, an assortment that stretched from Attu Island, at the farthest tip of the Aleutians, to Crown Prince Christian Land, on the wild and woolly northeastern Greenland shore. I spread the maps across my floor and knelt over them for hours, enthralled by the wonders hinted at in the bend of a stream, the bulge of a contour line, the resonance of a name. Everywhere I looked, my eyes landed on some peak or fjord or valley that I'd never visited, and every one of them cried out to be explored: Igikpak, Shishmaref, Yakataga; Bluenose Lake, Wager Bay, Ruin Point; Burnt Paw, Sam Ford Fjord, Meta Incognita Peninsula; Fury Beach, Hold-with-Hope Cape, Starvation Cove; Mount Cosmic Debris, the Zebra Cliffs, the Cat's Ears Spires, the Sons of the Clergy Islands.

As I ski along, I recite these names aloud like a mantra, and my mood rises in proportion to the scale of the country rising into the night around me. We're already thirty-nine days past the solstice, I tell myself. Each new day carries seven more minutes of daylight on its young back, which works out to nearly an hour of additional daylight every week. The temperature is now 26°F below, it's pitch dark and snowing and the calendar says we're still in the thick of winter. But I can feel it in my bones: spring is definitely on the way.

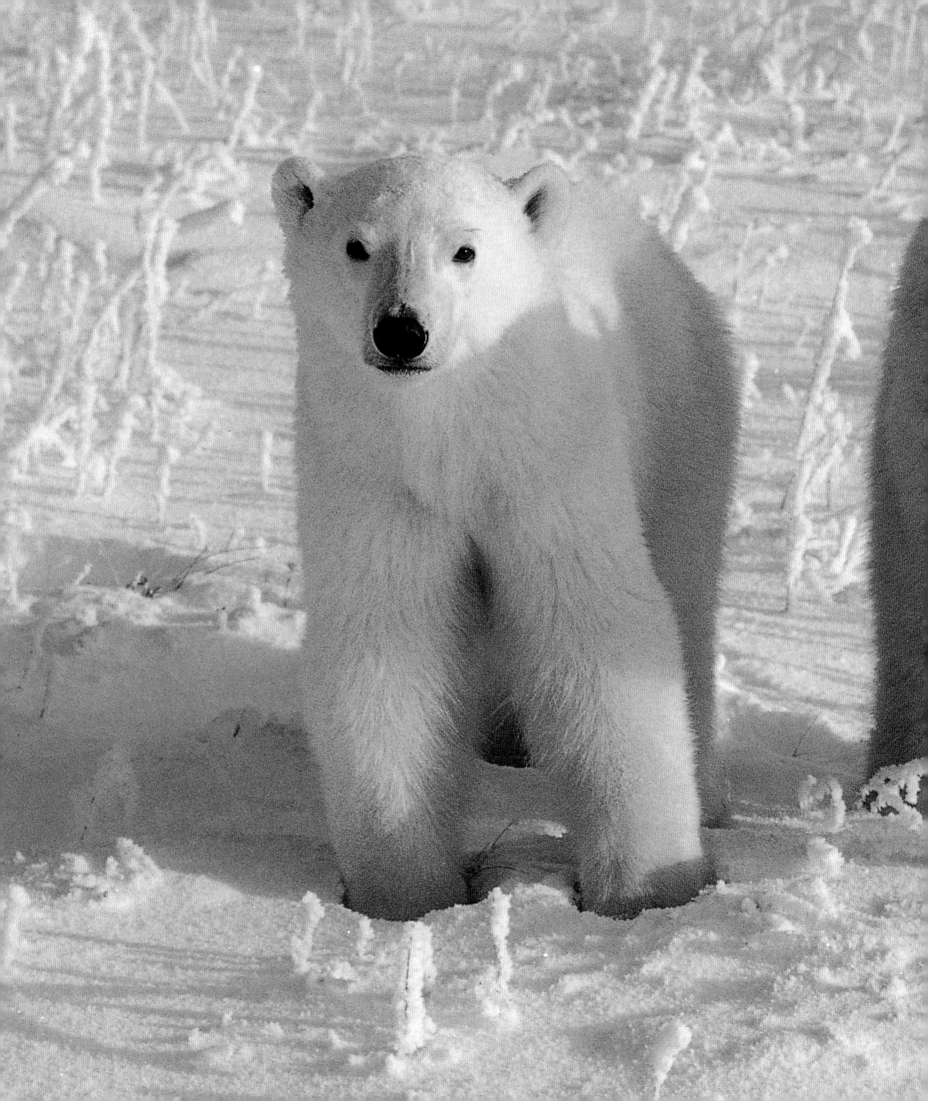

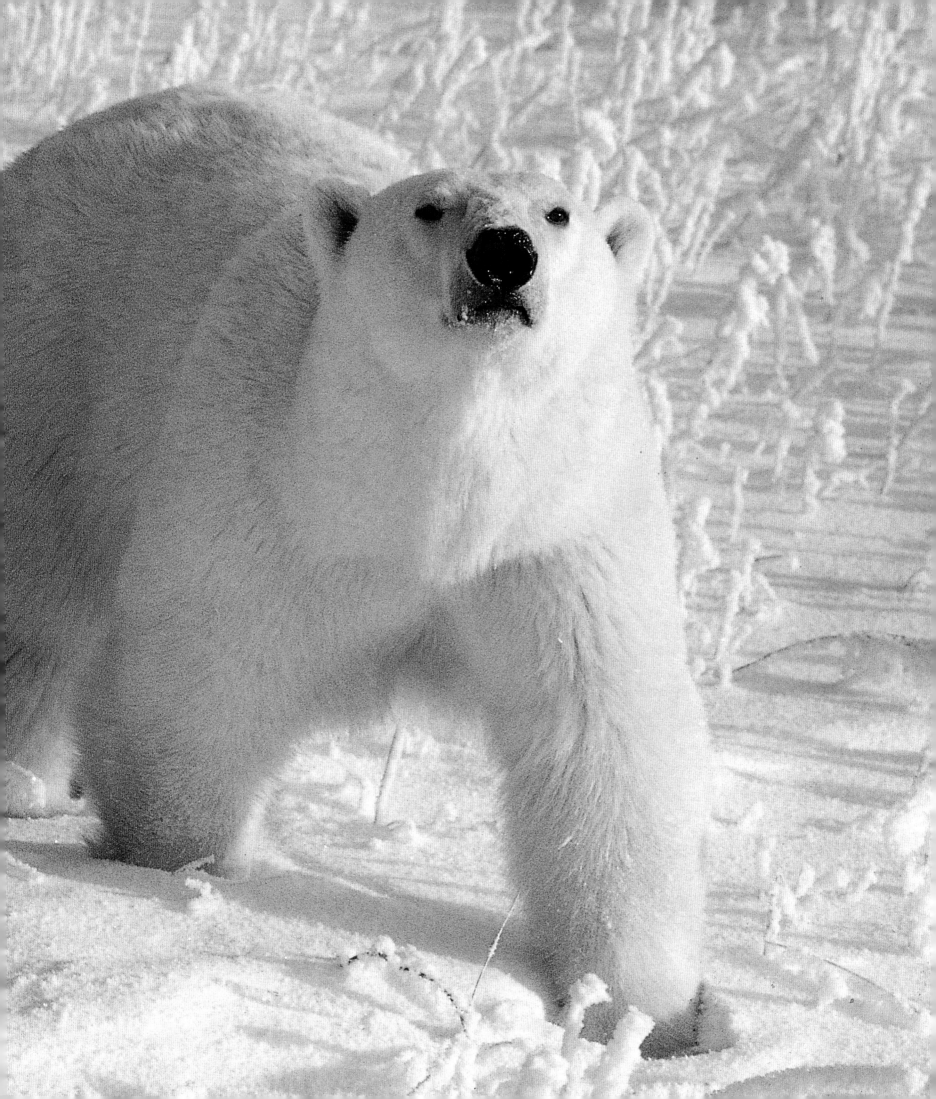

PREVIOUS PAGES: *A polar bear sow walks with her cub through rime-coated grasses. Cubs usually remain in their mother's company for two years, learning to hunt before striking out on their own.*

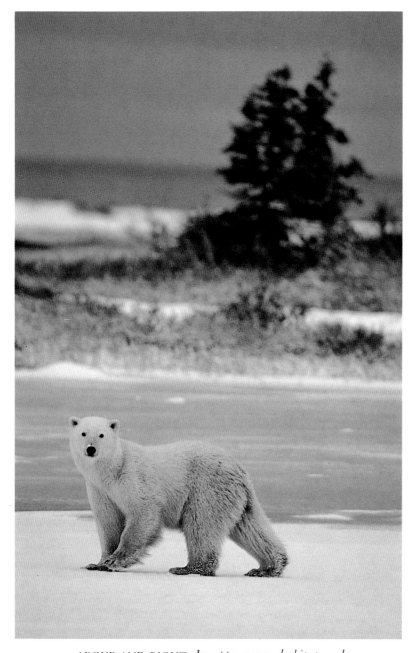

ABOVE AND RIGHT: *In appearance, habitat and behavior, the polar bear is very unlike its closest relative, the grizzly. For this reason, until quite recently taxonimists did not consider the polar bear to be part of the bear genus,* Ursus, *at all; the polar bear, rather, was thought to belong to a wholly separate genus,* Thalarctos.

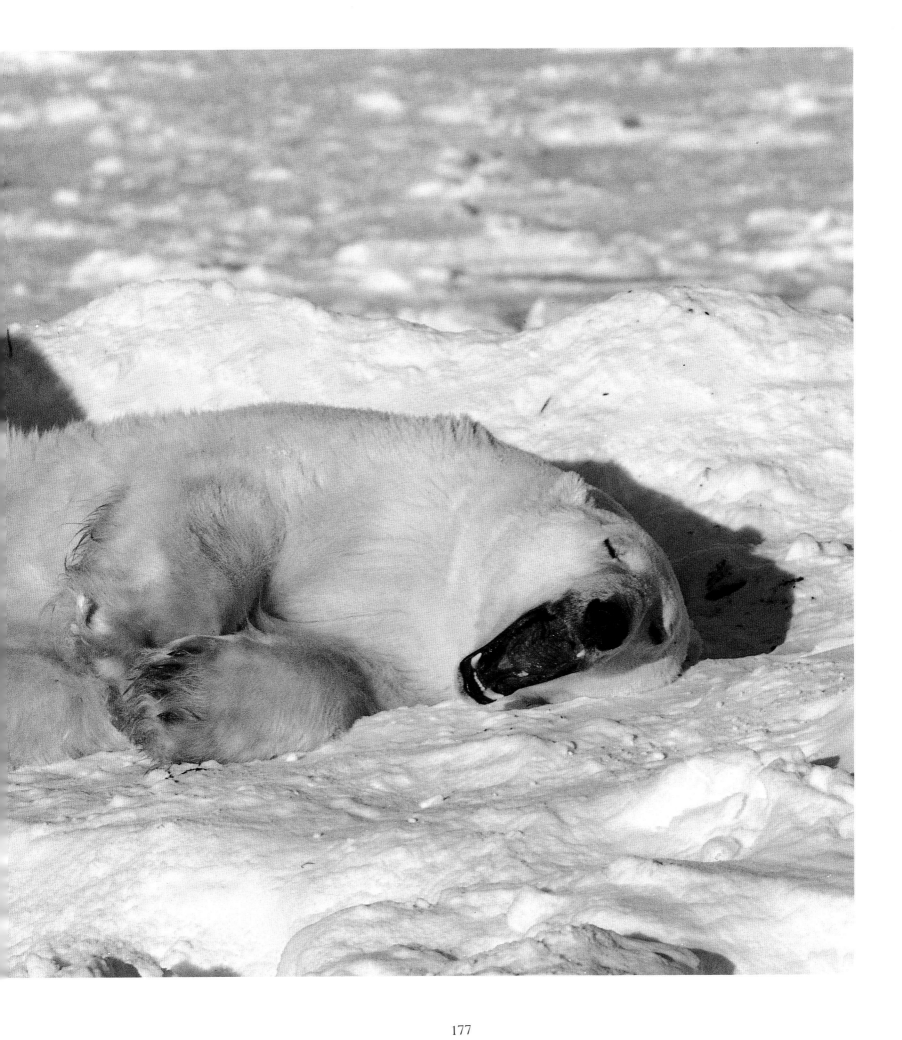

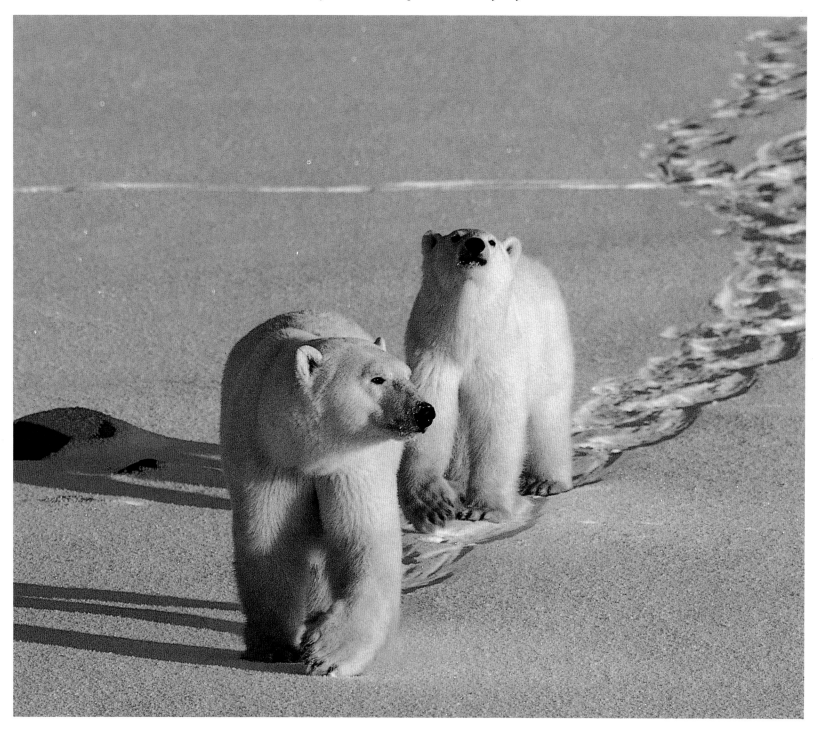

FOLLOWING PAGES: *Trapped by the freeze of winter, tiny air bubbles are suspended in a sheet of clear ice that has formed above the inky depths of an arctic lake.*

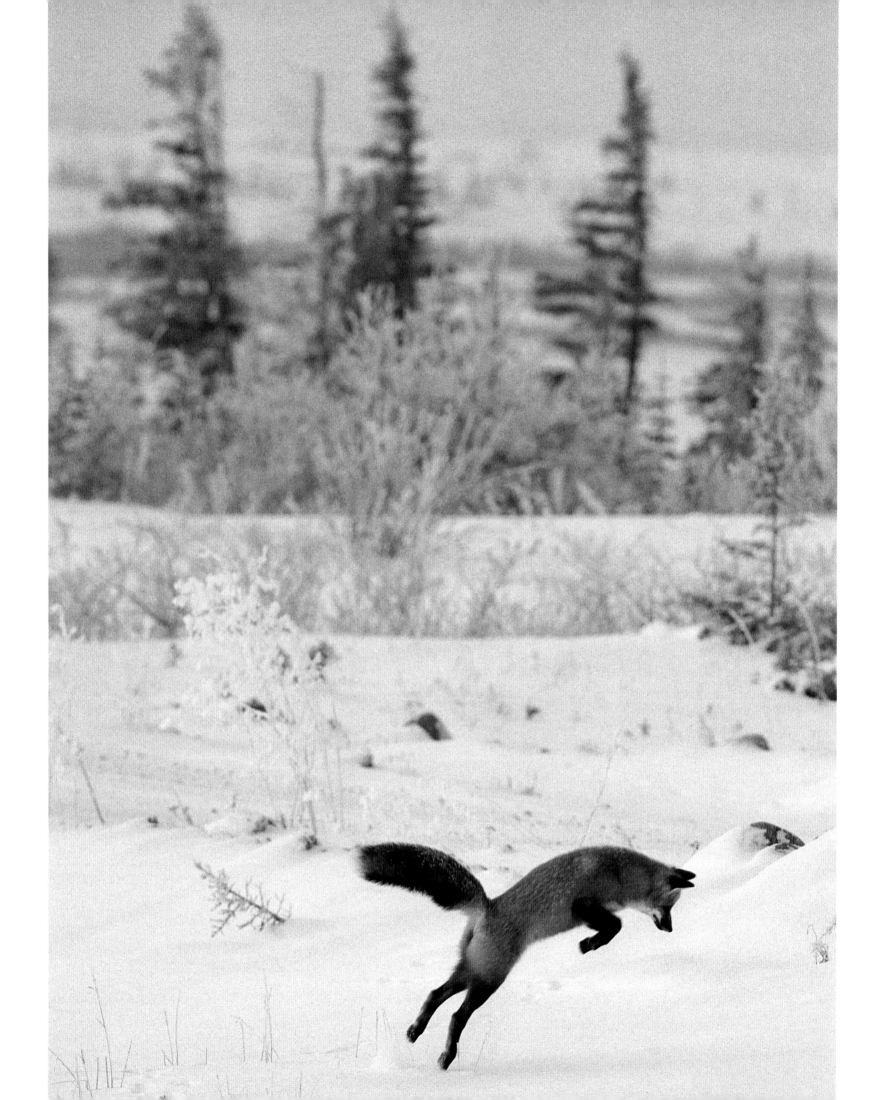

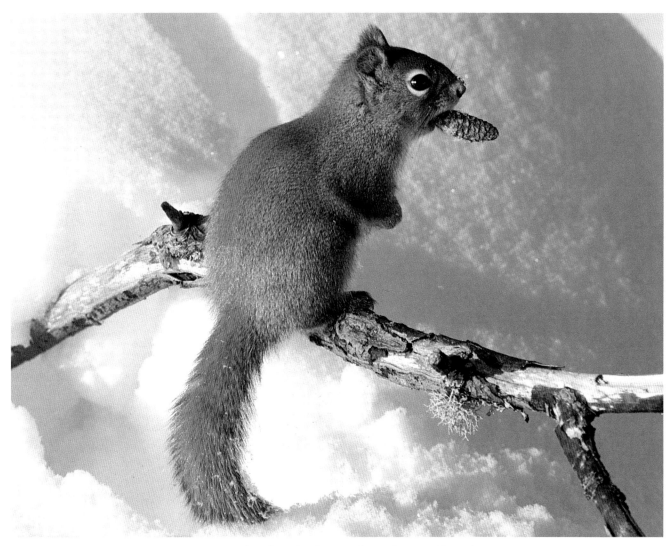

ABOVE: *A red squirrel unearths a pine cone from deep beneath a snow drift. Unable to store enough fat on their small bodies to hibernate through the long arctic winter, squirrels must locate food throughout the cold season.*

LEFT: *A red fox flies into the air to pounce on a mouse attempting to hide in a snowbank at the edge of the boreal forest.*

ABOVE: *A black-capped chickadee, barely four inches long from the end of its bill to the tip of its tail, roosts on an aspen branch.*

RIGHT: *The slender summit tower of Mount Monolith is a prominent landmark at the eastern end of the Tombstone Range. In 1981, four Austrian mountaineers completed the first ascent of this challenging peak.*

FOLLOWING PAGES: *Backlit by the low winter sun, an arctic fox traverses a snow-covered log. Better adapted to extreme winter temperatures than the red fox, the arctic fox has a bushier coat, a shorter muzzle and smaller ears.*

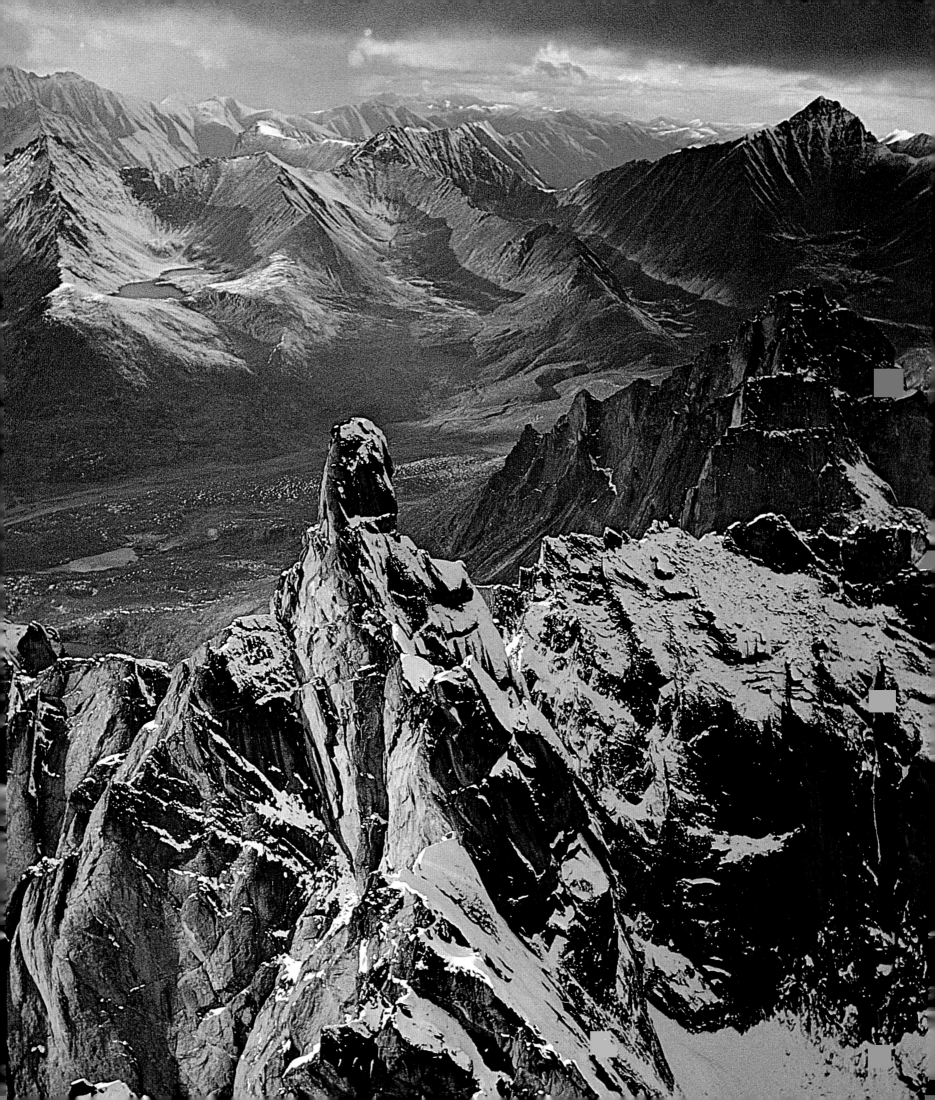

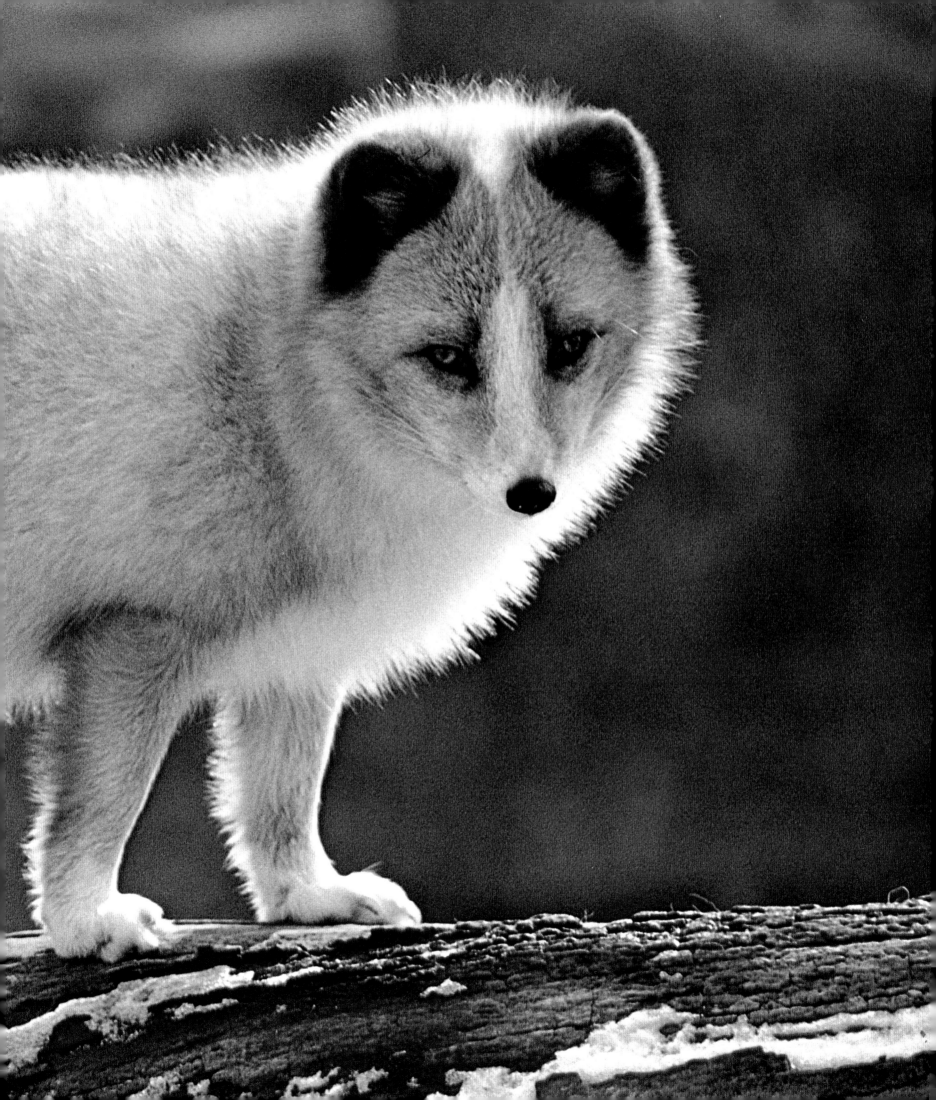

ABOVE: *Warbling its cheery, robin-like song, a male pine grosbeak provides a splash of brilliant color in an otherwise monochromatic winter landscape.*

LEFT: *Wearing a dusting of snow, a northern flying squirrel clings to a tree branch. Loose folds of skin along its sides enable the squirrel to glide as far as 125 feet between trees.*

FOLLOWING PAGES: *Stretching from the Klondike goldfields of the southern Yukon to the Mackenzie Delta of the Northwest Territories, the Dempster Highway traverses more than 500 miles of rugged, desolate country.*

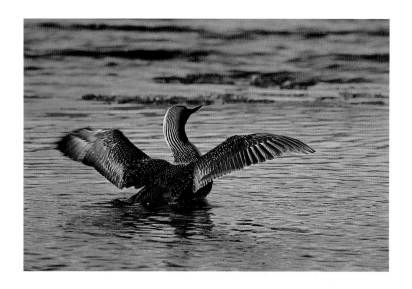